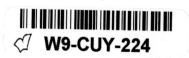

Highlights of the Collections

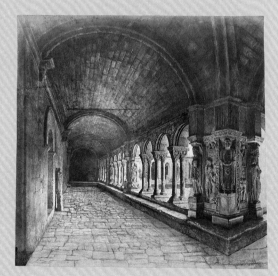

# University of New Mexico

# Art Museum

Highlights of the Collections

The publication of this handbook was made possible by a generous grant from The FUNd at the Albuquerque Community Foundation, assisted by a gift from Van Deren Coke.

The Institute of Museum and Library Services, a federal agency that fosters innovation, leadership, and a lifetime of learning, supports the University of New Mexico Art Museum.

Published by the University of New Mexico Art Museum
University of New Mexico
Albuquerque, New Mexico 87131-1416   (505) 277-4001

Designed by Hisako Moriyama
Photography of works of art by Damian Andrus
Printed in Singapore by CS Graphics Pte. Ltd.

Cover: Charles Sheeler, *Power House No. 1– Ford Plant*, 1927
Gift of Eleanor and Van Deren Coke (see p. 97)

ISBN number: 0-944282-22-9

# CONTENTS

## PREFACE

What a joy it has been, the project of conceiving, compiling, researching, writing, photographing, editing, designing, and seeing into print this handbook. Along the way, all of us involved in the project have come to appreciate even more the extraordinary privilege of working with—of working amidst—a permanent collection of art objects with the range, the excellences, the wonderful quiddities of this one.

The chapters start with "Old Spain, New Spain, New Mexico"—a look, which few if any other museums can provide, at the twists and turns and enduring themes of the Hispanic tradition in the visual arts, in both the Old World and the New, and both north and south of our border with Mexico. Then we proceed in roughly chronological fashion, from the Renaissance until now, from the old masters to contemporary artists. This conventional structure, however, allows us to give you a sampling of our fairly unconventional collection: one in which photographs and prints have a pride of place they rarely enjoy at other museums, one in which great masterpieces frequently rub cheeks with eccentric works of un- or under-known artists. Enjoy the journey.

Among those who made this journey possible are, of course, the many donors, to whom we individually give credit in the captions by each illustrated work. But here I want to thank all those responsible for building the collections: the donors and funders of all of the works for which we don't have space in this modest volume, the directors and curators and registrars and staff and friends of the University of New Mexico Art Museum who have, since our founding in 1963, labored to build and to nurture these collections.

Several people have worked particularly hard to bring this handbook to fruition. Linda Bahm, Associate Director, has served with her usual tact, and diligence, and insight as chief editor. Kathleen Stewart Howe, our Curator of Prints and Photographs, and her associates, Bonnie Verardo and Kate Guscott, were primarily responsible for selecting and pulling (and writing numerous entries for) the many works on paper. Tyler Anderson, whose official title is Museum Assistant, became chief whip for the tasks of photography and verification of measurements. Mark Cattanach, our Collections Manager, fielded all of our requests for object and artist information. I thank them, and all of their colleagues and student aides.

Elsewhere, we also give much-due credit to two non-staff contributors: Hisako Moriyama, who designed this handbook, and Damian Andrus, who took the photographs. Many of the works on paper, especially the photographs, look as good as they do because of conservation performed under a series of grants from the Stockman Family Foundation.

Finally, a generous grant from The FUNd at the Albuquerque Community Foundation, with an important supplemental gift from Van Deren Coke, funded the publication of this handbook. Thank you, both, and all.

Peter Walch
*Director*

## A HISTORY OF THE COLLECTIONS

Compiling a "Highlights of the Collections" handbook such as this is a daunting task for almost any museum, but perhaps particularly so for this one. After all, we have close to 30,000 works of art in our permanent collection (close to 40,000, were one to count the second impressions of the Tamarind Institute lithographs, which we archive). This is by far the largest collection of fine art in New Mexico. To put it further in perspective, when Neil MacGregor, director of the National Gallery, London, visited the University of New Mexico Art Museum collections a few years back, he could give an exact number for the works in his museum: "Two thousand, two hundred and twenty-three paintings and one sculpture" is what I remember as his answer.

How can it be, that this university art museum located in the high desert of New Mexico is, in terms of sheer numbers of art objects in its permanent collection, well over ten times the size of the National Gallery, London? And how could this have been accomplished in less than two score years of existence (compared with the almost two-century history of Mr. MacGregor's institution)?

The simple answer: the National Gallery is a collection exclusively of paintings (and that one odd sculpture)—very rare, mostly Old Master paintings—while the University of New Mexico Art Museum collects primarily works on paper. Lots and lots of works on paper, with special emphases on photographs and prints. Plus some drawings, plus quite a few paintings (both at the main museum and at the Jonson Gallery), and sculpture, and silver (mainly, Spanish Colonial silver), and ceramics, and just a very few textiles. These emphases (photographs and prints), and the wonderfully eclectic nature of our collections (both in terms of media, and in their makers—which range from world-famous artists [Rembrandt, Picasso, O'Keeffe] to anonymous crafts people) will become fully apparent as you peruse the pages of this handbook. But still, how did this come to pass? How and why did these particular collections come to be at the University of New Mexico Art Museum?

Each object has its unique history, part of which is revealed by its credit line. As you read through the handbook, you are invited to scan those credits and to thank—silently, with us—the various donors who gave these wonderful works of art, or provided the funds with which we acquired them. Only a very few objects are credited neither to a donor nor to a fund: those were purchased through the museum's own budget (in our early years—alas, no longer—we had a modest state-supplied acquisition budget). Another part of the object's history is revealed by the numbers—the accession numbers —which follow the credit line. The first two digits indicate the year of acquisition, those to the right of the period indicate the order in which it was received in that year. This is, by the way, a system widely employed by museums around the world. Now that you're in on the code, you may enjoy garnering these bits of insider information whenever and wherever you visit a museum.

So what do these credits, what do these accession numbers, tell us about the collections of the University of New Mexico Art Museum? At least one important thing: that our founders were very smart people. Two of them in particular stand out

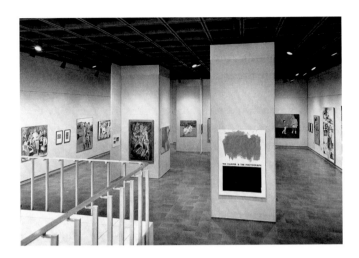

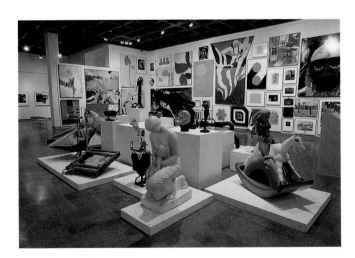

Installation view: "The Painter and the Photograph"
University of New Mexico Art Museum
April 4 – May 9, 1965

Installation view: "Art of this Century"
University of New Mexico Art Museum
September 26 – December 19, 1993

for having set us on the course which continues to this day. In August of 1961, Clinton Adams came to the University of New Mexico from Los Angeles (where he had been founding associate director of Tamarind Lithography Workshop) to be dean of the College of Fine Arts. He found planning underway for a University Art Gallery, to be constructed as part of a new performing arts building. Adams made one early "save": that gallery was, in the architect's draft plans, to have its north wall entirely of glass! Adams quickly had that changed to a more conventional surface upon which paintings could be hung. His second good move: hiring the photographer and photo historian Van Deren Coke, from his faculty and art gallery position at Arizona State University, to come in 1962 as founding director of the still-unopened UNM Art Gallery.

Adams and Coke were (and are) visionaries of a very high order. This new gallery would not just exhibit, but also collect. Particularly in a university setting, students and scholars need a permanent collection to research, to study, to learn from. But many of the traditional strengths of "encyclopedic" museums (the Louvre, the Metropolitan, the Chicago Art Institute) were already closed to entry by all but the wealthiest. Classical antiquities, medieval art, Old Master painting and sculpture (for the most part) were scarce and prohibitively expensive. But prints (about which Adams knew a lot) and photographs (in which Coke was one of the few experts at that time) were wide-open fields for collecting. So prints and photographs became the twin pillars upon which our collections were founded, and upon which they rest to this day.

You will read more about the histories of various subsets of the collections in the brief essays which precede each chapter of this handbook. Some very graphic evidence of the explosive growth of the permanent collections can be seen in two photographs documenting exhibitions held here, one in 1965 and the other in 1993. The earlier exhibition, "The Painter and the Photograph," was a travelling exhibition curated by Van Deren Coke; it demonstrated his (then radical) thesis that artists, since shortly after the 1839 invention of photography, had used—and still often use—photographs as the basis for paintings. Yes, that's a Marcel Duchamp

painting (loaned by the Philadelphia Museum of Art) on the wall left of the title panel. And paintings by Andy Warhol and Robert Rauschenberg on the right wall (which, without intervention, would have been all glass!). Amazing, what could be borrowed on a shoestring budget back in those days, before the escalation in insurance and shipping and all other exhibition expenses.

The 1993 exhibition, held to mark our thirtieth birthday, was called "Art of this Century." Two hundred and seven works, by artists from Berenice Abbott to Piet Zwart (with Benton and Beuys, Cartier-Bresson and Coburn, Diebenkorn and di Suvero—you get the idea—in between), in way over twenty different media (gelatin silver and platinum and Cibachrome and Polaroid photographs, lithographs, woodcuts, etchings, serigraphs, linocuts, welded steel, bronze and copper, terra cotta, foam rubber, plaster, wood, oils and acrylics and egg temperas, watercolors, charcoals, graphite and colored pencil and ink drawings... hey, you name it!), from all ten decades of the century, filled—some would say, filled to overflowing—the main gallery. And all came from the permanent collection. We got to thank fifty-five different individual and institutional donors for providing us, and our audiences, this remarkable cornucopia of 20th-century art.

In three decades, not only had the collections grown in numbers, depth, and excellence, they had—while keeping strong foci on prints and photographs—spread into such areas as Spanish Colonial art and even Old Master painting and sculpture. We had become, in short, a true museum, not just a gallery (the name had been changed in 1964, perhaps only slightly prematurely, to the "University of New Mexico Art Museum"). Especially around the collections of prints and photographs, strong programs—both undergraduate and graduate—had been established, then grew and flourished, in UNM's Department of Art and Art History. Tamarind Institute, founded at the University of New Mexico in 1970, continued the world-renowned programs in lithography begun ten years earlier at Tamarind Lithography Workshop in Los Angeles. Presses, programs, archives, and all were moved to Albuquerque, where the Institute's training and publishing programs both confirmed and enhanced the Museum's commitment to prints in general, and to lithographs in specific.

The story of photography at UNM—both studio photography, and the history of photography—bears particular telling. Van Deren Coke for a time wore two hats: museum director and chair of the Department of Art and Art History. He and his successors brought distinguished faculty to the department: Wayne R. Lazorik, Thomas F. Barrow, Betty Hahn, Patrick Nagatani, Adrienne Salinger, and James Stone on the studio side, and Beaumont Newhall, then Eugenia Parry, then Geoffrey Batchen in photo history. Wonderful students followed, students who obtained their education from the top-notch faculty, from their peers, and (in many cases, especially) from the superb Museum collections. Anne Noggle, Nicholas Nixon, Joseph Deal, Robert ParkeHarrison, Amy Conger, Thomas Southall, Sarah Greenough, Keith Davis, Steve Yates, Therese Mulligan (at the risk of offending those many others whose names might extend this list to several pages, I will stop here) ... the roster of studio photographers,

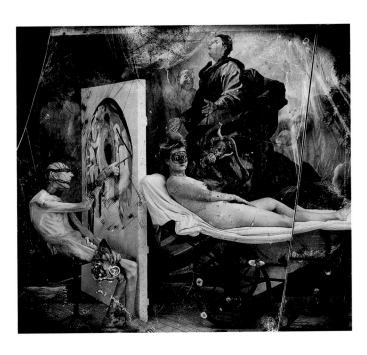

Joel-Peter Witkin
b.1939 Brooklyn, New York
*Poussin in Hell*, 1999
Gelatin silver print
13 3/4 x 15 3/8 in. (34.9 x 39.1 cm)
Gift of the artist
2000.30

photo historians, and curators of photography who have come out of this graduate program is impressive, impressive enough to have firmly established the program as one of the top two or three in the country.

The noted photographer Miguel Gandert still loves to recount how, beginning as an undergraduate, he haunted the Museum. At least once a week, he would ask for a box of photographs to be pulled for him, and in that fashion worked his way through the entire collection (then some 6,000 photographs), from A to Z. Joel-Peter Witkin— another noted studio photography graduate (one-person shows at the Guggenheim, the Louvre, etc., etc.)—still comes back to this collection, to hone his eye for special tonings and other subtle effects as practiced by earlier master photographers.

So it is that these collections have grown, and so it is that they have nurtured now several generations of students, scholars, and all who love and appreciate the visual arts. We hope that this eccentric selection of works from our collections will encourage you, also, to become a regular (or even more regular) visitor and supporter of the University of New Mexico Art Museum.

Peter Walch
January 2001

# Old Spain, New Spain, New Mexico

## OLD SPAIN, NEW SPAIN, NEW MEXICO

The Portuguese, it turns out, were correct: Christopher Columbus couldn't reach China—the stated objective of his famous first voyage—by sailing due west from Europe. So they refused to back his venture, and he turned instead to King Ferdinand and Queen Isabella of Spain. Among the fallouts of that momentous decision is the fact that most people in the Western Hemisphere now speak Spanish. And another enduring legacy resulted from the implanting on this soil of Spanish artistic traditions.

Here in New Mexico, those traditions still resonate over five centuries later. And here at the University of New Mexico Art Museum, we can—by comparing works made in Spain, Latin America, and New Mexico—measure and appreciate this artistic legacy. We can see how this legacy has been shaped, how it continues to be shaped, by the conditions and cultures of these lands. Through these works of art, some by famous artists, others by unknown artisans, we can come to grips with the still reverberating consequences of the impacts of European and American civilizations upon each other.

It should further be noted that the University of New Mexico Art Museum is one of the very few institutions equipped by collections and by mission to tell this complex story. Many museums are restricted to either just American art, or just the art of a single region, or just 20th-century art, or just "fine" as opposed to "folk" art. Thanks to the prescience of our founders and the continuing generosity of our patrons, we have here the full range of objects sufficient to demonstrate the intricacy and resiliency of the Hispanic tradition, on both sides of the Atlantic, and both sides of the equator, as well.

Only one major part of the equation is missing: the important contribution of the art of indigenous peoples, which at the University of New Mexico remains the domain of the Maxwell Museum of Anthropology. Fortunately, in recent years cooperative exhibitions have allowed both institutions to share their respective collections when appropriate, to the benefit of all of our audiences.

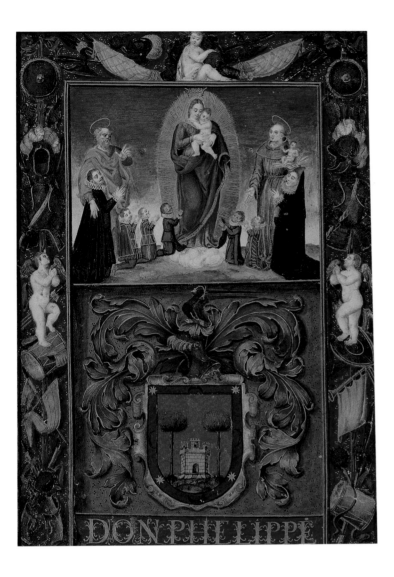

## UNKNOWN ARTIST

Active c.1600, Spain
*Manuscript Leaf from a Carta Executoria*, n.d.
Tempera and gold leaf on vellum
14 5/8 x 11 1/2 in. (37.1 x 29.2 cm)
Julius L. Rolshoven Memorial Fund
96.4

The Carta Executoria was a powerful and important document for Spanish families of the 16th and 17th centuries. This highly decorated page would have been followed by documents certifying that the petitioner had been adjudged to be of aristocratic descent, and thus (so long as he performed military service to the king) exempt from taxation. Both social standing and financial benefits flowed from such a determination, so it is not surprising that families who emerged from the process often commissioned artists to create elaborate frontispieces behind which to preserve this pivotal documentation.

We don't know for what family this particular page was created, though research on the coat of arms (which fills the lower half of the page) might one day allow us to uncover the specific "Don Phelippe" who—along with his wife, and their six children—is depicted above, being presented by attending saints to the Madonna and Child. The castle (flanked by two trees) suggests the possibility that the family is of Castillian origin. The surrounding border, filled with arms, armor, and battle drums, attests to Don Phelippe's military prowess.

Stylistically, this page is also a powerful testament, in this case to the multiple currents swirling through Spanish art at the dawn of the 17th century. We sometimes think of Spain and its art as somewhat isolated. But many times throughout history, the Iberian Peninsula has been swept by foreign currents, from ancient Rome, from Islam, from Italy, and even from the Low Countries (which Spain once ruled). In this work, the border (and, in particular, the nude cherubs) seem to have been lifted straight out of Italian Renaissance book illustrations, while the family portraits (and, to a lesser extent, the religious personages) are done in a tighter, more indigenous manner. Perhaps two artists worked on this page, or perhaps it was a single hand working in one place closely from a model while, in another, left more to its own devices.

—PW

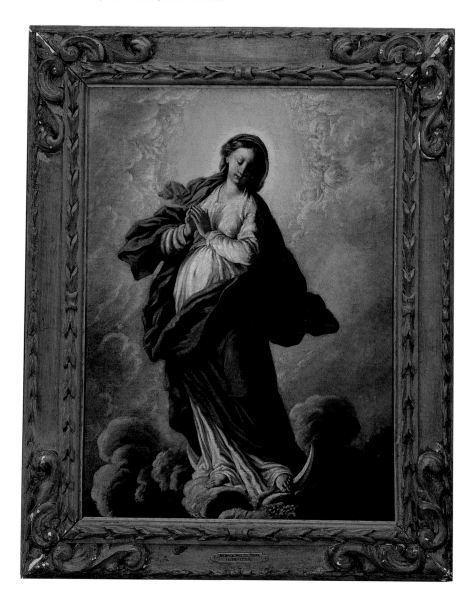

**ALONSO MIGUEL DE TOBAR**
**("TOVAR")**

b.1678 Higuera, Spain
d.1758 Madrid, Spain
*The Immaculate Conception*, c.1735
Oil on canvas,  34 3/8 x 28 1/8 in.
(87.5 x 71.5 cm)
Purchased with funds from the Friends of Art
74.193

Of all the religious subjects introduced into the New World by priests and artists, none was more prototypically Spanish than the Immaculate Conception. The doctrine that Mary, in the first instance of her conception, was preserved exempt from original sin, can be traced back to the early Church fathers. But this doctrine was highly controversial in the 17th century (it was not declared Church dogma until 1854). Particularly in Spain, the controversy raged—and particularly in Spain, most of the greatest Baroque artists (Velázquez, Murillo, Zurbarán) painted numerous examples of the Immaculate Conception.

It was a Spanish artist, Francisco Pacheco, who literally wrote the book on how artists should depict the Immaculate Conception. In his *El arte de la pintura (The Art of Painting)* of 1649, Pacheco included a lengthy description of the correct way to represent this subject. Revelation 12:1, "a woman clothed with the sun, with the moon under her feet, and on her head a crown of twelve stars," is the commonly mentioned Biblical source. Pacheco also suggests the possibility of a crushed serpent under Mary's feet, as a symbol of evil vanquished.

Alonso Miguel de Tobar (or "Tovar") inherited both this iconography and, generally, his style from the great masters of 17th-century Spanish art. Trained in Seville (where he was appointed court painter in 1729, when the Spanish court moved to that city), he was particularly influenced by Murillo. But in Tobar's art, the grandeur of the Spanish Baroque becomes gentled, prettified—becomes, that is to say, the Rococo. As a leading exemplar of advanced 18th-century taste in Spain, Tobar predicts and at least indirectly influences a slightly later move among Spanish Colonial artists (even in such faraway provinces as New Mexico) toward lighter palettes and more delicate paint handling.
—PW

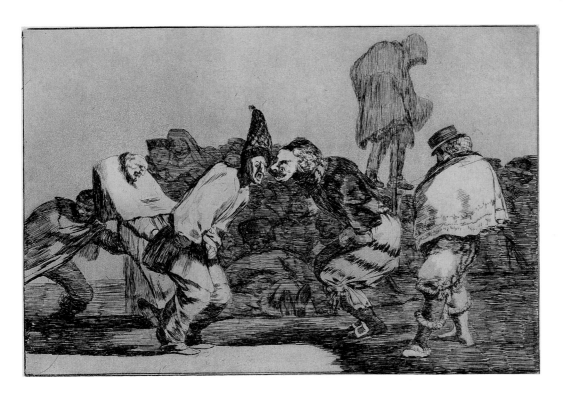

## FRANCISCO DE GOYA Y LUCIENTES

b.1746 Aragon, Spain
d.1828 Bordeaux, France
*The Folly of the Carnival*, from the series *Los Proverbios*,
c.1816-1823
Etching and aquatint, printed 1864
8 1/4 x 12 1/4 in. (21.2 x 31.1 cm)
65.94

When we see the word "carnival," we think of sideshows and cotton candy, of a supremely secular event. But you get a different image by breaking the word down to its Latin roots: *carne* = meat, and *levare* = take away. The original carnival is the celebration just before Lent when traditional Catholics give up eating meat to mark the days preceding Easter. Gradually, this observance grew into riotous outpourings—the famed Mardi Gras ("Fat Tuesday") of New Orleans, or modern-day Carnival in Rio de Janeiro: feasting, music, outlandish costumes.

Goya—one of the great graphic artists of all times—gives us a very dark view of Carnival. We see reeling drunks, hideously deformed faces, a monstrous stiltwalker. This is one of a series of highly enigmatic prints Goya made, examining the *disparates,* or follies, of humankind. Left unfinished at his death, with no indication of intended order or even individual titles, they were published decades later by the Academía de San Fernando in Madrid under the invented title, *Los Proverbios* (*The Proverbs*).

When Goya created this darkly pessimistic view of a terrified and terrifying populace, the Golden Age of Spanish civilization was long over. Spain was bankrupt, both financially and politically. It had recently endured the agony of occupation by the French, a protracted war to oust the invaders, and the restoration of a corrupt monarchy. Goya—once the star painter at the still-glittering courts of Carlos III and Carlos IV—was aging, ill, and now deaf. He recorded the stupidities and cruelties of life with unflinching honesty, without sentimentality, and in so doing gave birth to a tradition of socially engaged art which still flourishes with especial vigor in Spanish-speaking lands.
—PW

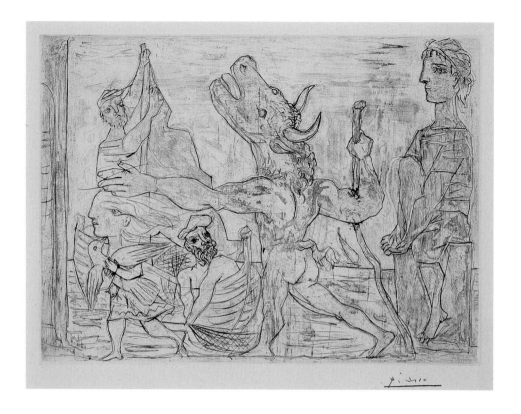

## PABLO PICASSO

b.1881 Malaga, Spain
d.1973 Mougins, France
*Blind Minotaur Led by Girl with Fluttering
Dove III*, 1934
Etching and engraving
8 7/8 x 12 1/4 in. (22.8 x 31.1 cm)
Julius L. Rolshoven Memorial Fund
65.88

Despite living almost his entire adult life in France, Pablo Picasso was quintessentially Spanish—the greatest artist of the Spanish tradition in our century. *Blind Minotaur Led by Girl with Fluttering Dove III* explores themes which resonate in Spanish culture.

The Minotaur was a mythical monster, kept by King Minos of Crete in the Labyrinth, a maze-like building. The offspring of a white bull and Pasiphaë, the wife of Minos, the Minotaur had the body of a man and the head of a bull. Each year, the Athenians had to offer in sacrifice to the Minotaur seven young men and seven maidens. In Greek legend, their hero, Theseus, finally killed this fearsome monster.

This ancient story reverberates throughout Mediterranean civilization, and particularly so in Spain. The bullfight—a bloody morality play, pitting man against bull—goes back to the bull wrestling games of ancient Crete. Picasso travelled extensively in his native Spain in 1933 and 1934, and much of his art from this period incorporates either the bull or his half-human counterpart, the Minotaur.

Among related projects was the photo-assemblage cover depicting the god-beast Minotaur which Picasso created (in conjunction with the photographer, Brassaï) for the inaugural, May 25, 1933, issue of *Minotaure*, the magazine of Surrealism published by Albert Skira. Then, as part of the *Suite Vollard* (an ambitious project of 100 etchings by Picasso, commissioned by his long-time dealer, Ambroise Vollard), Picasso in the period September through November of 1934 created four related images of a blind Minotaur accompanied by a young girl.

Here, in the third of these four prints, the blind Minotaur struggles uncertainly forward, led by the girl who holds a fluttering dove. A sailor watches impassively from the shore; two others look on from a sailboat. The voyage of life, innocence, and mortality are the themes of this drama—themes which occupied much of European civilization in the dark years leading up to World War II. Picasso addresses these issues through symbols which underlay centuries of Spanish cultural and artistic traditions.

—PW

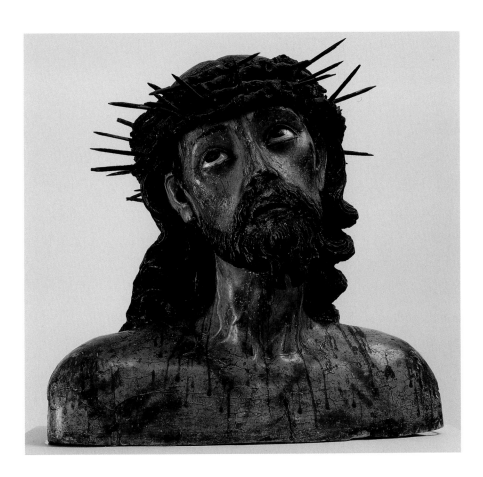

### UNKNOWN ARTIST

Active late 17th century, Bolivia (or Peru?)
*Christ with the Crown of Thorns*, c.1680
Wood, fiber, gesso, glass, and polychrome
14 5/8 x 16 x 8 3/8 in.
(37 x 40.5 x 21.2 cm)
Purchased with funds from the UNM
Foundation, Inc., and the Friends of Art
88.10

One of the most powerful pieces in our collection, this bust of Christ has been for many years one of our most challenging long-term research projects. The style is typically Spanish: intensely physical and emotional, and almost hyper-realistic. Note the corded veins in the neck, the blood-shot eyes, the bruises and lesions. All this comes directly out of the great masters of 17th-century Spanish sculpture.

But was it made in Spain? Ownership goes back to a private collection in Bolivia. That region of the New World (encompassing, as well, Peru) was in the 17th century vastly rich from intensive silver mining, and attracted both art and artists from the mother country to fill the many splendid new churches with both painting and sculpture.

Perhaps a physical investigation of the materials and methods of construction could provide useful clues. A CT-scan at Lovelace Medical Center, Albuquerque, provided a series of x-ray pictures, each representing a section or imaginary slice through the sculpture. Now we could see the interlocking set of ten wood blocks which provide the central armature, and the covering molded layer of gesso (gypsum-based plaster) and plaster-soaked fabric which appears as the bright white ring around the exterior.

The grain on the wood, according to University of New Mexico Biology Department experts, looks like that of any number of hardwoods. We had to extract a tiny sliver from the base for closer examination: the cells, it turns out, are consistent with South American walnut or mahogany.

A small sample of fabric fiber yielded confirmation: it is alpaca wool, which points directly and conclusively to a small area of Bolivia and neighboring Peru as the likely place of manufacture of our sculpture.

If the "where" is now provided by science, it remains for art historians to determine who exactly created this bust. Was it someone born and trained in Spain, or was it a native of the New World who imbibed the Spanish Baroque style at a remove? This mystery remains to be solved. —KSH

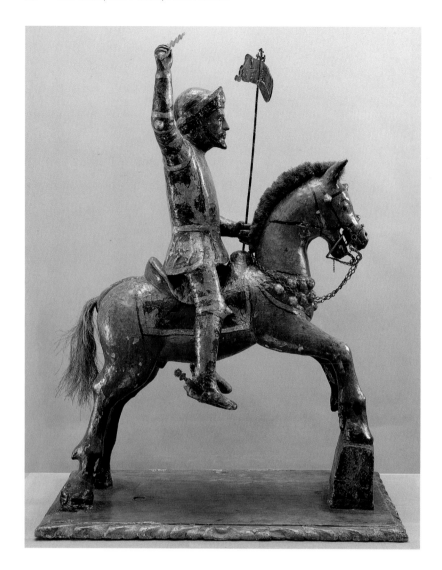

### UNKNOWN ARTIST

Active late 17th century, Mexico
*Santiago*, c.1680
Wood, cornstalk paste (?), gesso, polychrome,
glass, silver, iron, and horsehair
38 5/8 x 27 3/8 x 17 5/8 in.
(98.1 x 69.5 x 44.8 cm)
Purchased with funds from the Friends of Art,
the Julius L. Rolshoven Memorial Fund, C. Leslie
Everett, and anonymous donors
99.17

No saint looms larger in Spanish culture than Santiago, or Saint James the Major. Legend has it that Santiago converted Spain to Christianity in the first century, and that his body was later miraculously transported to Santiago de Compostela in northwestern Spain, which became the most important European pilgrimage destination during the Middle Ages. Santiago reportedly appeared at the front of Christian troops in their battles to reconquer Spain from the Moors. It was in this guise, as a mounted warrior, that Santiago Matamoros (Saint James the Killer of Moors) became the patron saint of many Spanish villages.

Subsequently, and by extension, Santiago became a leading metaphor of the Spanish New World campaigns of conquest and conversion against native populations. Both the conquistadors and the new converts adopted the cult of Santiago, who—it was widely alleged—often appeared on the side of the Spaniards during the battles of the Conquest. Cavalry warfare, and the horse itself, were, of course, introduced to the New World by the Spanish troops, and thus the mounted warrior-saint was an appropriate symbol, embraced both by the invaders and the defeated populace, of a powerful new force in the Americas.

To this day in Mexico, the feast day of Saint James (July 25) is marked with elaborate processions and other festivities. Our Santiago was almost certainly created to be carried in such processions. Its light weight suggests that the construction may be an amalgam of wood, gesso, and cornstalk paste (*caña de maíz*). The last, also called *pasta de caña*, is an unusually lightweight material traditionally used in prehispanic Mesoamerica to fashion large-scale processional figures.

One of the very few images of this size and condition to have survived, our Santiago can be dated on style to the late 17th century. Only modest modern additions or replacements have been made (the machine-linked metal reins, for example), while it still preserves the original silver spurs, banner, and sword—splendid and opulent testimony to the seminal importance of Saint James in the Hispanic New World.
—PW

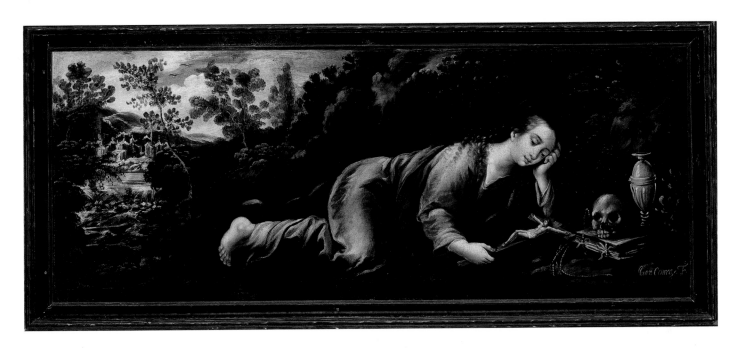

## JUAN CORREA

b. c.1646 Mexico City, Mexico
d.1716 Mexico City, Mexico
*Mary Magdalen*, c.1680
Oil on canvas
30 x 60 in. (76.2 x 152.4 cm)
Purchased with funds from the Friends of Art
74.247

Juan Correa's *Mary Magdalen* represents the full flowering of the Baroque style in Mexico. Correa shows the saint in her old age, fasting and reading in the wilderness. The skull symbolizes her penitence, her turning away from the material world and matters of the flesh. The alabaster vase refers to the ointment with which she bathed the feet of Christ.

The subject matter, the symbols, even the general style of this painting, all relate back to European models. For a short time after the arrival of the Spanish in Mexico, a curious hybrid art existed: native artists, under the supervision of Europeans, painted manuscripts which told of the local history and customs— and these manuscripts were more Aztec than European in style. But just as native religions were forcibly suppressed in favor of Christianity, so was native art overwhelmed by European models.

Thus we employ the term "Baroque"—originally used to denote European 17th-century art—to describe this painting. But Correa and his contemporaries demonstrate the emergence of a distinctive Latin American aesthetic. Compared with the gravity of 17th-century Spanish painting, what came out of Mexico is an art more exuberant, less restrained. Richly dramatic and decorative, Correa's *Mary Magdalen* embodies both the spirituality and the love of material splendor characteristic of New Spain's culture.

And there's a social history of note regarding this artist. Correa was the son of a surgeon-barber (also named Juan Correa), who was in turn the son of a Spanish father living in Mexico City and a Moorish mother. Thus Juan Correa, the painter, is listed in documents of his time as a *mulato libre*, a free person of mixed European and African descent. In Europe, this ancestry might have kept him from the higher levels of his profession. But in the New World, where innovative combinations of cultural heritages were very much the order of the day, Juan Correa became the most famous artist of his generation, whose many commissions included prominent works for the cathedral in Mexico City.
—PW

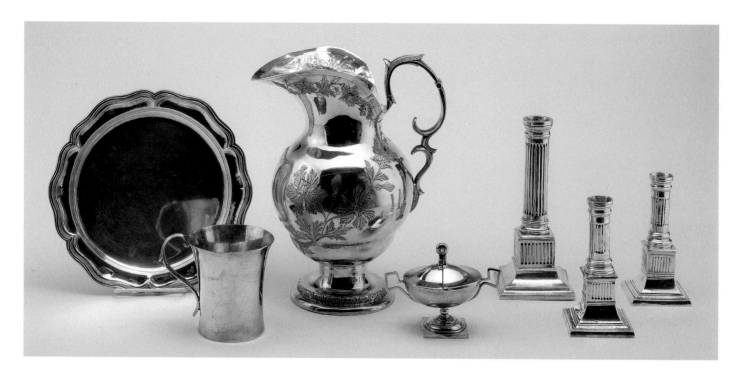

## UNKNOWN ARTISTS

Active 18th and 19th centuries, Mexico
*Domestic silverware*, c.1780-1860
Silver
The Mary Lester Field and Neill B. Field Collection
XO.124ff

We tend (for the most part, correctly) to think of Spanish Colonial-era life in New Mexico as harsh and unforgiving, for both Native and Hispanic populations. But 19th-century visitors from the United States often commented on the lavish silver which adorned the tables of their Hispanic hosts. The Field Collection silver (ninety-four pieces in all) at the University of New Mexico Art Museum represents one of the larger public collections of such domestic ware, which has tended to survive less well than church silver. Collectively, these often massively impressive pieces, reveal much about the lives and the ambitions of their original owners.

It must first be noted that Mary Lester Field, who formed this collection in Albuquerque during the decades either side of 1900, was incorrect in her assumption that the majority of the pieces were manufactured in New Mexico. Instead, modern research has revealed that most were created in Mexico; the stamped hallmarks (required by law, in part as proof that the appropriate tax had been paid) give us both dates and, in a few instances, the names of the craftspeople who fashioned them. However, a few pieces display either awkwardly-forged hallmarks or none at all, and these were probably of local manufacture. Universally, these New Mexican pieces are cruder than those from

Mexico City—or, put more positively, they reflect the values of the frontier: directness, frankness, and durability.

The Mexican Colonial silver, several pieces of which are here illustrated, tell another story. They tangibly represent the treasure extracted (sometimes at terrible human cost) from the mines of New Spain. It was, of course, the profusion of gold and silver (*oro y plata*) that most immediately excited the admiration and the avarice of the Spanish explorers who landed in present-day Mexico in the early 16th century. By the 17th century, the silver shipped from Mexico and Peru back to Spain was roughly fifteen times the total production of all European mines; for gold, the figure was about the same.

If these silver objects evidence the wealth of the New World, they also represent the arrival in this hemisphere of European customs and art forms. The candlesticks—in high Neoclassical style—are fluted to represent ancient Greek architectural columns, while the giant ewer is shaped like an upside-down Spanish helmet.               —PW

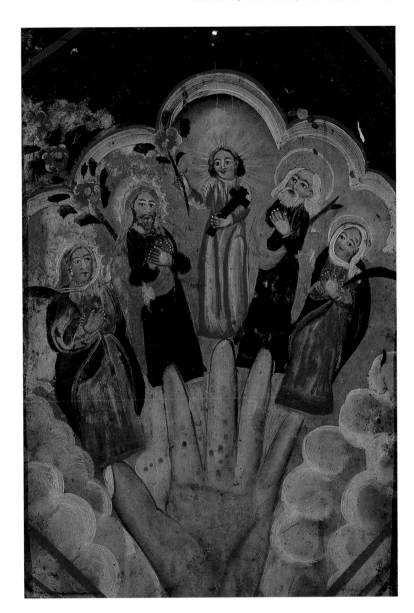

The folk art tradition of painting religious images on tin (called *retablos* or *laminas*) flourished in central Mexico during the 19th century. In 1827, a factory opened in central Mexico which produced 14 inch by 10 inch sheets of tin, intended for various industrial uses. These quickly replaced both canvas and copper as the preferred medium on which to paint inexpensive devotional images. A few of the more important tin *retablos* are full sheet in size (as is this one), but most are either half (10 x 7 inches) or quarter sheet (7 x 5 inches). Tens of thousands were produced in the 19th century, and some continue to be painted even today.

Folk artists living in what is called the Bahío area—the central Mexican states of San Luis Potosí, Zacatecas, Guanajuato, Querétaro, Jalisco, and Michoacán—produced the majority of tin *retablos*. Instead of being painted on commission, they were typically produced by workshops and peddled door-to-door or from stands set up in public places.

This popular art form was practiced mostly by self-taught artists who lacked academic training. Most remain anonymous. Dramatic Baroque church art of the 17th and 18th centuries served as prototypes. As a result, artists kept alive centuries-old subjects and styles well into the 20th century. This particular image—*La Mano Poderosa*, the Powerful Hand—is steeped in mystery and alludes to an unidentified allegory, perhaps the Mystic Vintage. The five figures represent members of the Holy Family. They are, from left to right, Mary, Joseph, and Jesus, and Mary's parents, Joachim and Anne.

This work comes from a group of 159 tin *retablos* given to the University of New Mexico Art Museum by C. Andrew Sutherland (UNM Class of 1929) in memory of his wife, Angia Rosa Sutherland (UNM Class of 1927).

—HL

## UNKNOWN ARTIST

Active mid-19th century, Mexico
*La Mano Poderosa*, c.1850
Oil on tin, 13 3/4 x 9 1/2 in. (34.9 x 24.1 cm)
Gift of C. Andrew Sutherland in memory of
Angia Rosa Sutherland
67.118.13

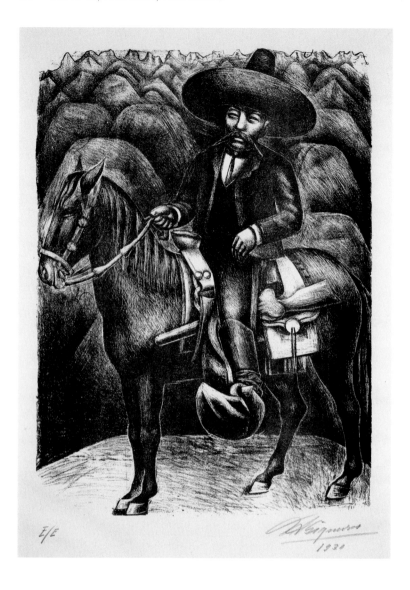

## DAVID ALFARO SIQUEIROS

b.1896 Chihuahua, Mexico
d.1974 Cuernavaca, Mexico
*Zapata*, 1930
Lithograph, 20 2/5 x 15 in. (51.8 x 38.7 cm)
Julius L. Rolshoven Memorial Fund
84.26

Best known as one of the "Big Three" Mexican mural-ists (along with Diego Rivera and José Clemente Orozco), Siqueiros led an extravagantly picturesque life during the heady days of the Mexican Revolution. Trained as an artist, he took up arms and served on the general staff of President Carranza's army from 1914 through 1918; it was as both military attaché and art student that he lived in Europe from 1919 to 1922; upon his return, he served in the government of President Obregón. In a widely discussed 1921 article in *El Machete* (the journal of the artists' union, which he had helped to form), Siqueiros championed the art of murals over that of easel paintings, which he derided as egotistical and elitist. From 1925 to 1930, he virtually gave up art production of any kind, as he devoted himself to working on behalf of the Communist Party. For his firebrand agitations, he was imprisoned in 1930-1931; Siqueiros went into exile in the United States in 1932, where his artistic ideology found fertile ground among American artists of the Great Depression years. It is sometimes alleged that Jackson Pollock's "action painting" stems in considerable measure from that artist's involvement in spray painting political floats in New York under the guidance of Siqueiros.

All this introduces this marvelously romantic litho-graphic image of Emiliano Zapata (1879-1919), one of the heroes of the Mexican Revolution. A mestizo military and political leader of farmer-revolutionaries, Zapata rallied support for agrarian reform with the cry, *"¡Tierra y libertad!"* ("Land and liberty!"). Instrumental in the overthrow of the corrupt Porfirio Díaz in 1911 (the signal event of the Mexican Revolution), Zapata repeat-edly led his army of followers against any and all subsequent presidents whenever their zeal for land distribution failed to measure up to his own. As a result, he was ambushed and assassinated by forces of the Carranza-Obregón government in 1919.

Siqueiros, of course, had served in exactly that same military (although in the fateful year of 1919 he was off in Paris). So there is some psychological tension in his turning to the martyred Zapata as the symbol of the true Revolution as he, Siqueiros, takes up the medium of lith-ography during his term in jail. Yet what a symbol it is, of fierceness and of independence; the man on the horse—an image of great resonance in Spanish art—is now a warrior-peasant, rather than a royal. And in his choice of lithography, which can make many hundreds of images for broad and inexpensive distribution, Siqueiros antici-pates the popularity the medium would have among the next generation of socially responsive Mexican artists.

—PW

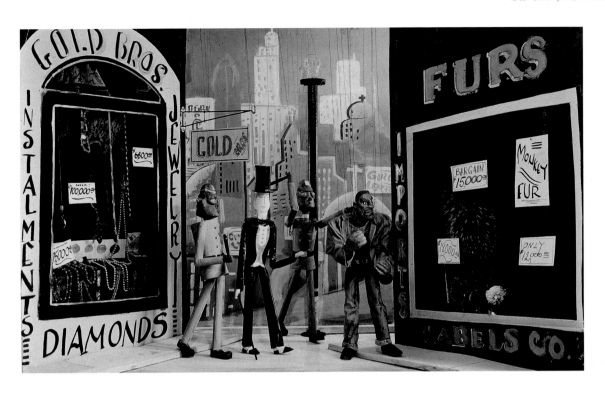

## ASSUNTA ADELAIDE LUIGIA (TINA) MODOTTI

b.1896 Udine, Italy
d.1942 Mexico City, Mexico
*Scene from* The Hairy Ape, *1929*
Gelatin silver print, 5 1/2 x 9 1/2 in. (14 x 24.4 cm)
The Beaumont Newhall Collection. Purchased with funds
from the John D. and Catherine T. MacArthur Foundation
90.2.2

*A corner of Fifth Avenue in the Fifties on a fine Sunday
morning. In the rear, the show windows of two shops,
a jewelry establishment on the corner, a furrier's next to it.
Here the adornments of extreme wealth are tantalizingly
displayed. From each piece hangs an enormous tag
from which the dollar sign and numerals wink out
the incredible prices.*

Eugene O'Neill, *The Hairy Ape,* 1922

One of the great icons of American theater (the critic Alexander Wolcott called it a "bitter, brutal, wildly fantastic play of nightmare hue and nightmare distortion"), Eugene O'Neill's *The Hairy Ape* features the steamship stoker Yank as its protagonist. Here, police come to the rescue of a top-hatted plutocrat whom Yank (on the right) has confronted amidst the fantastic wealth of New York's Fifth Avenue. The setting (the jewelry shop and the furrier, even the enormous price tags) is just as described in O'Neill's stage directions for scene five of his play. But of course, this photograph is not of the play as usually staged. Instead, it records a version produced by the renowned puppeteer Louis Bunin, in Mexico City in 1929.

Like the play, and like the puppeteer, the photographer—Tina Modotti—was an import from the United States to Mexico. Italian-born, Modotti emigrated to America in 1918; three years later, she met Edward Weston, with whom she moved to Mexico City in 1923, where he taught her photography. Increasingly in the late 1920s, her photographs reflected her active political life. So aggressively active were her politics (she joined the Mexican Communist Party in 1927) that in 1930, not long after she made this photograph, she was expelled from Mexico for the better part of a decade.

Here, Modotti employs the advanced Modernist idiom of sharp detail and dramatic contrasts of whites and blacks, quite different from the subtle gradations of shading in her earliest still lifes (often made as exquisite and expensive platinum prints). This style, of course, complements the harsh class distinctions in O'Neill's play. When she showed her photographs (at the Universidad Nacional Autonoma de Mexico) in 1929, the great muralist David Alfaro Siqueiros gave a lecture, "The First Revolutionary Photographic Exhibition in Mexico." Thus did the art and artists of the United States sometimes affect Mexican 20th-century culture, as well as the other way around.                                                      —PW

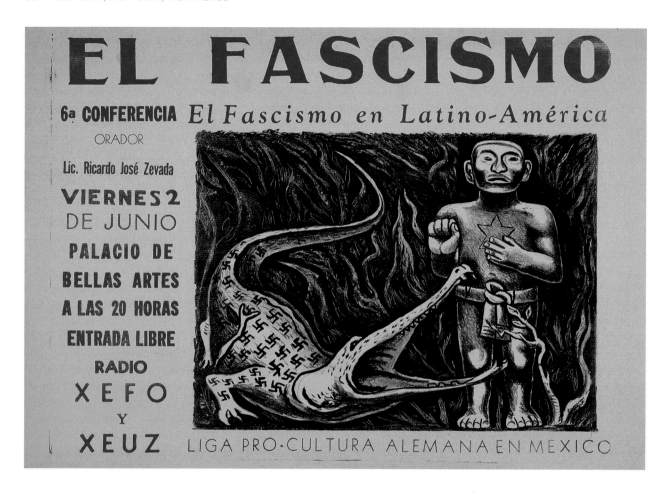

## JOSÉ CHÁVEZ MORADO

b.1909 Siloa, Mexico
*El Fascismo*, 1939
Lithograph, 18 1/2 x 26 3/8 in. (47.5 x 67.5 cm)
Taller de Gráfica Popular Collection
97.40.3

José Chávez Morado was an early member of the Taller de Gráfica Popular (Workshop for Popular Graphic Art). Founded in 1937 in Mexico City, the TGP applied the unique properties of the print—its rapid and inexpensive production and potent visual persuasion—to the consolidation and continuation of the aims of the Mexican Revolution. The founding artists of the TGP—Leopoldo Méndez, Pablo O'Higgins, Luis Arenal, joined shortly thereafter by Ignacio Aguirre, Raúl Anguiano, Angel Bracho, José Chávez Morado, Alfredo Zalce, Alberto Beltrán, and others—worked from the radicalized political tradition exemplified by the Mexican muralists, Rivera, Siqueiros, and Orozco, and the nineteenth-century popular graphic tradition of José Posada. The workshop's stated purpose was to further the aims of the Mexican Revolution by "defending and enriching the national culture," and to promote an art of the highest aesthetic standard which would reflect "the social reality of the period," and "truly serve the interests of the people."

In 1938 and 1939, the Taller produced eighteen posters for conferences sponsored by the League for German Culture to publicize the threat of fascism and nazism in Europe and in Latin America. As much as notices of events, the posters, such as this one, were visual denunciations of fascism, as well as works of graphic art exhibited in the Palacio de Belles-Artes during the conference. The artists of the Taller developed a visual language that integrated pre-Columbian motifs as potent symbols of national identity with traditional forms of European political protest graphics. Morado's composition pits the cayman, a creature associated with the underworld in Classic Maya iconography, against the flayed god as sacrificial victim, a motif from central Mexico, to express the destructive force of fascism in Latin America. The threat of fascism is shown as a problem that affects Mexico, rather than a peculiarly European or Asian problem.

The work of the Taller is a major collection and research focus for the University of New Mexico Art Museum and UNM's Center for Southwest Research. To date, we have jointly compiled a collection of over 600 objects which establishes UNM as one of the leading sites for research on this very important artists collective.                —KSH

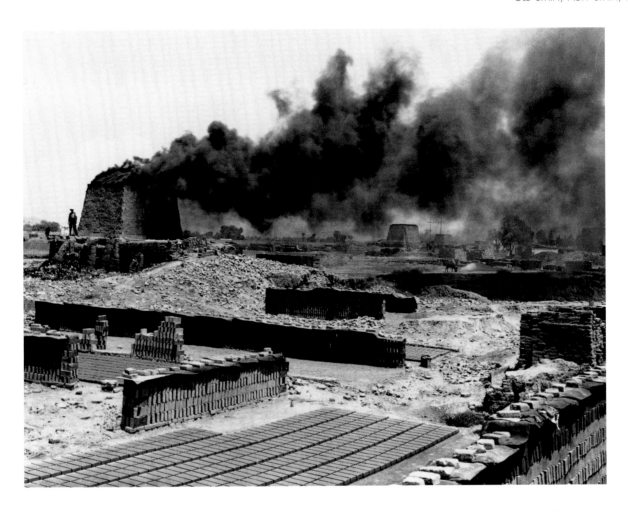

## MANUEL ALVAREZ BRAVO

b.1902 Mexico City, Mexico
*La Quema Tres* (*Kiln Number Three*), 1955
Gelatin silver print
7 1/4 x 9 1/2 in. (18.6 x 24.4 cm)
Julius L. Rolshoven Memorial Fund
72.603

*Alvarez Bravo has preferred photography to painting. It is possible that he may be right. In his work he arrives at conclusions which before him nobody in Mexico dared to imagine.*

Diego Rivera, 1930

Both his grandfather, Manuel Alvarez Rivas, and his father, Manuel Alvarez García, were painters and at least amateur photographers. But Alvarez Bravo started his adult life as an accountant in the Mexican Treasury Department, while studying literature and music at night. In 1923, he met the German-born pictorialist photographer Hugo Brehme and in 1927, to ultimately more effect, he met Tina Modotti. She encouraged him and effected introductions to Diego Rivera and (by mail) Edward Weston. Alvarez Bravo's photographic career was thus fully launched, and on a trajectory that made him Mexico's most influential photographic artist and teacher.

In 1938, the great "high priest" of Surrealism, André Breton, was living in Mexico, where he met Alvarez Bravo and claimed him (and Mexican culture, in general) for his movement. Certainly, in *La Quema Tres* as in so many other Alvarez Bravo photographs, there is a surreal dislocation of time— are these ancient monuments, perhaps Aztec or Mayan in origin?—and a sense of foreboding. Breton wrote of "the great message of the graves" which in Mexico "charges the air with electricity."

The facts, of course, are by comparison prosaic. These are brick kilns, not funeral pyres. They are devoted to the production of building material, not violent death. Yet even knowing these facts, one is moved—powerfully, emotionally—by the huge, dense swirls of smoke emanating from the kilns, and scrawling across the sky like some prehistoric harbinger of doom. —PW

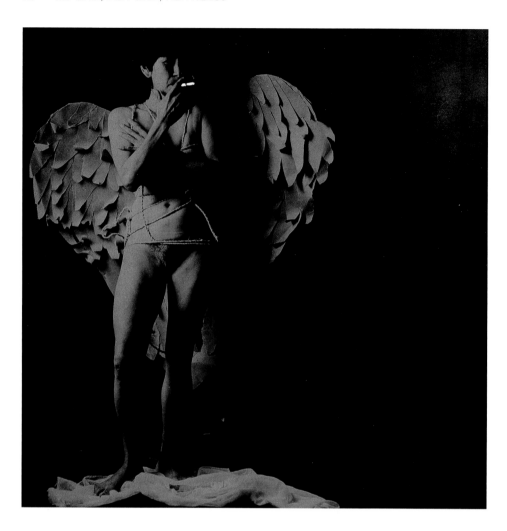

## LUIS GONZÁLEZ PALMA

b.1957 Guatemala City, Guatemala
*La Dama*, from the series *La Loteria I*,
1988-1991
Toned and bleached gelatin silver print
19 7/8 x 19 13/16 in. (50.5 x 50.3 cm)
Gift of Daniel and Noemi Mattis
95.28.1

Before photography, printmaking satisfied the need for multiple visual images, exactly the same in all respects. One of the first uses of printmaking (in the 15th century): the production of playing cards. And one particular set of cards, produced by the Spanish conquerors to teach their language to native New World peoples, served as inspiration for the contemporary Guatemalan photographer Luis González Palma in his creation of a set of nine photographs called, collectively, *La Loteria I.*

González Palma thus works (as do many contemporary artists) from a popular art source. One of the wonders of his art is how completely he transforms that humble source into images, such as *La Dama (The Lady)*, which tear at our heartstrings as they sear themselves into our visual memory.

"In almost all my work, I have tried to give woman in general a kind of divinity," the artist has written. Well, yes. The (obviously tacked on) wings denote the extraordinary, the celestial, the divine. At the same time, the stocky nonchalance of this cigarette-smoking woman (who, like most of González Palma's models, is emphatically of Indian heritage) has a totally earth-bound presence, even if beneath her feet the white cloth might be read as a stage-set cloud. (It is perhaps worth noting that González Palma began his photographic career shooting the costumed dancers of classical ballet.) And this is only the first of many dualities which this artist deftly packages into this single image.

Darkness (as smoky, rich, and mysterious as the interior of an ancient church) and light (the implausibly bleached and burnished whites). The old (this woman steps from a Baroque painting, or perhaps even a Mayan glyph) and the contemporary (yet, she is just as clearly of our time). The poetic and the prosaic. Grief and triumph. Compassion and irony. Such dichotomies fuse within as well as inform González Palma's art.

—PW

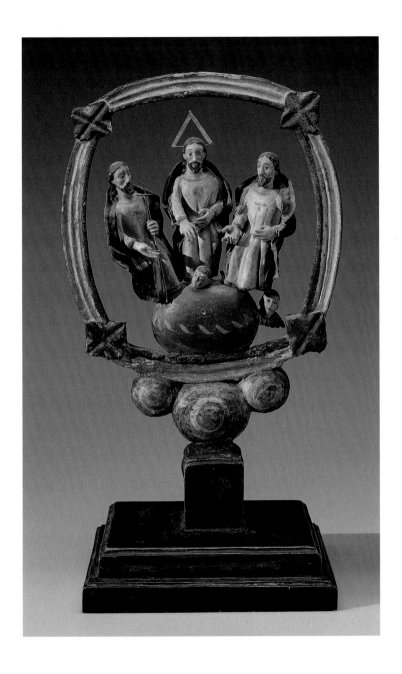

ATTRIBUTED TO **FRAY ANDRÉS GARCÍA**

Active 1747-1779, New Mexico
*Three-Person Trinity*, n.d.
Wood, gesso, paint
16 3/4 x 8 x 6 3/8 in. (42.6 x 20.3 x 15.6 cm)
The Mary Lester Field and Neill B. Field Collection
XO.205

During the first two centuries of New Mexico's colonization by the Spanish, most art works were imported from Mexico. Gradually, during the second half of the 18th century, both paintings and sculptures began to be locally produced. But about their makers, precious little is known. Hence, scholars have devised a group of descriptive names, ("Provincial Academic I," "The Laguna Master") about which to group, usually by common stylistic mannerisms, the early religious artifacts of the Upper Rio Grande Valley.

One of the few important exceptions to this rule of anonymity is Fray Andrés García, whom Church records list as having come from Puebla, Mexico, to serve parishes in New Mexico from 1747 to 1779. Further, the valuable chronicler of early Church life in the northern province, Fray Francisco Atanasio Domínguez, specifically recorded that García (who was his close contemporary) created sculptures (which Domínguez thought unattractive) for churches at Taos, Laguna, and Santa Clara. Starting with sculptures matching Domínguez's descriptions at both Taos and Santa Clara, modern scholars have built up a list of a couple of dozen works—including the University of New Mexico Art Museum's *Three-Person Trinity*—attributable with a reasonably high degree of certainty to Fray Andrés García.

While we don't know anything about García's artistic training, the relative sophistication of his work (both the sculptures, and paintings which have been associated with them) argues that he must have made art while he was in Mexico: this looks essentially like provincial Mexican work, made by someone who had first-hand familiarity with late-Baroque conventions of both figure and drapery modeling. Also noteworthy is the subject matter: a depiction of the Holy Trinity (the Father, the Son, and the Holy Ghost) as three, almost identical persons. This type of representation goes back to 11th-century European models, but it had virtually disappeared in most of Europe after an edict by Pope Urban VIII (1623-1644) mandating that the Holy Ghost be shown either as a dove or as tongues of fire. However, in the Spanish New World, the three-person Trinity kept its currency even into the 19th century, a demonstration of the tenacious survival of cultural conventions in provincial societies.
—PW

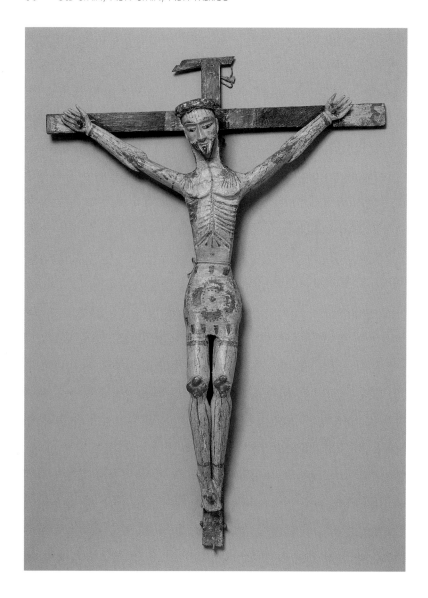

## JOSÉ BENITO ORTEGA

b.1858 La Cueva, New Mexico
d.1941 Ratón, New Mexico
*Crucifix*, c.1880-1907
Wood, gesso, cloth, water-based paint
30 3/8 x 20 5/8 x 4  3/8 in.
(77.2 x 52.4 x 11.1 cm)
68.85

If Fray Andrés García is one of the earliest identifiable *santeros* to work in New Mexico, José Benito Ortega represents the end of the unbroken tradition of carving saints in the Upper Rio Grande Valley. After he gave up the practice in 1907 (the year his wife died, and he moved from Mora County to Ratón), almost three decades passed before a younger generation of *santeros* emerged.

Ortega was both the last and, almost certainly, the most prolific of the late 19th-century *santeros*, with over 200 extant works known to have come from his hand. His carvings (and less frequent paintings) filled the churches, private chapels, and especially the Penitente *moradas* all along the eastern side of the Sangre de Cristo Mountains. While he depicted a wide range of religious subjects—including the Virgin Mary, individual saints, and death carts—the crucifix was his most requested and most characteristic work.

Scholars trace one feature of Ortega's crucifixes—the open eyes of the still-living Christ look down upon us—back to the early Spanish Baroque. In the contract for a 1603-1606 sculpture by the great master Juan Martínez Montañés for the cathedral of Seville, it was specified that the image should appear "alive before his death, looking at any person who might be praying at his feet, as if Christ himself were speaking to him." Approximately 300 years later, Ortega continues this Spanish convention.

If there is this remarkable linkage to the naturalistic conventions of the Spanish Baroque, there is also an equally remarkable transformation of that style into one of both great abstraction and great spirituality. The copious flows of blood obey no laws of gravity, but instead trace intricate patterns; the scrapes on Christ's knees now mushroom in symmetrical four-part bulges; even the loincloth receives a foliate decoration. However, instead of "prettifying" the crucifixion, these devices work along with the exaggerated emaciation of Christ's limbs and ribcage to intensify our awareness that we are witness to something quite literally extra-ordinary.

There's a gruff, direct honesty to Ortega's style. If there's a telling comparison to be made, it may be to the very earliest Christian art—art created by a sometimes brutally suppressed sect, living out its beliefs, sustained by its faith. Ortega lived and created his art at a time when New Mexico had been handed over to the United States and incorporated as a territory. He and his Hispanic contemporaries may well have made art like this crucifix as expressions of heartfelt faith maintained in the face of an often threatening new environment.

—PW

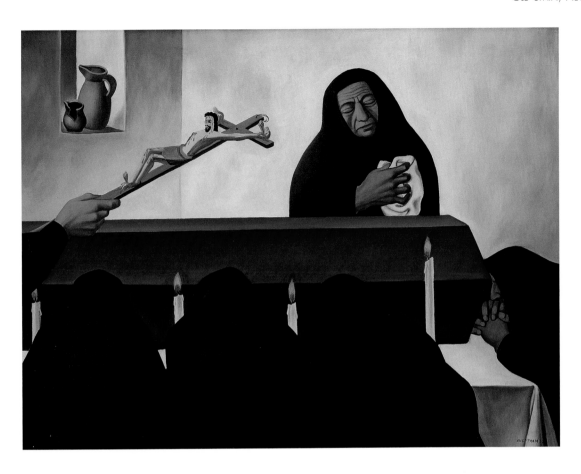

## EMIL BISTTRAM

b.1895 Nadlac, Hungary
d.1976 Taos, New Mexico
*Mexican Wake*, 1932
Oil on canvas
36 x 48 in. (92.3 x 123 cm)
Gift of the artist
70.139

Art and politics intersect in many surprising ways. In 1931, the John Simon Guggenheim Memorial Foundation awarded the Hungarian-born, New York-trained artist Emil Bisttram a fellowship to study abroad. In his application, the artist had specified Italy as his destination, with his intent to study the great Renaissance artists as part of his personal pursuit of Dynamic Symmetry: a theory of proportions the origins of which supposedly could be traced back to ancient Greek and Roman art and architecture. However, the rumblings of war in fascist Italy led Bisttram to ask that he be given permission to go instead to Mexico, with the aim of studying with Diego Rivera.

*Mexican Wake* directly evidences Bisttram's profound and original appreciation of the great Mexican muralist's art. The monumental simplification of forms, the restricted palette, the air of stillness and gravity, the emotional and physical concentration on a ritual service—in both form and content, Bisttram's painting is almost unthinkable without reference to Diego Rivera's work.

But, despite the title, this is a New Mexican (and not a Mexican) painting, done after Bisttram rejoined his wife and mother in Taos, where he had installed them during his Guggenheim months in Mexico City. Beyond the fact that it was painted in Taos, it also depicts a New Mexican (and, again despite the title, not a Mexican) event. In correspondence around the time of the artist's donation of his painting to the University of New Mexico Art Museum, he refers to it as his "Penitente painting," and gave permission for the Museum to re-name it *New Mexican Wake*. Nonetheless, the artist's original title (inscribed by his hand on the reverse) has stuck.

Frustrated by bureaucratic non-acceptance, Bisttram soon abandoned his attempt to import wholecloth to New Mexico a mural movement based upon Mexican models. By the late 1930s, he developed a fully non-objective style, and is today best known as an important member of the Transcendental Painting Group. *Mexican Wake* remains a fascinating anomaly in his long and distinguished career, a reminder of a time when Mexican models were all-important to a generation of artists in the United States.

—PW

## JOSÉ ARAGÓN

Active c.1820-1835, New Mexico
*San Antonio de Padua*, c.1820
Wood, gesso, and water-based paint
14 1/2 x 8 1/4 in. (36.8 x 21 cm)
Purchased with funds from the Friends of Art
94.20.2

## ATTRIBUTED TO JUAN AMADEO SANCHEZ

b.1901 Colmor, New Mexico
d.1969 Ratón, New Mexico
*San Francisco*, c.1940
Egg tempera on board
12 1/2 x 12 in. (31.8 x 30.5 cm)
Julius L. Rolshoven Memorial Fund
96.1.1

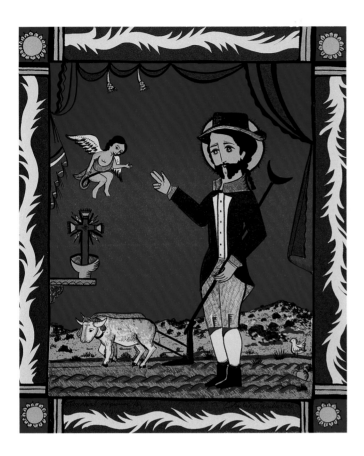

**CHARLES CARRILLO**

b.1956 Albuquerque, New Mexico
*San Isidro Labrador*, 1990
Lithograph, 18 x 15 in. (45.7 x 38.1 cm)
The Tamarind Archive Collection
90.15.7

When it comes to the Hispanic tradition of religious painting in New Mexico, these three images pretty much tell the story. Up until the late 18th century, most of the paintings in New Mexico churches were imported. Gradually, however, local artists (mainly self-taught) began to supply the demand for religious paintings, and also about this time the preferred support changed from either canvas or hide to wooden board. These *retablos* (literally: "before the altar") proliferated throughout most of the 19th century. But the tradition expired for a time when, in the 1890s, chromolithographs—which provided attractive, low-priced reproductions of famous paintings—saturated the market for religious images. During the Great Depression of the 1930s, the *retablo* tradition briefly came back, under Federal programs dedicated to a nation-wide revival of craft traditions. But it was really in the 1960s and 1970s that a sustained rebirth of Hispanic art forms took place, and today many score *santeros* paint and sculpt within the old traditions.

Oral tradition has it that José Aragón emigrated from Spain. Stylistically, however, Aragón's only important distinction from his contemporary New Mexican *santeros* is his greater reliance upon late 18th- and early 19th-century Mexican and European print sources. This makes his paintings (and his sculptures; he ran an active workshop) somewhat more sophisticated in their modelling of form than is true of most works by his peers. He was also probably the most prolific artist of his time in northern New Mexico. Juan Sanchez, to whom we attribute on stylistic grounds our *San Francisco*, never claimed to be a "real" *santero*. Working originally under the Federal Art Project, he copied with great and loving accuracy the old works found in northern churches, chapels, and *moradas*, that they might be preserved and exhibited in museum settings; later, he worked also for the collector and tourist markets, spreading awareness of the old traditions. Charles Carrillo is one of the most talented *santeros* of his generation. Though he works mainly with traditional materials and methods, in 1990 Carrillo joined five other artists to create lithographs at the University of New Mexico's Tamarind Institute. His *San Isidro* (the patron saint of farmers, here dressed in Spanish Colonial garb) comes from that *Seis Santeros* suite. Together, Aragón, Sanchez, and Carrillo demonstrate the resiliency and the magic of the *santero* tradition in New Mexico.                —PW

**LUIS ELIGIO TAPIA**

b.1950 Santa Fe, New Mexico
*Our Lady of Sorrows*, 1992
Wood, paint, and nails
17 x 13 3/4 x 10 in. (43.6 x 35.3 x 25.4 cm)
Purchased with funds from the Friends of Art
93.9

Of all the fine contemporary *santeros* in New Mexico, Luis Tapia best fuses the ancient traditions with those of contemporary sculpture, and does so with both reverence and—at many times—great good humor. Back in the 1970s, Tapia was a founder of the Cofradía de Artes y Artesanos Hispanicos, an organization, as its name suggests, dedicated to the preservation of traditional Hispanic arts. However for him, that tradition is not static, but instead a living, evolving thing. "I believe in the tradition," he has written, "but tradition is not copying. What I do to continue my heritage is to renew it, like a growing plant."

At times, Tapia carves entirely secular forms: a low-rider dashboard, for example. *Our Lady of Sorrows* hews more closely to tradition. Or, maybe better, traditions. Because Tapia has, in this image, brought together several different strands of Catholic iconography. Usually, Our Lady of Sorrows (the Mater Dolorosa) is shown weeping for her son. Separately, the Seven Sorrows of the Virgin (the prophecy of Simon, the Flight into Egypt, the disappearance of the twelve-year-old Jesus when he disputed in the Temple,...) are symbolized by seven swords piercing the Virgin's breast. Here we have instead seven nails; in most Catholic images, three (or, sometimes, four) nails allude to the Crucifixion. Separate yet in Church art is the representation of the Holy Heart of Mary (promulgated by Father Jean Eudes in the 17th century), which Tapia here combines with a heart burning with flames: an emblem of ardent love of God, usually associated with Saint Augustine or Saint Catherine of Siena. Finally, the rays of light surrounding the heart typically (as in images of the Virgin of Guadalupe) signify a vision of the Virgin.

Tapia has rummaged broadly through Church iconography, chosen various devices each with a long tradition, and combined them into a startling, fresh, and evocative image all of his own invention. The "here-and-nowness" of his sculpture is further proclaimed by the almost Day-Glo intensity of his paint, far removed from the somber, earthen-pigment hues employed by more traditional *santeros*. The result: an unforgettable image, which both references traditional Hispanic religious art and exists as an object unique and wonderful.

—PW

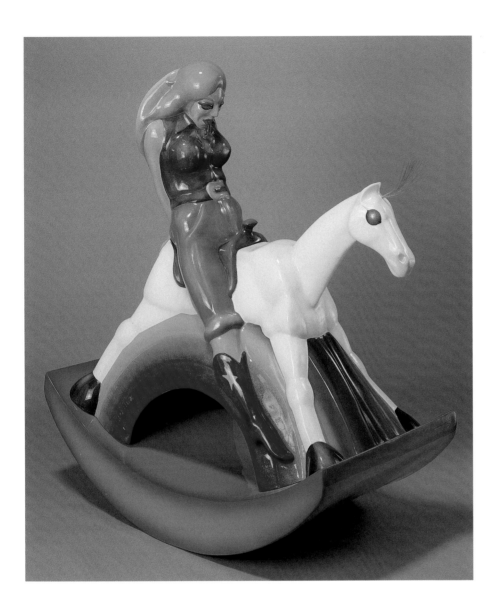

**LUIS JIMÉNEZ**

b.1940 El Paso, Texas
*Rodeo Queen*, 1972
Fiber glass, epoxy, and metallic
powdered paint
50 x 47 x 23 in. (128 x 120.5 x 59 cm)
Purchased with funds from the
National Endowment for the Arts, with
matching funds from the Friends of Art
75.35

Luis Jiménez, Sr. entered the United States (illegally) in 1924 at the age of nine. Through pure work ethic, he rose to become the owner of a sign shop in El Paso, where he created spectacular neon monuments to American pop culture. It was into this environment that Luis Jiménez was born, and in his father's shop that he first worked. Now, decades later and one of America's most renowned public sculptors, Jiménez still celebrates the vibrant forms and colors and cultures of his birthright.

Jiménez loves to take on the big themes, the great legends of the West and the Southwest: prairie schooners, Aztec chieftains, cowboys and Indians, fiesta dancers, honky-tonk bars, and, here, cowgirls. He does so with a mixture of wide-eyed enthusiasm and tongue-in-cheek satire. His rodeo queen rides, not a prancing palomino, but a patently unreal hobbyhorse.

Does a fiber glass rodeo queen on a hobbyhorse have anything to do with the great tradition of Spanish art and its New World offspring?

But of course. Think of the basic subject matter: the Spanish brought the horse to the New World, and "rodeo" is a Spanish word. Think of the magic, the power, of the man on the horse; think of Santiago. Jiménez uses the horse the way Picasso used the bull: as a basic cultural symbol, with particular resonance to people of his native land. There is also a lot of the feel of Goya's *Folly of the Carnival*; Jiménez, like Goya, explores the excesses of human vanity and human folly. Finally, Jiménez achieves a sense of super-realism, of heightened physicality, which recalls the 17th-century Bolivian *Christ with the Crown of Thorns*.

Part of the fascination of this work lies in its being both very modern and very traditional. Fiber glass, epoxy, metallic powdered paint—these materials come right out of our time, out of the world of custom cars and strip malls. But the subject matter, and the artistic approach, have deep and nourishing roots in the Hispanic tradition, spanning three continents and five or more centuries.        —PW

# Old Master Painting, Sculpture, Prints, and Drawings

## OLD MASTER PAINTING, SCULPTURE, PRINTS, AND DRAWINGS

When the University of New Mexico Art Museum was founded in 1963, the decision was made to concentrate on 19th- and 20th-century art. Photography and lithography were to be focal points, and they were invented in 1839 and 1798, respectively. Old Master art—the art of the Renaissance through the 18th century—was thought to be largely unattainable: much of it was already in public collections, and what was on the art market was much more expensive than 19th- and 20th-century works.

Even in the early years of the Museum, however, an effort was made to acquire a modest study collection of Old Master prints. These were seen as both important in their own right, and as a useful prelude to the advent of lithography. And even in those early years, a few important gifts of Old Master art entered the collections: most importantly, a choice group of Dutch and Flemish paintings given us by Jacob Polak.

By the mid-1980s, we became both more ambitious and more aware of the absolute necessity to include the art of the old masters within our collecting mandate. No other museum in this state has such a collection; our students—particularly our undergraduate students, most of whom come from New Mexico—lack other opportunities to experience firsthand Renaissance and Baroque painting or sculpture.

Thanks to the generosity of several patrons (most notably, Albert A. Anella and Andrew Ciechanowiecki), thanks to important assistance from our Friends of Art supporters, and thanks to the vagaries of the art market which found in the 1980s and 1990s Old Master prices lagging behind most other fields, we've been able to put together a very interesting collection of 16th-, 17th-, and 18th-century European art, some individual highlights of which appear in the following pages.

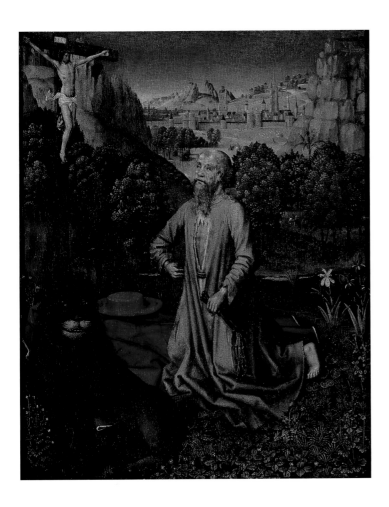

## MASTER OF THE LEGEND OF SAINT LUCY

Active late 15th century, Bruges, Belgium
*Saint Jerome in a Landscape*, c.1480-1483
Oil on wood panel
17 3/8 x 14 1/8 in. (44.1 x 35.9 cm)
Gift of Mr. Jacob Polak
68.8

Since the 17th century, artists have been under considerable pressure to set historical and religious paintings accurately to the time and place in which the events occurred (one famous debate among French academic artists concerned whether or not ripe figs would have been available to the Holy Family on the flight into Egypt!). Fortunately for us, such quibbles didn't apply to the artist of our *Saint Jerome*, who put the saint in a landscape which contains (among many other beautiful details) a closely rendered cityscape of Bruges, as it existed in the late 15th century.

Saint Jerome never came within 500 miles (or 1,000 years) of this city. Born in present day Slovenia around 347 A.D., Jerome by the 15th century was commonly represented in art in two different situations: either living in solitude doing penance (he retired for two years to a Greek desert island), or pouring over books in the study which he established late in life in Bethlehem (where he died, in 419/20 A.D.). As in this painting, he is often accompanied by a lion (by legend, he removed a thorn from a lion's paw, whereupon the beast became his closest companion) and usually is further identified by his flat, red, cardinal's hat.

We don't know very much about the so-called Master of the Legend of Saint Lucy. As is the case with many other Early Renaissance artists (particularly in Northern Europe), we can't put a proper name to him.

But the eminent art historian Max J. Friedlander proposed that some forty-five to fifty paintings, all closely related to a dated (1480) panel in the Church of Saint James at Bruges which depicts three episodes from the life of Saint Lucy, are all by the same master. He was clearly a very successful artist, because some of his works went immediately to clients in Estonia, Italy, and Spain—all centers with commercial ties to Bruges.

Two things help particularly to distinguish works by the Master of the Legend of Saint Lucy: his loving depiction of the plant world (here, note not just the splashy irises and columbines, but the intricate little field strawberries and daisies), and his usual inclusion of a highly detailed Bruges in the background of his panel paintings. Indeed, so faithful are this artist's cityscapes that we can date his paintings by alterations to the large square belfry atop the old market hall. Here, the roofline of the belfry (a truncated pyramid) is the same as in his 1480 *Legend of Saint Lucy* panel; in 1483, the city tore down that slate roof and began erecting an octagonal tower, and very immediately the Master of the Legend of Saint Lucy recorded those alterations in his paintings. By style, our painting is probably later than the *Saint Lucy* panel. By roofline, it's pre-1483. Hence the precision of our suggested date: c.1480-1483.

—PW

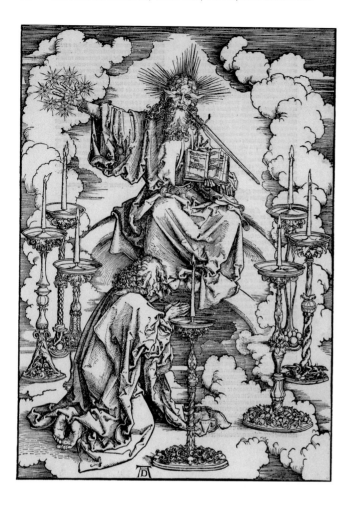

## ALBRECHT DÜRER

b.1471 Nuremberg, Germany
d.1528 Nuremberg, Germany
*The Vision of the Seven Candlesticks,* 1498
Woodcut, printed in 1511
16 5/8 x 11 1/4 in. (39.8 x 28.6 cm)
92.10

*And I turned to see the voice that was speaking to me. And having turned, I saw seven golden candlesticks.*

*And in the midst of the seven candlesticks, one like to a son of man, clothed with a garment reaching to the ankles, and girt about the breasts with a golden girdle.*

*But his head and his hair were white as white wool, and as snow, and his eyes were as a flame of fire;*

*His feet were as fine brass, as in a glowing furnace, and his voice like the voice of many waters.*

*And he had in his right hand seven stars. And out of his mouth came forth a sharp two-edged sword; and his countenance was like the sun shining in its power.*

The Apocalypse I: 12-16

Painter, draughtsman, printmaker, and writer on art theory, Albrecht Dürer is judged by many art historians to be the greatest German artist of all time. He first trained with his father, a goldsmith, then apprenticed with Michael Wolgemut (1434/7-1519), in whose workshop he learned woodcut book illustration. In 1495, Dürer travelled to Venice, where he experienced firsthand the marvels of Italian Renaissance art. Not long after he returned to Nuremberg, he conceived an ambitious project: a series of fifteen woodcuts on the Book of Revelations.

Small wonder that these prints, of which our *Vision of the Seven Candlesticks* is one, were the making of Dürer's international reputation. For one thing, the sheer scale of the images was well beyond anything tried in woodcut before. Also, this was the earliest book designed and published by an artist as exclusively his own undertaking: an enormous investment of time, energy, capital, and ego for an artist still in his twenties.

The greatest factor in the success of the Apocalypse prints must, however, have been their still-overwhelming power of visual fascination and persuasion. This is, of course, the most literally visionary book of the Bible, describing fantastic events attendant upon the Second Coming of Christ. Dürer makes it all both very real and very surreal at the same time. Note, for example, the clouds, which at the bottom of the print form a sort of carpet upon which Saint John (he who narrates the vision) kneels; then they bend and curl upwards, both supporting and then providing a background for the huge candlesticks. None of this makes much sense in terms of logical perspective systems, yet Dürer makes it work, visually.

—PW

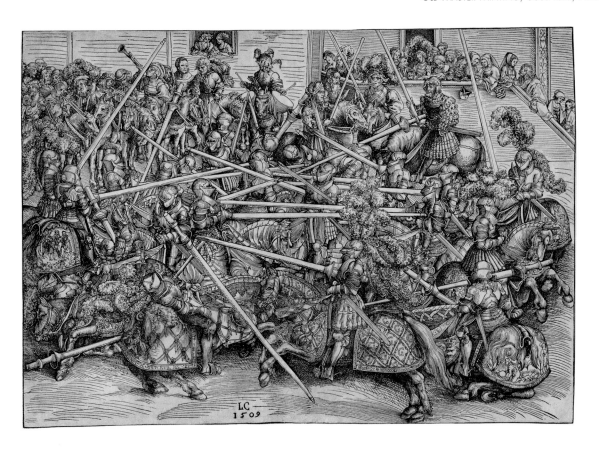

## LUCAS CRANACH, THE ELDER

b.1472 Kronach, Germany
d.1553 Weimar, Germany
*The Third Tournament,* 1509
Woodcut
11 1/2 x 16 3/8 in. (29.2 x 41.6 cm)
85.34

He was born in Kronach (from which he derived his last name) and died in Weimar, but it was in Wittenberg—the capital and court city of Saxony—that Lucas Cranach emerged as one of Europe's major artists. Duke Frederick the Wise lured Cranach from Vienna in 1505, making him official court artist (and, eventually, one of Wittenberg's wealthiest citizens).

By 1509, the date of this magnificent woodcut, tournaments such as the one here depicted were more pageantry than serious preparation for combat. In most of Europe, the earliest form of the tournament—the mock battle, or *mêlée*—had long since given way to one-on-one jousts. But partly due to the medievalist enthusiasms of Frederick the Wise and his successors in Saxony, such open field tournaments remained popular in Germany even into the early 17th century.

Cranach's woodcut reports, then, largely fact. The knights (only noblemen participated) wear the proper armor of the day; the horses are mostly decked out in fancy cloth panoplies (although two, in the center, second rank, have wartime armor plate on their necks); musicians and marshals oversee the contest from the rear; in German fashion, the lances still have sharp points (not the blunt coronals affixed in Western European tournaments); even the improbable plumes (usually combining five ostrich feathers!) atop most helmets accord with what we know of early 16th-century practice.

But the extraordinary crowding of this tourney field (there are twenty-two knights and their horses in a space roughly thirty-six by twenty-four feet), is surely Cranach's invention. Was he, perhaps, trying to recall the restless crowding and roiling energy of medieval manuscript illuminations? Whatever, he created a monster of a problem for the (anonymous) craftsmen who actually carved the woodblock from which this sheet was printed. But they, just as clearly, were up to the task, faithfully transcribing his design into turbulent patterns of swirling, expressive light and shade.                 —PW

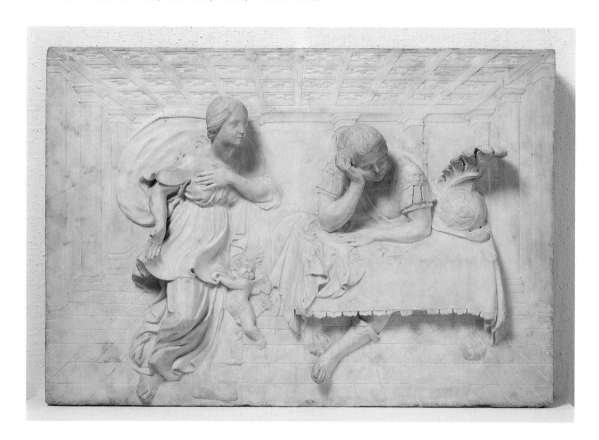

## UNKNOWN ARTIST

Active second half of
16th century, Venice
*Scipio's Dream (?),* c.1575
Marble
26 x 30 x 7 1/8 in. (66 x 76 x 18 cm)
Purchased with funds from the Friends of Art
86.184

This fine marble relief is Italian, and it's Renaissance. On that (and on little else) everyone agrees. It came to us from Heim Gallery in London, acknowledged specialists in European sculpture. Their expert, Alastair Laing, catalogued it as probably by an artist working in Florence, and done in the last quarter of the 15th century; Laing also suggested that the subject is Scipio's Dream. According to ancient authors, the Roman general Scipio Africanus the Younger dreamt of the ghosts of his father and grandfather. During the Italian Renaissance, scholars conflated this story with one told about Scipio Africanus the Elder (the grandfather), which focussed on the choice between sensual pleasure and duty. Our relief, if this interpretation is correct, depicts Venus and a lewdly gesturing Cupid, appearing as in a dream before the sleeping Scipio, and tempting him (we are to presume, unsuccessfully) to enjoy carnal pleasures.

So who did it? When the relief arrived here, we first concluded on purely a stylistic basis that the artist might be Venetian, rather than Florentine, and maybe from the early 16th century. Antonio Lombardo (1458?-1516) or someone working in his circle seemed a good bet. The newest information, supplied by the noted authority Prof. Anne Markham Schulz of Brown University, makes it clear that our piece is, indeed, Venetian, but from sometime after 1556.

We know this, because our relief was once part of the decorative scheme of the Palazzo Grimani. It was originally created and installed as an over-door in the Tribuna of that grand Venetian palace (upon which construction started in 1556). Presumably removed and sold by private owners in the 1960s, it was replaced by a plaster cast.

Suddenly, the curiously archaic style (short, stocky bodies with large heads; the abrupt perspective of the architecture) makes sense. The Grimani were great antiquarians, owning (and eventually donating to the Venetian state) arguably the finest private collection of Greek and Roman statuary available anywhere in Renaissance Europe. Indeed, a 2nd century B.C. Roman marble *Venus and Cupid* from the collection of Cardinal Domenico Grimani (today, at the Museo Archeologico, Venice) may have served as a specific source for our artist's rendition of the Goddess of Love and her son.

We still don't have a specific name to attach to our relief. And further scholarship may contest our identification of its subject. The fascination of a piece such as this, particularly for the audiences at a university art museum, lies in goodly measure in these uncertainties which invite continuing research.                                    —PW

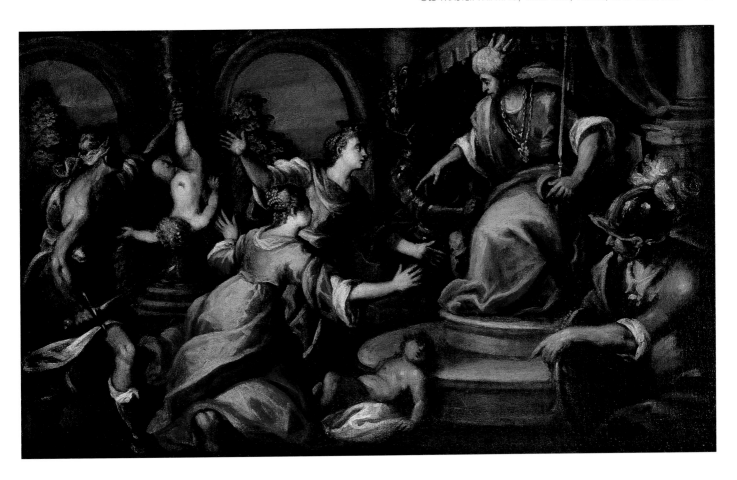

## ANDREA MICHIELI, CALLED ANDREA VICENTINO

b.1542 Vicenza, Italy
d.1617 Venice, Italy
*The Judgment of Solomon,* c.1580
Oil on canvas
22 1/4 x 37 1/2 in. (56.5 x 95.3 cm)
The Albert A. Anella Collection in memory
of Mia Anella
87.1

In one of the most famous episodes from the Bible, King Solomon figures out who is the real mother of the living child by proposing that the baby be split in two; the false mother agrees, while the true mother asks that the baby be spared even if it means giving up her claim (III Kings 3: 23-27).

Our artist, Andrea Michieli (called Andrea Vicentino, after his native town of Vicenza), is not today a name known to many save those who specialize in Venetian art of the 16th century. But spend any time poking around in the churches and civic buildings of Venice, and you can't help but be impressed by the quantity of large-scale commissions executed by Vicentino, who must have been on everybody's short list of artists to be contacted whenever a big painting was needed in a hurry. His style—quick, bold, luminous, with cold, silvery-white highlights and emphatic gestures—also becomes easily recognizable. It represents an idiosyncratic merger of Paolo Veronese, Jacopo Tintoretto, and Jacopo Bassano (all more famous, and presumably higher-priced, artists of that time).

In 1577, fire heavily damaged the Doge's Palace (or City Hall) of Venice. Vicentino, already one of the leading artists of the city, received several commissions during the redecoration, including a *Judgment of Solomon* (now lost) for one of the courtrooms. He perhaps painted our oil sketch as part of his process of working up ideas for this prestigious project. —PW

## MARCO ANGOLO DEL MORO

b. c.1537 Verona (?), Italy
d. after 1586 Murano (?), Italy
*Augustus and the Tiburtine Sibyl,* c.1570-1579
Etching and engraving
10 1/2 x 16 in. (26.7 x 40.6 cm)
Julius L. Rolshoven Memorial Fund
95.29

Although only ten etchings (including this, his recognized master-piece) are confidently ascribed to Marco Angolo del Moro, he is still hailed as one of the great Italian printmakers of the 16th century. Why? Because he exemplifies the importance of the landscape subject for North Italian etchers, who in turn fed the imaginations of artists all over Europe as they pioneered this new genre.

Marco studied with his father, Battista Angolo del Moro; the son's style is in all ways an advance, toward freedom and spontaneity, and toward an open, atmospheric quality which features delicate tonalities (at, admittedly, the expense of solid forms and secure linear boundaries).

Marco's subject matter also marks a distinct evolution in aesthetic freedom. The legend of the meeting between the Roman emperor Augustus and the Tiburtine Sibyl originated in 12th-century literature. When the Roman Senate proposed to deify Augustus, he sought the counsel of the Sibyl of Tibur (modern day Tivoli). She granted him a vision of a greater god to come: the image of Jesus in the arms of Mary up in the sky. Whereupon, Augustus refused the Senate's offer. This tale, then, is of ancient Rome beginning to turn from paganism to Christianity.

But Marco's print is really about the triumph of the emerging secular landscape tradition over the older religious art of the Middle Ages. Note on the far shore of the river a flock of sheep, in front of which ghostly lovers (the shepherd and his beloved?) embrace. For now, the artist has lightly burnished out the pair, so that the lines on the etching plate barely hold ink enough to print. But he does leave them legible, talismans of the new, romantic tradition of earthly pleasures which will come to full flower in European art over the next centuries.
—LPT & PW

MILITES    REQVIESCENTES

## JAN AND/OR LUCAS VAN DOETECHUM,
### AFTER A DESIGN BY PIETER BRUEGEL

b. c.1525 Breda (?), The Netherlands
d.1569 Brussels, Belgium
*Milites Requiescentes* (*The Sleeping Militia*), c.1555-1560
Etching and engraving
12 3/8 x 16 7/8 in. (31.4 x 42.9 cm)
Purchased with funds from the Friends of Art
95.6

Best known as a depictor of fat, jolly peasants, Pieter Bruegel is just about everybody's favorite 16th-century artist. Yet, remarkably little is known about his life (even the place and date of his birth are open to speculation). What little we do know—that he was a well-travelled city person, who moved easily in a circle of sophisticated humanists—is significantly at odds with what we might expect from his characteristic rural imagery.

*The Sleeping Militia* is one of twelve large landscape prints made after his designs (the van Doetechum brothers did the etching and engraving of the plates), and published around 1555 by Hieronymous Cock in Antwerp, where Bruegel was then living. He had just returned from three years of travels, which had taken him through the Alps and then down the entire length of Italy. The mountainous landscape in this print reflects his exposure both to Alpine scenery and to Italian artists' renditions of it. Compare, for example, the spacial organization here with that in Marco Angolo del Moro's *Augustus and the Tiburtine Sibyl* (p. 44). In both, we look over a dark foreground hillock, and the spaces revolve around central trees which are limbless up to ten feet or more, the better to allow us to look past them into the receding mountain ranges. Distant farmhouses, animals, and human travelers give scale to these vistas, while the lightly etched and inked lines of the faraway landmarks provide a realistic sense of the atmospheric blurring which attends deep vision.

Bruegel, of course, goes even further than Angolo del Moro in giving us a purely secular landscape, one without any ostensible subject matter beyond the three arms-bearing militiamen who stretch into wakefulness (and give this print its title). But they—the militia—are perhaps not as benign as we might at first think. The third quarter of the 16th century was a particularly awful time in the Low Countries. Their Hapsburg, Madrid-based monarchs (Charles V, and then his son Philip II) bloodily suppressed both rising Protestantism and attempts (ultimately successful) to separate Belgium and the Netherlands from Spanish rule. Bruegel, part of the internationalist, free-thinking intelligentsia in Antwerp, would even more than many others of his countrymen have harbored distinctly antagonistic feelings toward the king's repressive militia. Did he, perhaps, expect his audience to understand that the two central travelers (seen from the back in this print) have happily escaped possible harm due to the slumber of the soldiers?

—PW

## GIORGIO GHISI

b.1520 Mantua, Italy
d.1582 Mantua, Italy
*Apollo and the Muses,* after Luca Penni, c.1557
Engraving
12 1/2 x 15 7/8 in. (31.9 x 40.2 cm)
86.145

Mannerism is the name given to the style period in European art between the Renaissance and the Baroque, a period lasting roughly from 1520 to 1600. A time of intellectual and social upheaval, it produced art in sometimes violent reaction against the classical principles of lucidity, clarity, and rationalism that had been the hallmarks of Renaissance style. One critic has called Mannerism "the most wilful and perverse of stylistic periods."

Just about everything you need ever know about Mannerism is contained within this single, mid-16th century engraving by Giorgio Ghisi, after a design (probably a painting, now lost) by Luca Penni.

Ghisi and Penni were part of an army of Italian artists (Primaticcio, Giulio Romano, Nicolo dell'Abate, and many others) working in Paris and at the royal palace at Fountainebleau. Collectively, they created a style of almost extravagant elegance. Their fantastic visions of a classical antiquity are peopled with gods, goddesses, and mortals all of a languid beauty coupled with a nearly aggressive hauteur.

The subject matter of this engraving exemplifies the Mannerist love of complex, allusive, intellectually challenging iconography. Some of it is (fairly) straightforward: Apollo sits atop a rocky hillock, playing a *lira di braccio* (one of a virtual catalog of Renaissance instruments herein displayed). He presides over the land of the nine Muses: Mount Helicon. The winged horse Pegasus stamps his hoof, and causes the Hippocrene spring to issue forth from the rock. The Muses—four at left, and five at right—all play instruments, but not necessarily the ones assigned to them in antiquity, so scholars still argue about exactly who's who (which is typical of the willfully obscurantist tendency of Mannerist artists and authors). Cherubs overhead bring laurel wreaths; Apollo has judged the Muses the victors in their poetry contest with the upstart nine daughters of Pierus. But who are the two male poets (?) to the left rear? Homer and Virgil? Ovid and Hesiod? Nobody knows.

What we do know is that this was one of Ghisi's all-time most popular prints, widely distributed and widely copied in a variety of mediums, showing up on everything from engraved armor to musical instruments. This very popularity perhaps explains why there are today extant so few fine impressions (as this one is) in good condition of this masterwork of art.

—PW

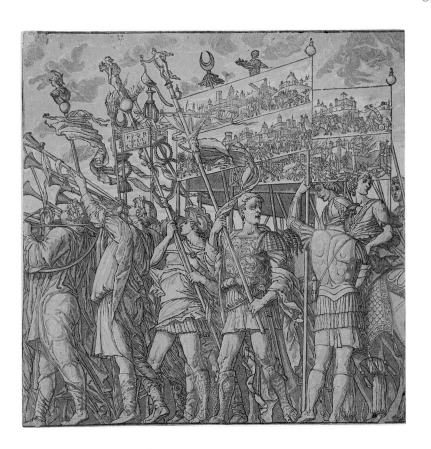

### ANDREAS ANDREANI

b.1558-1559 Mantua, Italy
d.1629 Mantua, Italy
*Trumpeters, Bearers of Standards and Banners,*
after Andrea Mantegna, plate 1 from the series
*The Triumph of Julius Caesar,* 1598-1599
Chiaroscuro woodcut
14 1/2 x 16 5/8 in. (36.8 x 37.1 cm)
Gift of Nancy R. Briggs and William C. Briggs
67.100

In the period right around 1490, the eminent Renaissance artist Andrea Mantegna (1431/2-1506) created nine large canvasses (each roughly nine feet square) for the Gonzaga family's ducal palace at Mantua. Together, these told the story of Julius Caesar's triumphant celebration in Rome of his conquest of Gaul. Giorgio Vasari, writing in the mid-16th century, called this series "the best thing that Mantegna ever painted." Still, these paintings (today in the British Royal Collection at Hampton Court) lapsed from view, until in the waning days of the 1590s they were re-installed by the Gonzagas. On that occasion, the artist Bernardo Malpizzi made detailed drawings of the panels, which drawings served as the basis for a set of prints by Andreas Andreani.

Though somewhat ravaged by time, the Mantegna paintings even today are impressively brilliant of color: vivid reds, oranges, yellows, and greens jump against the mid-range warm brown tones of the background. What a travesty it would have been to reproduce those paintings in the austere black lines of an engraving. But Andreani, of course, didn't go that route. Instead, he employed his favorite medium: the chiaroscuro woodcut. Invented probably somewhere in Germany or the Low Countries in the early 16th century, this medium came into its own especially in Italy from the 1570s onward, and Andreas Andreani was renowned as one of its greatest masters. Using several blocks (here, four: two tonal blocks in light and medium olive-tan, plus one block for the white highlights, and the black contour line block) the chiaroscuro woodblock artist vividly emulates the rich tonal contrasts typically available in painting. "Chiaroscuro"—literally, *chiaro*=light, *scuro*=shade— refers to the use of dramatic shading to create the illusion of volume.

And what volumes are vividly created here: the bulging cheeks of the trumpeters, the boldly articulated statuettes carried aloft by the standard bearers, even the highly schematic (but fully convincing) townscapes depicted in the battle scenes on the banners, all these are carried forward by Andreani's medium. At this date, there is as yet no attempt to print in the same array of colors available to the painter. But the emergence of the chiaroscuro woodcut, and its early maturity in the hands of artists such as Andreani, constitute an important milestone in the evolution of the color print.—PW

## HENDRICK GOLTZIUS

b.1558 Mülbracht, The Netherlands
d.1617 Haarlem, The Netherlands
*Ecce Homo,* 1597
Engraving
7 7/8 x 5 3/16 in. (20 x 13.2 cm)
85.32

## AFTER HENDRICK GOLTZIUS

*Ecce Homo,* c.1850
Engraving
7 7/8 x 5 3/16 in. (20 x 13.2 cm)
85.33

Draughtsman, printmaker, print publisher, and painter, Hendrick Goltzius was one of the superstars of 16th-century art. Kings, princes, and even popes vied to have their portraits made by him. When at age thirty-two, he went to Italy, he found it necessary to travel incognito, to avoid the crush of admirers. By 1597, the date of our engraving, examples of his prints had found their way to places as remote as the Arctic island of Novaya Zemlya (Russia). Andy Warhol would have killed for such international fame!

Upon what was his reputation based? Above all, upon the technical skill, the almost superhuman virtuosity of his engravings. We were delighted to be able to purchase this fine example of his later, post-Italy, classicizing manner (his earlier engravings feature wildly exaggerated, implausibly contorted figures). What cinched the

deal was the willingness of the dealer (the noted Hom Gallery, in Washington, D.C.) to include as part of the purchase price a fine 19th-century copy after the print.

Look closely, and even in these reproductions you may spot some minor variations: the figure "8" (this was the eighth in a series of twelve prints of the Passion) is slightly different, for example, and the monogram sits up a bit in the copy. But the main difference may be summarized by noting that the 19th-century copy is much "punchier." In the taste of that time, contrasts of light and shade are greater. This is both because more lines are engraved in areas such as the architectural shadows, and because those lines are more heavily inked. What a wonderful, instructive comparison this has been over the years for students of prints at the University of New Mexico.    —PW

## ANTIVEDUTO GRAMMATICA

b.1570-1571 between Siena and Rome, Italy
d.1626 Rome, Italy
*Allegory of Virtuous Love*, c.1610
Oil on canvas
48 1/4 x 30 1/4 in. (102.2 x 76.8 cm)
The Albert A. Anella Collection in memory of Mia Anella
87.14.2

Cesare Ripa published in Rome in 1603 an illustrated "recipe book" for the visual representation of allegorical figures, which book quickly became a standard item in the libraries of almost all 17th-century artists. Antiveduto Grammatica must have owned (or had access to) a copy of Ripa's *Iconologia*, because in this painting he faithfully follows the prescription for representing *Amor di Virtù* (Virtuous Love):

> *A nude boy, winged, wearing a laurel wreath on his head, and holding three others in his hands. The laurel wreaths are a sign of great honor, for the laurel is evergreen and the form of the wreath is a circle, hence a perfect form, without beginning or end, just as virtue is perfect. The wreath on his head signifies Prudence; the others are the Moral or Cardinal Virtues: Justice, Fortitude, and Temperance.*

Virtuous Love is, then, here the subject. But one can't help but think that our young boy sports a decidedly un-virtuous, positively wicked little smirk. This teasing sensuality was one of the trademarks of the *Caravaggisti*: artists, both Italians and foreigners, in Rome in the years just after 1600 who carried on the style of Michelangelo Merisi da Caravaggio, the greatest, most revolutionary talent in European painting of that time. Caravaggio and his followers specialized in dramatically lit figures against dark backgrounds, in uncompromising realism (note here the slightly dirty fingernails), and in pushing the boundaries of taste. John T. Spike, a noted scholar of Italian Baroque art, helped us both in the identification of our painting's subject and in affirming that its author must be Antiveduto Grammatica, one of the most important of the *Caravaggisti*.

Along with his prominent place in art history, Antiveduto Grammatica possesses one of the greatest names among artists. According to his early biographer Giovanni Baglione, Grammatica's parents were journeying from Siena to Rome when his mother went into labor and gave birth at an inn, an event that had been foreseen (*antiveduto*) by his father ("I just knew it would happen!"), and hence led to his striking name.

—PW

**LUIGI GARZI**

b.1638 Pistoia, Italy
d.1721 Rome, Italy
*Saint Agnes Raises to Life the Son of the Prefect,* c.1680
Oil on canvas
39 5/8 x 30 5/8 in. (100.6 x 77.8 cm)
The Albert A. Anella Collection in memory of
Mia Anella
87.14.4

The story told is that of Agnes, an early Christian saint martyred by the Roman emperor Diocletian. Sempronius, whom she here miraculously cures, was the son of the chief magistrate; he fell in love with Agnes whom he wished to marry, but she spurned him, stating that she could have no spouse but Jesus Christ. When he persisted, he was struck with blindness and convulsions, which Agnes cured with prayer. The crown of martyrdom held by the angel and the palm frond in the cherub's hand (as well as the supernatural glow around Agnes's head) foreshadow her later martyrdom and sainthood.

Luigi Garzi was one of the most important Italian painters of the late Baroque—the last decades of the 17th century, and the early ones of the 18th. At the age of fifteen he entered the Roman workshop of Andrea Sacchi, from whom he acquired the classical training that served him throughout his career. Honored by academic appointments and official commissions, Garzi was at the very heart of the Roman art establishment.

The sober, careful drawing and painting, the restricted palette (brown, red, blue, white, and little else), and the clear, almost architectural composition (the people are like building blocks, carefully placed in geometric order) bespeak Garzi's traditional Roman qualities. At the same time, the slightly busy or scattered composition (things happening all over the place) evidence the breaking up of the concentrated vision found in earlier Baroque art. All in all, a fascinating monument of the late Baroque at Rome.                                                      —PW

## REMBRANDT HARMENSZ VAN RIJN

b.1606 Leiden, The Netherlands
d.1669 Amsterdam, The Netherlands
*Woman Bathing Her Feet at a Brook*, 1658
Etching, drypoint, and engraving
6 3/8 x 3 1/8 in. (16.2 x 7.9 cm)
66.73

In all of Western art, no prints are more widely known and highly valued than those by Rembrandt. Etching—his signature medium—had been around since the early 16th century (and the use of corrosive action to create designs on metal armor goes back even farther). But it was Rembrandt who unlocked etching's full potential—its richness, complexity, and vitality—in ways which have never been surpassed.

The basic principles of etching can be quickly stated: a metal plate (usually, copper) is coated with an acid-resistant "ground." The artist then scratches a design through that dark ground, using a sharp steel needle to reveal the bright metal beneath. Dipping the plate in an acid bath cuts the design into the metal; the ground is removed, the plate inked (with the ink collecting in the acid-bitten grooves), and then pressed against paper to transfer the design (in reverse) to that sheet.

So much for the basics. What Rembrandt realized, more fully than any artist-etcher before or since, is that etching allows for much greater spontaneity and freedom than do other print mediums. For one thing, the etcher's needle scratching through the ground moves much more quickly and loosely than does, say, the engraver's burin, which needs a firmer, more deliberate pressure to cut directly into the metal printing plate. The resulting etched line has a nervous, tremulous quality; it very much records the "hand" of the artist.

Rembrandt accentuated this inherent aspect of etching by frequently reworking his plates (as here) in other mediums, including especially drypoint (which leaves a soft, ink-catching curl of metal on the surface of the plate) and engraving. Then, instead of striving for exactly the same look for each print of an edition (which might number 100 or even more), Rembrandt inked his plates with tremendous variations. Our *Woman Bathing*, for example, is relatively open and light, whereas other prints from this same first state show much deeper shadows, resulting from incompletely-wiped plates.

These late prints by Rembrandt, like his justly-famous late self-portraits, exude personality, and show us what creating a great work of art is all about.

—PW

## JAN VAN DE VELDE III

b.1619/1620  Haarlem, The Netherlands
d.1662 Amsterdam, The Netherlands
*Still Life,* 1654
Oil on wood panel
11 1/2 x 9 1/2 in. (29.2 x 24.1 cm)
Gift of Mr. Jacob Polak
68.6

In some countries, academic theory, and art market practice, conspired against artists who specialized in landscape or still life. From the Renaissance right into the 19th century, French and Italian artists (in particular) worked under a value system that ranked history and religious paintings at the top of the heap, followed by portraits, and trailed by art that didn't feature human subjects. In Protestant Holland, however, there was little market for religious paintings, and there was a wealthy (but not aristocratic) class of patrons who delighted in pictures of places and of things.

And yet this small panel painting, by Jan van de Velde III, is not quite the humble object it might first appear to be. It is, instead, all about display: display of the artist's prowess in convincingly depicting a wide array of objects, and display of the wealth of material goods available in prosperous 17th-century Amsterdam.

In some 17th-century Dutch still life paintings, there lurk hidden allegories: of the five senses, of the four elements. Probably nothing like that exists here. Still, why does our artist show three different glass vessels: the roemer (a distinctive Dutch-German footed glass) on the left, the beaker in the middle, the extravagantly-tall flute on the right? And he fills them with three different liquids: probably cider, certainly beer (or ale), and perhaps wine, respectively. He lovingly peels the lemon, and shows us the equally-exotic orange both whole and in section. Tobacco is scattered on the table; punk glows, ready to light the clay pipes. Chalk scratches keep score of the momentarily abandoned card game.

It all adds up to an inventory of the riches brought back to the mother country by aggressive merchant fleets which roamed the seven seas on behalf of Dutch prosperity. Just as Dutch sailors conquered the oceans, so Dutch artists achieved new heights of realism and essentially conquered the visible world. Jan van de Velde III (from an extended line of artists, stretching back to his great-grandfather) essentially seems to be saying: "There is nothing I can't paint, and paint so convincingly as to deceive your eye into thinking that this is really a glowing fire, that a moist and succulent oyster, and here a lemon the zest of which virtually tingles your nostrils."

And, of course, he's right.                                    —PW

## JAN DE BRAY

b. c.1627 Haarlem, The Netherlands
d.1697 Haarlem, The Netherlands
*Family Portrait,* 1656
Graphite on paper
6 1/2 x 8 1/4 in. (16.5 x 21 cm)
Gift of Joan and Van Deren Coke
84.10

What a marvelous, and marvelously complex, portrait drawing! It yields its secrets slowly. The sheet of paper tacked to the trunk in the lower right gives the date, "1656," and the name of the artist, "JBray" (Jan de Bray). The date is repeated and even elaborated along the lower margin: "A. 1656 4/30." Follows a series of ages of the first four figures: 54 for the (very solidly built) father, 8 for the daughter (her birthday is also given: 6/27), 2 for the son, and 31 for the mother. But what about the two figures on the right: the richly dressed woman holding a necklace, and the African woman behind her?

And, come to think of it, what about this rather peculiar setting? The figures are all up above us. That, plus the way the kneeling woman's dress falls forward off the platform, plus the drapery behind, strongly suggests a stage. Is this some kind of amateur theatrical performance? But then, why give the ages of four of the actors?

It turns out that Jan de Bray, though primarily a portrait artist, pioneered a strange cross between history painting and pure portraiture. What he loved to do (and has done here) is portray his solidly middle-class Dutch patrons as gods and goddesses, heroes and heroines, straight out of classical antiquity. In this instance, the story line is that of Cornelia, mother of the Gracchi, from Roman history. A virtuous widow, Cornelia was visited by a well-to-do friend who brought along her latest jewelry. When Cornelia was asked to show her own treasures in return, she famously pointed to her two young sons (who would grow up to be noted Roman statesmen) and replied, "These are my jewels."

So the story doesn't quite fit: here, the father is still alive, and we have a daughter as well as a son.  But still, its flattering implications are clear: this is a family which (despite commissioning its portrait by a leading artist of the day) has its values firmly opposed to ostentatious display.

—PW

**ROMBAUT VERHULST**

b.1624 Mechelen, Belgium
d.1698 The Hague, The Netherlands
*Portrait of a Dutch Naval Officer,* c.1675
Terracotta
31 1/4 x 22 1/4 x 8 in. (79.4 x 56.5 x 20.3 cm)
Gift of Andrew Ciechanowiecki
90.26.1

A Fleming by birth, Verhulst after initial training at home moved to the Netherlands, where he attached himself to the older, classically-inclined Flemish sculptor, Artus Quellinus. When that master returned to Flanders in 1665, Verhulst inherited the position of the most prominent sculptor working in the Netherlands. Known for his sensitive handling of textures and his ability forcefully to convey the personality of his sitters, Verhulst specialized in both portraits of the living and funerary monuments.

We often think of Dutch 17th-century art as exempt from what the art historian Erwin Panofsky called the "lordly clamor" characteristic of the Baroque in Italy, France, and Flanders. But by the 1660s, there had arisen a wealthy class of bankers, merchants, and military heroes not at all adverse to a bit of flash, dash, and flamboyance. Verhulst, master of swags of drapery and of aggressive poses, was just the artist to satisfy this new generation of Dutchmen. One should note, however, that while a Frenchman, or Italian, or Fleming of this class and time would have insisted on being portrayed in a formal wig, this Dutchman appears in his natural hair—emblematic of the more democratic social order in the Netherlands.

We can no longer sustain the traditional identification of our sitter as being the Lieutenant-Admiral Cornelis Tromp; none of the other known portraits of Tromp depicts the luxurious mole seen on the right cheek of this man. But the beautifully-rendered, quasi-classical uniform strongly suggests that our sitter came from the upper ranks of the Dutch navy. Verhulst executed many tombs and portraits of such men, including those of Tromp's father, Marten Harpertszoon Tromp, and also Tromp's great rival, Michiel Adriaanszoon de Ruyter.

Perhaps one day we will be able to put a name to the sitter for this terracotta bust, which was surely intended later to be worked up in marble. Until that time, it remains a vivacious reminder that the Dutch could be just as Baroque (with the capital "B") as their contemporaries to the west and south.                —PW

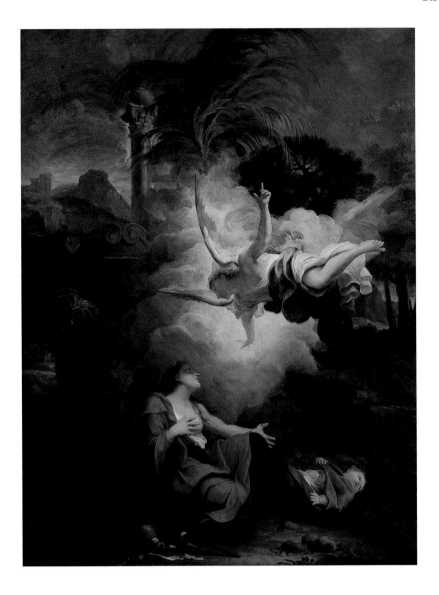

## LOUIS DE BOULLOGNE THE YOUNGER

b.1654 Paris, France
d.1733 Paris, France
*Hagar and the Angel,* c.1710-1720
Oil on canvas
49 3/8 x 37 1/2 in. (125.4 x 95.3 cm)
Gift of Andrew Ciechanowiecki
90.26.2

Exiled by Abraham and Sarah, Hagar and her son Ishmael wandered in the wilderness until their meager supplies were exhausted (Genesis 21:14-19). Hagar laid the child down under a bush, despairing that he would soon die unless she could find water. An angel appeared, telling Hagar that her son would live to father a great nation, and revealed to her a nearby spring (presumably, under the roiling ground cloud in the center of this painting).

Louis de Boullogne the Younger was the most distinguished member of an extended family of French artists; both his father Louis Boullogne (1649-1674) and older bother Bon Boullogne (1649-1717) were painters. In 1673, the younger Louis won the coveted Prix de Rome, a fellowship for students at the Royal Academy's schools, which enabled graduate study in Rome. Upon his return to Paris, Boullogne was quickly employed in producing vast decorative paintings for Versailles, Marly, Meudon, Fontainebleau, and other great *châteaux*. Made Director of the Royal Academy in 1722, ennobled in 1724, and finally appointed First Painter to the King in 1725, Louis de Boullogne was many times officially recognized as the leading French artist of his generation.

Stylistically, this painting owes a great deal to the Grand Manner: the bold, serious style of painting much in favor in both Paris and Rome during the 17th century. One may note, for example, that this "wilderness" into which Hagar and Ishmael have been expelled includes magnificent classical architecture. However, as is typical of paintings done by Louis de Boullogne the Younger during the later decades of his career, there is here a loosening up of the pictorial structure which anticipates the relative informality of much 18th-century Rococo painting.    —PW

## GUISEPPE MARCHESI, CALLED "IL SANSONE"

b.1699 Bologna, Italy
d.1771 Bologna, Italy
*The Sacrifice of Iphigenia*, c.1740
Oil on canvas
41 1/4 x 54 1/4 in. (104.8 x 137.8 cm)
The Albert A. Anella Collection in memory
of Mia Anella  87.14.1

Our story comes from the Greek tragedy *Iphigenia at Aulis* by Euripides. The Greek army, on its way to beseige Troy, lies becalmed at a place called Aulis. Kalchas, the priest, tells the Greek leader Agamemnon that the goddess Artemis is angry and will only let the winds blow if Agamemnon sacrifices his daughter, Iphigenia:

*King Agamemnon groaned aloud and turned his head, hiding his eyes with his robe. The whole army stood with their eyes fixed on the ground, and the priest took up the knife. And the miracle happened. Everyone distinctly heard the sound of the knife striking, but no one could see the girl. She had vanished. The priest cried out, and the whole army echoed him, seeing what some god had sent. A deer lay there gasping. Then Kalchas shouted, "The goddess has placed the victim on her altar, a deer from the*

*mountains, and accepts this instead of the girl. Now she blesses our voyage to attack Troy. Therefore let everyone who is to sail take heart and go down to his ship."*

(W.S. Merlin and George E. Dimock, Jr., trans.; Oxford Univ. Press)

Artemis has taken Iphigenia away to become a priestess; we see them together in the sky.

One of the leading painters in 18th-century Bologna and an active member of that city's Accademia Clementina, Giuseppe Marchesi specialized in large-scale paintings, both oils and frescoes. The nickname "Il Sansone" (Samson) still today in Bologna indicates someone of extraordinary physique, and the same may be said of the artist's creations. Marchesi's elegant, complicated style (both heroes and heroines seem at times triple jointed!) is highly dramatic; indeed, in this painting the drapery to the left seems a deliberate reference to stage curtains. But note one all-important difference between the "staging" of the narrative by Euripides and by Marchesi: in the play, things happen sequentially. Agamemnon hides his face, and then Kalchas takes up his knife, and then Artemis spirits away Iphigenia and substitutes the deer. The painter compresses or collapses time, showing these events as if they were happening all at once. Such manipulation of space and time seems both archaic and, curiously, very modern.                                                    —PW

RESTES DU PALAIS                    DU PAPE JULES.
Tiré du Cabinet de M. le Comte de Baudouin, Brigadier des Armées du Roi. Capitaine aux Gardes françoises.

Before the invention of photography, the vast majority of prints had reproductive accuracy (rather than artistic expression) at the core of their genesis. Reproducing natural fact, scientific invention, or mechanical device—or, oftentimes, a work of art in another medium—was the first order of the day.

Engraving—which gives that tough, precise line we still find so compelling on stamps and paper currency—was especially well-suited to carrying accurate information about machinery, or even about the art of those masters (primarily Italian) who themselves emphasized line and contour. But by the mid-18th century, especially in France, there had arisen a new style in art—delicate, subtle, infinitely complicated, and highly dependent upon color rather than upon line—called the Rococo, which defied the best efforts of engravers to reproduce it with anything resembling the spirit of the originals. Shortly, a new generation of printmakers came along to tackle, and to conquer, this task. Jean-François Janinet was at the very forefront of this new generation, and our print exemplifies his achievements.

Probably first apprenticed to his father, a gem engraver, by the early 1770s Jean-François was working in the studio of Louis-Marin Bonnat, one of the leading printmakers of the day, who specialized in the so-called "crayon manner"—a technique which aped the look of pastel drawings. In 1772, Janinet published in his own name a small oval print from several plates, *The Meeting* (after the minor artist Peter-Paul Benazech), with the inscription, "This print done in imitation of watercolor by F. Janinet, the only person who has discovered this manner."

This was not, evidently, an idle boast, because soon Janinet was making prints after works by France's leading artists, including this one which reproduces the work of Hubert Robert. What, exactly, was his breakthrough discovery? In part, we surmise, the invention of new engraving tools: mattoirs, with irregularly spiked, rounded metal knobs. Early versions of such instruments had been used by Bonnat (and others) to imitate the grain of chalk. Now made both finer and more irregular, in the hands of Janinet they allowed him to simulate the look of delicate ink and watercolor washes. By precise manipulation against the metal plate, the mattoirs roughened the surface just sufficiently to hold enough ink (itself, of a new transparency) to print as if flowed from a watercolorist's brush. Even when viewed under relatively high magnification, this illusion holds amazingly well.

—PW

## JEAN-FRANÇOIS JANINET

b.1752 Paris, France
d.1814 Paris, France
*Restes du palais du Pape Jules,*
after Hubert Robert, 1775
Color etching and engraving
11 1/2 x 9 5/8 in. (29 x 24.4 cm)
Julius L. Rolshoven Memorial Fund
86.174

## GIOVANNI BATTISTA PIRANESI

b.1720 Mogliano, Italy
d.1778 Rome, Italy
*Untitled* (Plate XIV from the series *Prisons*), 1761
Etching
16 1/4 x 21 3/4 in. (41.3 x 55.3 cm)
Julius L. Rolshoven Memorial Fund
69.96

Such was the power and the ubiquity of Piranesi's grand etchings of Roman monuments that his vision became the standard by which the city itself was judged (and, sometimes, found wanting). The English sculptor John Flaxman was but one of many 18th-century visitors to Rome who found the city to exist "on a smaller scale, and less striking, than [I] had been accustomed to suppose after having seen the prints of Piranesi." Another Englishman, Horace Walpole, wrote in 1786 of "the sublime dreams of Piranesi, who seems to have conceived visions of Rome beyond what it boasted even in the meridian of its splendor."

Piranesi was himself a foreigner. He grew up in Venice, and trained as both an engineer and an architect. Still, his earliest graphic works, including the fantastic *Prisons* (first etched around 1750, then reworked and published in 1761), showed the powerful, transformative imagination he would bring to virtually every project he undertook. "I need to produce great ideas," he wrote, "and I believe that were I given the planning of a new universe, I would be mad enough to undertake it."

In the great monuments of Imperial Rome, he found his spiritual match. For Piranesi, for all 18th-century visitors and residents alike, the grandeur of the ancient baths, theaters, and other public buildings bespoke a race of vanished giants. Rome at the time of Augustus boasted one million inhabitants; in the Middle Ages, that had shrunk to less

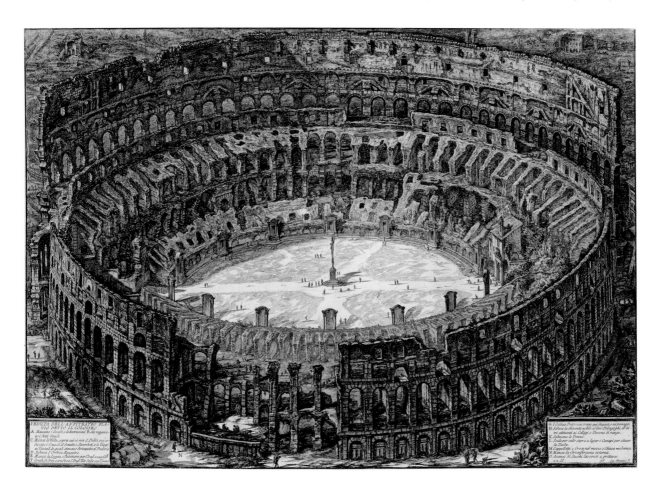

than 50,000, and wolves roamed within the old boundary walls; even by the late 18th century, the population was barely 150,000, living amid vast edifices—such as the Colosseum—built on a scale which mocked the ambitions of the current inhabitants. Piranesi took such structures and inflated their already imposing size. Here, his vantage point hovers hundreds of feet in the air. The little humans wandering inside the ancient arena are as a race of pygmies. At the same time that the proto-Romantic in Piranesi exults in the great bulk of the building (which crowds the entire width and height of his print, pushing against the borders like a sumo wrestler in a telephone booth), the engineer peels away the surface (even more than had actually been accomplished by the ravages of time) to reveal the structure and the building techniques. Out of such tensions, he produced great art.

—PW

### GIOVANNI BATTISTA PIRANESI

*The Colosseum,* 1776
Engraving
19 3/8 x 28 in. (49.2 x 70.9 cm)
Purchased with funds from the Friends of Art
67.102

# The Nineteenth Century

# THE NINETEENTH CENTURY

Your daily newspaper—and, indeed, this handbook, with its combination of text and image—are products of two 19th-century innovations: lithography and photography. In addition to their separate and combined impacts on the mass media, lithography and photography were both seized upon by artists early on after their inventions. Even those artists who remained aloof found their visions of the world forever transformed by the easy availability of lithographic prints and photographic representations of the world's places, people, and events.

Perhaps because of their ubiquity, both lithography and photography struggled to find full acceptance as fine art mediums. For lithography, its handicap was the confusion between original fine art prints and those mass-produced prints that reproduce works (paintings, drawings, sculpture, or even architecture) done in other mediums. Photography's mechanical nature, and then the exploitation by Kodak and other industrial giants of its ability to be a popular or even folk medium, made more traditional artists loath to grant it the status of a truly fine art (a debate which lingered on even well into the 20th century).

The University of New Mexico Art Museum (and UNM's Department of Art and Art History) fortunately did not labor under any suspicion of either lithography and photography, but instead, earlier than most similar institutions at other American or European universities, moved to develop distinguished collections and closely related academic programs in both mediums. Thus the founding base of early lithographs and photographs was established at a time when such materials were both plentiful and relatively inexpensive, and our continuing pre-eminence in these fields makes us a magnet for further important donations, the primary device by which these collections still expand in both quantity and quality.

Thus since our founding in 1963, we have been primarily a museum of the 19th and 20th centuries: of the age of lithography and photography. In addition to many works in those two mediums, we have also developed distinguished collections of paintings, drawings, and sculpture from the 19th century and beyond. We have done so both for the intrinsic worth of such objects, and for their ability to illuminate the context within which artist-lithographers and artist-photographers lived and worked. More so than most other museums, it has been our belief and practice that all of these mediums should be experienced side-by-side; that is the way you will experience them in the following pages, devoted to highlights of our 19th-century collections.

**BENJAMIN WEST**

b.1738 Springfield (now Swarthmore), Pennsylvania
d.1820 London, England
*Angel of the Resurrection*, 1801
Lithograph, 12 1/4 x 8 3/4 in. (31.3 x 22.3 cm)
Purchased with funds from the Friends of Art
97.55

Many "firsts" are in dispute (the first photograph? the first automobile?). But not the first artist's lithograph. That title, without question, belongs to Benjamin West's *Angel of the Resurrection*, of which we—a museum especially devoted to the history of lithography—are very proud to have this fine impression.

The history is well established. In 1798 (or, possibly, early 1799) Aloys Senefelder invented lithography. Looking for a faster, cheaper way to publish the plays which he had authored, Senefelder finally achieved the printing of multiple and identical images from a flat stone by means of a chemical process based upon the antipathy of grease and water. Basically, a greasy drawing is chemically fixed into just the right kind of limestone; when wet, it accepts ink only where the image was drawn; when run through a press, that inked image is transferred to paper (in, of course, the reversed sense).

Patents were issued, first in 1799 in Bavaria, and then in 1801 in England, where Senefelder had established a press in partnership with Philipp André. It was André who conceived the notion that this new medium (which he called "polyautography") might gain prestige if he could interest leading artists to make drawings on his stones. Starting at the top, André approached Benjamin West, the American-born President of the Royal Academy. West's *Angel of the Resurrection* was thus the very first artist's lithograph. It bears within the image the date "1801," and our impression is on paper also watermarked that same year. Apparently, André printed a good number of these proofs, to show about and attract other artists to his project. It was in 1803 that he published (as *Specimens of Polyautography, Consisting of Impressions Taken from Original Drawings Made Purposely for this Work*) the first group of twelve prints by various artists, including this West.

Beyond its historical importance, our print is vigorously drawn and brilliantly printed (save only a slightly pale area on the angel's right arm). Clearly, it demonstrated everything that Senefelder and André might have hoped: that lithography, though in its infancy, was an attractive medium for artists. Within a decade, both in Britain and on the Continent, many leading artists experimented successfully in lithography.
—CA & PW

## PIERRE-JEAN DAVID D'ANGERS

b.1788 Angers, France
d.1856 Paris, France
*André Chénier*, c.1839
Plaster, 31 3/8 x 12 x 11 3/4 in. (80.4 x 30.6 x 30 cm)
Purchased with funds from the Friends of Art
76.35

Fame in the United States in the year 2001 might be measured by being on the cover of *Time* (or *The National Enquirer*). Fame in France in the second quarter of the 19th century meant being sculpted by Pierre-Jean David d'Angers. The most prolific of 19th-century sculptors, David d'Angers was—in the words of art historian James Holderbaum—"considered by a majority of French critics and intellectuals to be the great representative sculptor of his time." And why should such critics and intellectuals think otherwise? After all, most of them had been flattered to sit for their portraits by David d'Angers, who left his mark in portraiture above all other sculptural genres. Goethe, Chateaubriand, Paganini, and Thomas Jefferson are just a few of the international "glitterati" whom he sculpted.

Pierre-Jean David has always had "d'Angers" added to his name, partly to identify his native city (which generously sponsored his studies and early career) and partly to distinguish him from Jacques-Louis David (1748-1825). In fact, David d'Angers during his student years in Paris (1808-1811) came to know the older David, who was the most respected exponent of neoclassical painting in France; David and David d'Angers were both staunch and openly declared supporters of the French Revolution. There is a bit of ironic tension, then, in David d'Angers's apparent receipt of a commission, sometime in the 1830s, to execute a posthumous portrait bust of André Chénier, the proto-Romantic poet who was executed in 1794 at the hands of the Revolution, and buried in a common grave with some 1300 other victims. Incised into the base of our sculpture are two lengthy excerpts from the poet's *Elegies*, and a short memorial poem by his brother, Marie-Joseph Chénier. A related terracotta model of our bust (signed and dated 1839) is today at the Musée David d'Angers in his native city; our plaster was at some point painted brown, perhaps to simulate the intended bronze final version, of which there is no trace of its having been accomplished.

Of particular note is Chénier's huge forehead, way beyond anything suggested in the several lifetime portraits of the poet which David d'Angers might have consulted. Indeed, this was a characteristic common to most of the sculptor's portraits of great men and women, and stems from his enthusiastic study of phrenology and the pseudo-scientific treatises of Franz Joseph Gall. Hyperbolically towering foreheads, vastly domed craniums, lengthened and ennobled noses: according to Gall, these were all unmistakable signifiers of great genius.
—PW

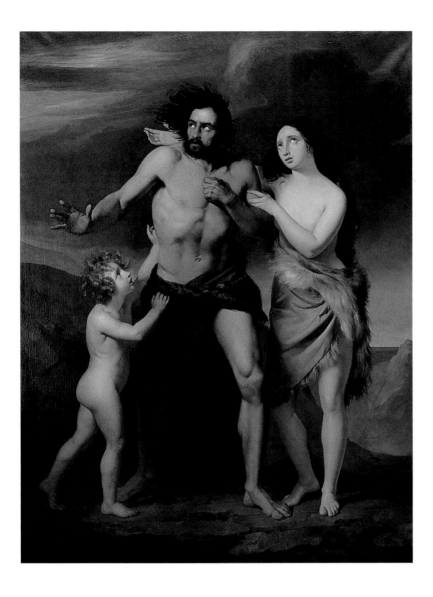

## LODOVICO LIPPARINI

b.1800 Bologna, Italy
d.1856 Venice, Italy
*Cain and His Family Fleeing God's Wrath*, 1837
Oil on canvas
82 1/2 x 63 5/8 in. (209.5 x 160.5 cm)
Gift of Andrew Ciechanowiecki
97.15.1

One of the great crowd-pleasers in our collections, this robust exercise in Italian neoclassical painting puts the lie to the notion that American Abstract Expressionists pioneered in the 1950s the big canvas. These fully life-sized figures (Cain measures just over five foot six, with the barrel chest of a weightlifter) stand out all the more, as they are juxtaposed against a bleak, primeval, storm-lashed landscape. A couple of details to note: how Lipparini thoughtfully reverses the animal skin so that Cain's wife wears hers soft-side to skin, and how the artist in pre-Mendel days (and thus with an imperfect understanding of genetics) provides the child of two brown-eyed parents with blue eyes.

The story is, of course, biblical. After Cain killed his brother Abel, the Lord cursed Cain and banished him to a life of wandering. Cain expressed fear that whoever would see him would murder him. "And the Lord set a mark upon Cain, that whosoever found him would not kill him" (Genesis 4:15). Various scholars, and various artists, have given different versions of what this mark might have been.

Lipparini shows, on Cain's forehead, the Hebrew letters "L" (*lamed*) and "H" (*hey*). *Hey* is one of the letters of Yahweh, God's name in Hebrew. *Lamed* is the prefix meaning "of" (hence, Cain is "God's," and not to be touched); *lamed* is also the first letter, and a close cognate, of "*Lamech*"—the name of Cain's grandson who will one day by accident kill him. This scholarly play with the mark of Cain suggests that Lipparini probably consulted a learned member of the very active Jewish community in Venice.

It was in Venice that Lipparini trained, and where he became one of the most important and decorated members of the Venetian academy. Painter of portraits and of both religious and classical subject pictures, he enjoyed patronage throughout northern Italy and Austria-Hungary. This particular painting was commissioned by a Milanese banker, Ambrogio Uboldo, who was a well-known patron of contemporary art, a Counselor of the Accademia di Belle Arti of Milan, and an associate of those of Venice, Florence, Rome, Bologna, Ravenna, Turin, Verona, Padua, and Arezzo. Uboldo, like Lipparini, deserves further study, as does the whole phenomenon of academic, or neoclassical, art in 19th-century Italy.    —PW

**HIPPOLYTE LOUIS FIZEAU**

b.1819 Paris, France
d.1896 Seine-et-Marne, France
*Untitled (Portrait of Two Young Men)*, 1841
Daguerrian engraving
4 1/8 x 3 1/8 in. (10.5 x 7.9 cm)
Julius L. Rolshoven Memorial Fund
97.32

There are some objects that demand to be in the collection of a university so strongly engaged in the study of the history of photography and the graphic arts. This simple portrait of two young men stands at the beginning of the history of photomechanical reproduction—the way that we see photographs in books, magazines, and newspapers. The photographic image is printed in ink on paper rather than composed of light sensitive chemicals on a support.

The young Fizeau was a scientist and the protégé of François Arago, the president of the French Academy of Sciences who first announced Daguerre's process for making a permanent photographic image in 1839. Immediately hailed as an almost magical invention, the daguerreotype produced an exquisitely detailed photographic image on a mirror-like metal surface, yet it had a serious drawback: it was a single, unique picture. Two years later, Fizeau developed a process for converting the polished metal daguerreotype plate into an aquatint printing plate from which multiple copies of the image could be printed. The result which he called daguerrian engraving was the first method of reproducing a photographic image in print.

In this early example of Fizeau's process, a quarter-plate daguerreotype portrait was chemically treated and etched. The printer then heightened facial details and outlines with an engraving tool. The resultant printed image has the veracity and detail of a photograph and the tonal range of an aquatint.

Examples of Fizeau's process are rare. The printing surface wore down rapidly so very few impressions could be pulled from a plate. After an initial interest in the process, the fragility of the printing surface spelled its end. A few of Fizeau's daguerrian engravings were included in the first volume of *Excursions Daguerriennes* (1841), the first book with illustrations derived from photographs, but the publisher quickly returned to hand-engraved copies of daguerreotype images because Fizeau's plates did not stand up to repeated printings.
—KSH

## HONORÉ DAUMIER

b.1808 Marseilles, France
d.1879 Valmondis, France
*"Célui-là on peut le mettre en liberté! Il n'est
pas plus dangereux."* (*"This one you can set free!
He is no longer dangerous."*), 1834
Lithograph
8 7/8 x 10 1/8 in. (22.5 x 25.7 cm)
74.13

We're an art museum, and our collections clearly reflect this fact. But we're also aware that most prints (and photographs) have come into the world with aims and audiences outside of the art/art museum world. Certainly Honoré Daumier was well aware of this fact: one of the greatest 19th-century artists, he (barely) eked out a living as a cartoonist. But talk about making lemonade out of lemons! Daumier's cartoons make you laugh, make you cry, and constantly dazzle you with their graphic elegance. Almost every art museum in the world is proud to include them in their collections.

"*Célui-là...*" belongs to an extended group of cartoons critical of Louis-Philippe's government, published by Charles Philipon in his weekly, *La Caricature*. Daumier depicts the corpulent monarch, recognizable even from the back by his pear-like body and extravagant sideburns, at the bedside of a political dissident who has expired, shackled to his prison cot; the pardon is callously granted, now that he can no longer speak out. *La Caricature* was responsible for the notorious association of the king and *la poire* (the pear), slang for "fathead" or "simpleton." The image was used by Philipon as a figure of speech, and by Daumier and other cartoonists as a physiognomic exaggeration, with malicious intent, thus provoking frequent arrests of the artists, the publisher, and the printer.

Daumier's more popular prints (such as this one) were also printed on a better grade of paper and sold at La Maison Aubert, run by Philipon's brother-in-law Gabriel Aubert in the passage Véro-Dodat, close by the Palais-Royal. Aubert dominated the commercial print trade in the 1830s. —FMC & PW

## CHARLES JOSEPH TRAVIÈS DE VILLERS

b.1804 Winterthur, Switzerland
d.1859 Paris, France
*Faut avoir que l'gouvernment à une bien drôle
de tête* (*It's obvious that the government has a
pretty funny face*), 1831
Lithograph
8 1/4 x 10 5/8 in. (21 x 27 cm)
96.40

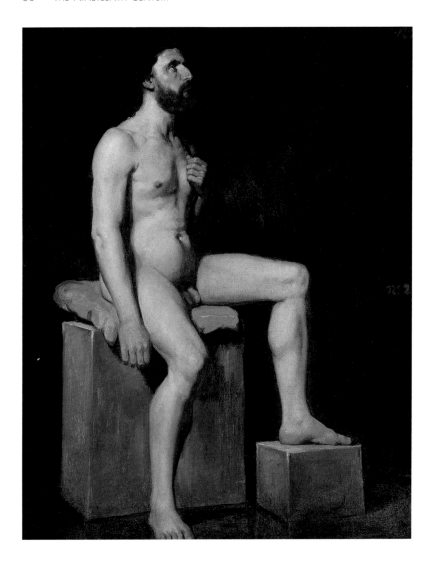

**ABEL-FRANÇOIS-NICHOLAS-PIERRE BERGER**

b.1826 France
*Nude Male*, 1854
Oil on canvas
32 x 25 1/2 in. (81 x 65 cm)
87.15

Today, "academic art" is (usually) a pejorative term, conjuring up images of vast, stuffy, unadventuresome canvasses by artists who stood in the way of modern developments. But right through most of the 19th century, the great European art academies (first initiated in Italy in the 15th and 16th centuries) trained most of the greatest artists in their schools; membership in them (and getting one's work hung in their annual exhibitions) was necessary in order to compete for the richest, most prestigious commissions. Berger—hardly one of the greats—dropped out of sight after his student days at the Ecole des Beaux Arts in Paris, but this oil study of a nude male model tells us much about the kind of education undertaken by aspiring French artists of his era.

From all over France (and from her colonies, as well), the brightest and most ambitious students all hoped to gain admittance to the Ecole des Beaux Arts in Paris; once there, they competed to earn a lucrative *Prix de Rome*—a sort of graduate fellowship, to study at the French Academy in Rome. Since the 1700s, the *Prix de Rome* was awarded annually on the basis of a competition in which invited students all painted (or sculpted) works on a given subject, usually a morally-uplifting story from classical antiquity.

By 1846, so many students wanted to enter the competition that a qualifying round was instituted, in which ten top students (chosen by the faculty) had to pass a test consisting of a painted figure study. This made perfect sense: for all French artists who aspired to official success, the ability to paint the nude male figure was essential. Such figures were the starting point for the complicated historical paintings demanded by the Church and by the State. The winners received prizes and permission to go on to other contests. The canvas size was set; the model was "posed" by the officiating professor; each student drew by lot his vantage point (the "No. 2" in red paint indicates the position from which this canvas was done) and had to complete the study in four seven-hour sessions. The relatively unfinished look of the lower part of this figure suggests that Berger ran short of time. He would compete again, more successfully, in 1856.   —PW

## DAVID OCTAVIUS HILL

b.1802 Perth, Scotland
d.1870 Edinburgh, Scotland

## ROBERT ADAMSON

b.1821 Fife, Scotland
d.1848 St. Andrews, Scotland

*Fisher Lassies*, c.1845
Salted paper print from paper negative
6 1/2 x 8 1/8 in. (16.7 x 20.8 cm)
Gift of Alexander Novak and Family
2000.12.2

The partnership of Hill and Adamson was formed for the express purpose of making photographic portraits, primarily as *aide-mémoires*, for a complex group painting that Hill envisioned. As with the other early partnership in photography, that of Southworth and Hawes, Hill and Adamson's success was the result of a blend of the two men's talents; Adamson was an engineer and according to Hill "a master of chemical manipulations"; Hill was an artist, trained in lithography and painting. During a four-year collaboration which ended at Adamson's early death at twenty-six, they produced a body of work recognized as one of the first and finest explorations of photography as a fine art.

Distinct from the portraits of Scottish churchmen made for Hill's initial project, are the more than 130 photographs of the people in the fishing village of Newhaven, a small town on the shores of the Firth of Forth about one mile from Edinburgh. The Newhaven pictures are both the earliest social document in photography and an exploration of photography's ability to emulate Dutch genre paintings. In *Fisher Lassies*, a group of traditionally dressed women sit with their wicker baskets listening to the woman at the left who reads a letter. This is a theme that Hill and Adamson explored several times, honest working women caught at a moment of repose. The women of Newhaven were noted for their natural beauty and picturesque costumes; Ms. Rigby described them in her journal as "with as heavy a load of petticoats as of fish… petticoat over petticoat, striped and whole color; all of the thickest woolen material."

In 1845, Hill announced that he and Adamson would publish a book of photographs to be titled *The Fishermen and Women of the Firth of Forth*. The title reflects more accurately the scope of the project; photographs for this series were made at Newhaven, St. Andrews, and in the outdoor studio at Hill's home in Edinburgh. This photograph is one of the latter. Perhaps three other studies similar to this picture were done at the same time, all arranged around the theme of a woman (in this case, Grace Findlay) reading a letter.    —KSH

**(CHARLES-ERNEST-RODOLPHE-)
HENRI LEHMANN**

b.1814 Kiel, Germany
d.1882 Paris, France
*Saint Agnes* (*Posthumous Portrait of Mlle...*), 1859
Oil on canvas
51 1/4 x 38 3/8 in. (130 x 97.5 cm)
Gift of Andrew Ciechanowiecki
97.15.3

When it comes to treatments of the dead, every culture, every age, has practices which seem bizarre to outsiders. Why, we might well ask ourselves, would a wealthy and sophisticated French family of the 19th century, choose to have a deceased young girl commemorated in a portrait which shows her as an Early Christian martyr-saint? Moreover, this commemoration was not a family secret: our *Saint Agnes* was in 1859 exhibited at that most public of French art exhibitions, the Paris Salon.

Adding to the strangeness is the morbid history of Saint Agnes. Martyred under the Emperor Diocletian in 304, Agnes was a young Christian girl, for whom the son of a high Roman official conceived a passion. She rejected his offer of marriage, saying she was wedded already to Christ. The father, incensed, had her tortured, then stripped and flung into a brothel. She was miraculously protected: her hair immediately grew long, covering her nakedness, and shining light enveloped her. Finally, however, on orders from the official, soldiers cut off her head. Not a story which many parents would wish their deceased daughter to be associated. But, of course, Lehmann shows none of this narrative, and identifies Agnes as a martyr only by the palm frond which she holds. He concentrates our attention on the heavenward gaze and ethereal near-smile of the girl, and her literally radiant beauty.

The origins of this other-worldly style are complex. Lehmann came to Paris at age seventeen to study with the greatest French academic artist of the 19th century: Jean-Auguste-Dominique Ingres. Soon favored by important public commissions, Lehmann became a naturalized citizen in 1846; later, he was appointed Professor at the Ecole des Beaux-Arts. For all this adopted Frenchness, however, Lehmann kept his native German artistic contacts. He was particularly close with a group of German artists just a couple of decades his senior, artists who studied in Rome and called themselves the Nazarenes. These artists—and Henri Lehmann—took their clues not from classical antiquity or the High Renaissance (Raphael, et al.), but rather from the more primitive artists of the Early Renaissance. Thus, as here, a flattening of forms and a stripping away of non-essential information, and a concentration upon transcendental, religious values. This aspect of Lehmann's art—a deliberate regression to primitive values, as an antidote to contemporary sophistication—becomes a major theme in modern art, where often to be the more primitive is to be the more modern. —PW

## REVEREND CALVERT RICHARD JONES

b.1804 Swansee, Wales
d.1877 Bath, England
*Santa Lucia, Naples*, 1845/1846
Salted paper prints from calotype negatives
Left: 8 3/8 x 6 5/8 in. (21.5 x 16.9 cm)  70.123
Right: 8 1/2 x 6 1/2 in. (21.8 x 16.7 cm)  87.28
The Beaumont Newhall Collection. Purchased with
funds from the John D. and Catherine T. MacArthur
Foundation

Reverend Calvert Jones was an intimate of William Henry Fox Talbot, the inventor of positive/negative photography, and an early photographic experimenter. Dissatisfied with the narrow field of view that early camera lens provided, Jones pioneered the segmented panorama which he called simply "double pictures" or "joiners." In this format, two slightly overlapping photographs could be joined to yield a view that approximated more closely that of the human eye.

Jones made this "double picture" of Naples while sailing with Talbot's cousin Kit (Christopher Rice) Talbot in the winter of 1845-1846. He used his friend's calotype process (a process which used a paper negative to make a paper print) invented just three years earlier. On this Mediterranean cruise, Jones hoped to produce a group of negatives from which a quantity of prints could be made at the Reading Establishment—the first photographic printing business, established by Talbot's assistant Nicholas Henniman in 1843—and offered for sale. Unfortunately, his plans to market his photographs were never realized, and Jones's "double pictures" remain quite rare.

Reverend Jones's pictures are innovative, not only in terms of his strategy for creating a larger visual slice of the world, but because of his subject matter. At a time when photographs seemed to be focused on the singular object or person, Jones conceived of a photographic representation that would capture the experience of a place. This is a picture about the flow of life—the market stalls, drying laundry, and blur of street activity. Instead of a static transcription of things in front of the camera, we see a slice of life along the Naples waterfront.

The two prints that make up this "double picture" entered the Museum's collection separately. The left half was acquired in 1970; seventeen years later the right half was purchased at auction, reuniting both halves of Reverend Jones's "double picture" almost 150 years after they were taken.    —KSH

## EDUARD BALDUS

b.1813 Grunebach, Prussia
d.1889 Arcueil-Cachan, Paris, France
*Cloister at Saint-Trophîme, Arles*, 1851
Salted paper print from multiple paper negatives
15 1/4 x 15 3/4 in. (39 x 40.4 cm)
Gift of Eleanor and Van Deren Coke
72.214

## CHARLES MARVILLE

b.1816 Paris, France
d.c.1879 Paris, France
*Portail Principal de la Cathédrale d'Amiens*, from *L'Art religieux: Architecture, Sculpture, Peinture*, published by Blanquart-Evrard, Lille, 1853-1854
Salted paper print from paper negative
13 7/8 x 10 1/8 in. (35.6 x 26 cm)
Gift of Judith Hochberg and Michael Mattis
2000.22.1

Interest in preserving and studying the rich architectural history of France was given impetus by the orgy of destruction that accompanied the French Revolution and the rise of a new national consciousness. Official government commissions (such as the Historic Monuments Commission) and commercial projects (such as the printed volumes published by early photographic printer Blanquart-Evrard) turned to photography to provide records of medieval structures throughout France. In 1850, the Commission established the Missions Heliographiques which dispatched five photographers to designated sections of France. They sent Eduard Baldus south to Fontainebleau, through Burgundy, the Dauphine and Lyonnais, Provence, and a section of Languedoc, to photograph fifty-one monuments, including Saint-Trophîme.

The north gallery of the cloister of Saint-Trophîme at Arles, built in 1165-1180, is one of the architectural and sculptural masterpieces of medieval France. It also posed an extraordinarily difficult problem for a photographer. Even with a large view camera set as far back against the end wall as possible, only a small portion of the space was within the frame of the picture. Furthermore, no negative could capture the full range of light and shadow—from sunlit garden to the deeply shadowed capitals inside the cloister. Baldus solved the problem by making several negatives, each focused and exposed for different sections of the cloister. The print is the result of a jigsaw puzzle of nine or ten negatives, carefully pieced together. Where the camera could not record detail—the vault almost directly overhead and the worn stone floor in the foreground—Baldus drew the architectural details onto paper negatives. The result is a photograph that not only documents the site but conveys the sensation of being in the barrel-vaulted space. It is a tour de force of photographic manipulation created a scant decade after photography's birth.

Prints of Baldus's work for the Missions Heliographiques are extremely rare because the negatives were turned over to the commission almost immediately upon the photographer's return to Paris. None of the work done for the Commission was published in any systematic way. Only two other prints from this negative are known. On the other hand, the photographs made by Charles Marville for Blanquart-Evrard's two-volume set, *Religious Art: Architecture, Sculpture, Painting*, had a much wider distribution. Blanquart-Evrard used Marville frequently for architectural views for his publications. The *Portal at Amiens* is an example of Marville's solid, workman-like approach to recording sculptural decoration. Baldus also photographed the portal in 1855 as it was being restored.

—KSH

**JOHN BEASLEY GREENE**

b.1833 LeHavre, France
d.1856 Egypt
*Tomb of the Christian, Algeria*, 1856
Salted paper print from paper negative
9 1/8 x 12 in. (23.1 x 30.5 cm)
Julius L. Rolshoven Memorial Fund
84.95

From the first announcement of Daguerre's breakthrough, archaeology and photography were intimately connected. (The President of the French Academy of Sciences specifically mentioned photography as a way to record the hieroglyphic inscriptions of Egypt.) Perhaps the first to use photography in a systematic manner in an archaeological setting was J.B. Greene, the French-born American protégé of the most powerful man in French Egyptology, Viscount de Rougé. With Rougé's assistance, Greene made three trips to Egypt, on one of which he conducted excavations at Thebes. He made photographs on all of his Egyptian travels and deposited carefully annotated prints with the French Academy of Inscriptions, the predominant organization in archaeology at the time.

In April 1856, Greene accompanied a French official in Algeria on an expedition to excavate a mound known as the Tomb of the Christian, the journey on which this photograph was made. In this series, Greene provided a document showing the tomb from all sides, the entrance to the tomb, and the layers of excavation. As with the Egyptian photographs, copies were deposited with the French Academy. We don't know if Greene intended to publish the photographs and results of the excavation; within six months, he was dead at twenty-three, the victim of tuberculosis.

Traveling to Egypt in 1849 with his friend Gustave Flaubert, Du Camp photographed antiquities along the Nile. His work from the Middle East is more often discussed than Greene's because it is better known. One hundred and twenty-five photographs from this trip were published in the first photographically illustrated travel book, *Egypte, Nubie, Palestine, et Syrie* (1852). Du Camp's reaction to Egyptian antiquity is that of an Orientalist in the romantic tradition, rather than that of the archaeologist. His photograph of a colossus at Abu Simbel captures the looming grandeur of the monument, while Greene's transcription of an excavation site focuses on the structure and situation of the "tomb."    —KSH

**MAXIME DU CAMP**

b.1822 Paris, France
d.1894 Baden-Baden, Germany
*Ibsamboul, Colosse Médial du Spéos de Phrè*
(*Abu Simbel, Colossus from the Facade of
the Temple of Ramses II*), 1850, from the
book, *Egypte, Nubie, Palestine, et Syrie*, 1852
Salted paper print from paper negative
8 1/4 x 6 1/2 in. (20.9 x 16.4 cm)
Gift of Eleanor and Van Deren Coke
72.142

**JULIA MARGARET CAMERON**

b.1815 Bengal, India
d.1879 Sri Lanka
*Rosalba,* 1867
Albumen silver print
23 x 18 in. (58.4 x 45.7 cm)
76.92

In the conservative atmosphere of Victorian England, Julia Margaret (Pattle) Cameron gained a sense of independence from her mother who maintained households in India, Paris, and England. Julia and her six sisters spent most of their youth near Paris with their maternal grandmother. Theirs was a liberal and informal education and the family inhabited a world of poets, writers, and artists. This upbringing would later play an important role in her life as a photographer.

In 1835 Julia met both Charles Hay Cameron who was a distinguished liberal reformer and Sir John Herschel, an astronomer and pioneer in photochemistry. Julia and Charles were married in Calcutta in 1838, and Herschel became a lifelong friend and mentor. In 1848 Julia, Charles, and their six children moved to England where she became a part of the artistic community.

At the age of forty-eight, Julia received the gift of a camera from her daughter and son-in-law and set out to pursue her interests in photography. A year later she wrote to Sir John Herschel: "My aspirations are to ennoble Photography and to secure for it the character and uses of High Art by combining the real and Ideal and sacrificing nothing of Truth by all possible devotion to Poetry and beauty."

Cameron joined The Photographic Societies of England and Scotland in 1864. She promoted and sold her own work, often financing her own exhibitions. Living on the Isle of Wight in Dimbola Lodge—her home and studio—she photographed the distinguished members of Victorian society including poets Robert Browning and Alfred, Lord Tennyson as well as friends, neighbors, and her family. The model in this photograph titled *Rosalba* is identified by Cameron as Cyllene Wilson, one of three orphaned children she and Charles adopted from their friend, the Reverend Wilson. As in this portrait, Cameron's subjects were often dressed in costume and were typically situated close up to the picture plane where they occupy the whole space. She referred to portraits such as this one as "Life sized heads" and wrote ".....they lose nothing in beauty & gain much in power."
—BKV

## THOMAS MORAN

b.1837 Bolton-le-Moor, Lancashire, England
d.1926 Santa Barbara, California
*Mountainous Gorge,* 1869
Ink and wash drawing
10 5/8 x 17 3/4 in. (27 x 19.6 cm)
67.64

"**P**rint the legend!" So advises the crusty old newspaper man in the classic western film, *The Man Who Shot Liberty Valance,* when asked what to do if the facts don't support a popular mythology. Thomas Moran—born in a grubby industrial town in England—became, as much as anyone else, the author of the visual legend of the American West: vast, unpopulated spaces, with towering mountains and turbulent skies. Moran's *Grand Canyon of the Yellowstone* (over 7 by 12 feet in size), called in one newspaper account "the finest historical landscape yet painted in this country," sold in 1872 to the United States government for the then-staggering sum of $10,000. Wood-engraved illustrations after his designs appeared in almost all major American periodicals in the 1870s and 1880s, making Moran the principal visual interpreter of the West in those post-Civil War decades.

Our *Mountainous Gorge* dates from 1869, which is two years before the artist first ventured out to Yosemite, the Tetons, New Mexico, and Arizona. Where, then, might the artist have encountered such dramatic scenery, such dramatic combinations of rocks, trees, and clouds? Not anywhere around Philadelphia, where the Moran family had settled in 1845. Nor does it resemble anything that Moran might have seen in Europe, which he visited on several occasions, beginning in 1862. It is, one must conclude, fantasy or legend, rather than a factual record of a specific place.

If, then, *Mountainous Gorge* is the product of Moran's imagination, that imagination, in turn, was forever transformed during the artist's first trip back to his native England. It was in the summer of 1862 that Moran spent many days in the National Gallery in London, faithfully copying the great Romantic landscapes of his hero, Joseph Mallord William Turner (1775-1851). Though it is not dependent upon any specific model in Turner, our *Mountainous Gorge* clearly evidences Moran's admiration and devoted study of the Englishman's paintings and drawings. Above all, Moran learned from Turner how to not just represent nature's effects, but to emulate and even to embody them in the physicality of his art. The rough, active surface of our wash drawing exudes the very smell and feel of landscape.                —PW

AFTER **THOMAS MORAN**

*Walls of the Grand Canyon,* n.d.
Wood engraving
9 1/8 x 6 1/8 in. (23.3 x 15.7 cm)
Gift of Dr. Robert M. Bell and
Dr. Stirling M. Puck
91.67.45

**PAUL SIGNAC**

b.1863 Paris, France
d.1935 Paris, France
*Application du Cercle Chromatique de Mr. Ch. Henry*, 1888
Lithograph
6 1/4 x 7 1/4 in. (16 x 18.6 cm)
96.39.1

**PAUL SIGNAC**

*Le Soir* (*Evening*), 1898
Lithograph
7 5/8 x 10 in. (19.5 x 25.4 cm)
Purchased with funds from the Friends of Art
66.202

Modest in size, Paul Signac's *Application du Cercle Chromatique de Mr. Ch. Henry* (illustrated opposite in its actual dimensions) lies at a particularly vital intersection of late 19th-century French art, science, and literature. Its artist, Paul Signac, was, with his close friend Georges Seurat (1859-1891), a leader in the newest style, Neo-Impressionism. Building upon the advances in color and light made by the Impressionists, the younger Neo-Impressionists wished to be more scientific in their theory and practice of color: they championed the splitting of color into its component parts, which they called "divisionism." They were also more regular in their application of paint: in the late 1880s, both Seurat and Signac favored minute dots of paint, which they called "pointillism." In later works by Signac (such as his *Le Soir* of 1898, illustrated above), these dots evolved into mosaic-like blocks of color.

Charles Henry (1859-1926), whose book on color theory this card advertises, was one of the great polymaths of his (or any other) day: versed in mathematics, chemistry, physics, psychology, Asian religions, and aesthetics; fluent in Greek, Latin, Sanskrit, and German; by age twenty, author of learned articles in both the *Revue archéologique* (on Descartes) and the *Bulletin des sciences mathématiques* (on the square roots of two and three); friend of leading critics and poets (Félix Fénéon, Gustave Kahn, Jules Laforgue); lecturer at the Sorbonne (where Seurat and Signac both sat in attendance)—Henry, by all accounts, possessed a dazzling intelligence.

And Signac was his closest disciple, providing illustrations for Henry's various books on aesthetics. Here, he advertises Henry's *Cercle Chromatique* (Paris, 1889) and, at the same time, applies Henry's principles in the composition of the central circle. Henry's color circle had two distinguishing features which also crop up in Signac's illustration: the color red is at the top, and from a central light area the colors move out to black. As Clinton Adams has pointed out (in his handbook/history of 19th-century lithography, based on our collection), only that central area was hand drawn by Signac; the colors of the border and the letters show the mechanical dot pattern used by professional colorists employed by Eugéne Vernau's shop, in which this placard was printed.

The "T-L" refers to the Théâtre-Libre, an experimental little theater run by André Antoine and then in its second season. Antoine, perpetually short of funds, evidently cut a deal: he printed the programs for several of the eight evenings of his 1888-1889 season on the backs of these Signac-Henry placards. Our example has on its reverse the program (plays by Henry Céard and Jean Jullien) presented on January 31, 1889. Perhaps both the impresario and the aesthetician recognized that they shared audiences with similar avant-garde tastes.

—PW

**EADWEARD MUYBRIDGE
(EDWARD JAMES MUGGERIDGE)**

b.1830 Kingston-on-Thames, England
d.1904 Kingston-on-Thames, England
*Glacier Rock, No. 27*, from the series
*Valley of the Yosemite*, 1872
Albumen silver print
16 3/4 x 21 1/4 in. (42.5 x 54 cm)
Gift of the Mattis Family Collection
94.24.1

Eadweard Muybridge and Carleton Watkins are the two pre-eminent photographers of the California landscape; both achieved fame with views of the Yosemite Valley. In 1872, Muybridge made a series of mammoth plate views that were seen as a challenge to the views made by Watkins in 1865-1866. When Muybridge won the medal of progress at the Vienna International Exposition, he was catapulted into international prominence and the comparison (and competition) with Watkins was made explicit.

As Muybridge's reputation grew, Watkins found himself first facing bankruptcy and the loss of his studio and negatives and then working on commission for Collis Huntington, the owner of the Central Pacific Railroad. His photograph of the steamer *Solano* was such a commission. The *Solano*, the largest steam ferry in service, took Central Pacific Railroad cars across the bay, thus saving the time associated with the long overland circuit by way of Stockton into San Francisco. Watkins's photographic van, partially hidden on the dock, bears the legend, "Yosemite Gallery." Its inclusion is particularly poignant because Watkins was to lose the gallery and his negatives to his investors that year.

Both Muybridge and Watkins participated in the rush to photograph the natural grandeur of California. Their photographs are intimately tied to the paradox of America's response to landscape as both a source of national pride in its sublime beauty and a recognition of its possibilities as an exploitable resource. Both photographed the industrial and technological dynamo that was California. Governor Stanford commissioned Muybridge to provide photographic evidence of the gait of a trotting horse. And it was Stanford who proposed the gigantic ferry *Solano* as a railroad connection that Huntington commissioned Watkins to photograph as a paean to the rich possibilities of California. The move from the celebration of pristine landscape to the celebration of industrial might is encompassed in the work of these two photographers over less than twenty years.

—KSH

**CARLETON WATKINS**

b.1829 Oneonta, New York
d.1916 San Francisco, California
*Steamer Ferry* Solano *Discharging Train,
San Francisco Bay at Port Costa,* 1876
Albumen silver print
14 3/4 x 21 in. (36.5 x 53.5 cm)
The Beaumont Newhall Collection. Purchased
with funds from the John D. and Catherine T.
MacArthur Foundation
87.19.1

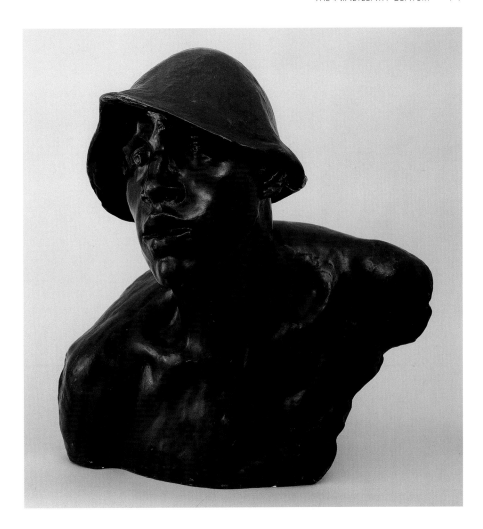

## CONSTANTINE EMILE MEUNIER

b.1831 Etterbeck, Brussels, Belgium
d.1905 Exelles, Brussels, Belgium
*Le Puddleur,* c.1889
Bronze
19 3/8 x 20 1/2 x 19 3/4 in.
(49 x 52 x 50 cm)
Purchased with assistance from
Mr. and Mrs. Gene Calkins
74.391

With Rodin, the most internationally famous of late 19th-century sculptors, Meunier started his artistic career as a painter. From early on, he searched for a realist style suitable to record every-day life and common people. His paintings of the 1860s and 1870s featured peasants and Trappist monks. In 1878, quite by chance, he visited the industrial area of Wallonia and experienced something close to an epiphany: he had found his life subject-matter, the modern world of steel mills and industrial workers.

Critics were astonished when, in 1885, he exhibited his first works representing the mill hands, for with a few paintings were five bronze sculptures. Meunier never explained why, in mid-career, he turned to sculpture (which quickly became his preferred medium). Perhaps he felt it appropriate to represent these laborers in a metallic medium, like unto that with which they themselves worked. Perhaps also he wished to imbue his subjects with the heroic properties traditionally—since antiquity—associated with bronze portrait sculpture. At least one contemporary critic, Julius Meier Graffe, quickly seized upon this analogy, writing that Meunier treated the worker "as the ancients had treated their Zeus, their Hector, their David."

*Le Puddleur* represents one of the workers at the Cockerill steel mills in Seraing, outside of Liège, which Meunier visited in 1884. The puddler's job is to convert molten pig iron into malleable wrought iron by constantly stirring it in the presence of oxidizing substances. A hotter, more backbreaking, more monotonous, and generally more disagreeable job can hardly be imagined. "Lodged in fact" is how Emile Verhaeren (one of the great art critics of the 1890s) described Meunier's workers, and certainly the almost brutish features of our puddler reflect the sub-human conditions under which he has toiled. At the same time, he raises his head and his eyes and, again in Verhaeren's words, "affirms himself as real, alive, and tragic."

We are today still stirred by this empathetic social message; we equally respond to the liquid, luscious surfaces of Meunier's bronze. Tracked into it are the very fingerprints of the artist, as his hands worked the original wax medium from which it was cast. Meunier the social conscience and Meunier the aesthete happily coincide; it is as if Charles Dickens and Henry James were one and the same.    —PW

## THÉOPHILE-ALEXANDRE STEINLEN

b.1859 Lausanne, Switzerland
d.1923 Paris, France
*La Rue,* 1896
Lithograph
92 3/4 x 120 3/4 in. (235.3 x 306.4 cm)
Julius L. Rolshoven Memorial Fund
68.153

One reaction on viewing this enormous (and enormously impressive) lithograph: what a miscarriage of poetic justice. "Steinlen" in German means "little stone," whereas the stones—twenty-eight of them, in all—needed to create this work each measured roughly 4 1/2 by 3 1/2 feet. Even today, lithographers whistle in amazement when they see what this medium produced more than a century ago.

Steinlen created *La Rue* as an advertisement for the technical expertise available at his friend Charles Vernau's printshop. The lifesize figures are printed on six sheets of paper, joined together to depict a bustling Paris street. The four left and center sheets ultimately received five different colors (each from a separate stone); the two right sheets,

four each. Our impression is a rare early proof, before the blue stones which provided both lettering and various patterns (on, for example, the cloth covering the laundry basket).

Beyond the technical achievement, *La Rue* also speaks eloquently to the art and the social conscience of its creator. Trained initially in his native Switzerland, Steinlen arrived in Paris in 1881. He quickly gravitated to the burgeoning artistic district of Montmartre, and especially to the lively crowd of avant-garde artists and writers who frequented the Chat Noir cabaret. The common thread was politics, of a sometimes extreme left-wing sort; this was a time of anarchists, of bomb-throwing anti-establishment activism, of writers such as Emile Zola and Guy de Maupassant who experimented in new forms appropriate to urban life and championed the causes of the poor, the oppressed. Steinlen found his spiritual home in this place and among these people, and here he lived and worked for the rest of his life.

In *La Rue* we find the typical cast of Steinlen characters. Working class laborers and the laundry woman on the left contrast with the fashionably-dressed shoppers and the corpulent middle-class gent on the right. Out in the city street, the new democracy prevails, as these citizens literally rub shoulders with one another. The verve of Steinlen's drawing captures the new velocity of urban life.                    —PW

**EUGENE ATGET**

b.1857 Libourne, France
d.1927 Paris, France
*Intérieur de photographe* (*The Photographer's Studio*),
from the series *Métiers, boutiques, et étalages de Paris,*
(*Trades, shops, and shop displays of Paris*), c.1900
Albumen silver print
8 1/2 x 7 in. (21.5 x 17.6 cm)
The Beaumont Newhall Collection. Purchased with funds from
the John D. and Catherine T. MacArthur Foundation
88.15.1

For over fifty years, Eugene Atget recorded the physical fabric of Paris. The sign hanging on his door on the rue Campagne advertised "*Documents pour artistes,*" and he considered himself a tradesman providing photographic documents for the use of artists, set designers, and illustrators. His business might be seen as the precursor of modern stock photography services.

Atget photographed his own studio as the business establishment of an anonymous tradesman, a photographer, and he filed the photograph in the album labeled *Métiers, boutiques, et étalages de Paris.* (Atget organized groups of photographs under general headings and placed them in albums as a way to control his vast archive and to make pictures available to his clients.) Although acclaimed as a modernist master of photography, Atget saw himself as a tradesman making and selling photographs. When Man Ray negotiated with him to use his photograph *L'Eclipse* as the cover for the surrealist journal *La Révolution Surréaliste,* Atget refused the credit line common to artists. He said, "Don't put my name on it. These are simply documents I make."

The photograph of Atget's studio shows the stock in trade of his business—the lettered pigeon-holes in which he organized the views he sold. A copy of Rochegude's guidebook, *A Travers le Vieux Paris,* a book that Atget used to identify locations to shoot, is tucked into the shelves. A stack of paper albums sits on the table; the top one labeled *IIeme Serie Vieux....* The worktable at the left is loaded with the paraphernalia for making photographs, bottles and jars of chemicals sit on shelves and ledges, and the corner is a jumble of reproductions, a calendar girl, and Gervex's *Avant l'operation* (1887). The photograph of Atget's work space joined other photographs of Parisian working spaces—a ceramist's shop, a fish merchant's display, a bakery, a news kiosk—the working heart of Paris.
—KSH

## GERTRUDE KÄSEBIER

b.1853 Des Moines, Iowa
d.1898 New York, New York
*Adoration*, 1899
Gum bichromate print
11 1/2 x 8 7/8 in. (29 x 22.4 cm)
Gift of Mrs. Hermine M. Turner
72.490

Gertrude Käsebier's biography is a quintessentially American story of achievement. Born in the Midwest, raised in a Colorado mining camp, she opened her own portrait studio in New York, and in 1900 was described in *Camera Notes* as "beyond dispute the leading portrait photographer in this country." She became a photographer after a brief stint studying portrait painting at the Pratt Institute in New York City. Käsebier saw the possibilities inherent to photography and traveled in Europe to learn the finer nuances of chemical control of the process, as did her mentor Alfred Stieglitz.

Throughout her career, she blended the commercial demands of a studio practice that produced "artistic" portrait photographs for a privileged clientele and the pursuit of photographic art. In 1897, the year she opened her business, she submitted fifteen studies to the exhibition of the Boston Camera Club. In 1900 she joined the New York Camera Club, then under the control of Alfred Stieglitz. They had much in common in their aspirations for a photographic art that was distinct from the easily produced, and soulless, pictures available with contemporary technology. The Pictorialists, as the group of photographic artists came to be known, emphasized making pictures, objects which by their content and their presentation met the standard of fine art.

In *Adoration*, one of a group of photographs made in 1899 under the general title of *Mother and Child*, Käsebier explores a subject common to Western art and one that contemporary artists, such as her countrywoman Mary Cassatt, continued to mine. She presented her image in the newly developed gum bichromate process in which the photographic image is printed in pigments on roughly textured art paper. The gum print could not be further from the flat, glossy surface of commercial photographic papers. It permitted the photographer an extraordinary degree of control over the final image because the photographer could remove areas of the image selectively by washing the gum off the print. The interaction of the gum pigment and the texture of the paper produced an image that approximates a crayon or charcoal drawing. It was a hand-wrought object with no hint of commercial technology.                —KSH

**THEODORE EARL BUTLER**

b.1860 Columbus, Ohio
d.1936 Giverny, France
*Sunset, Veules-les-Roses,* 1909
Oil on canvas
25 3/4 x 31 3/4 in. (65.4 x 80.6 cm)
Gift of Mr. and Mrs. Harry William Hind
79.34

Back before the ubiquity of color film, Hollywood directors used a special glass to view in black-and-white the scene they were about to shoot, to make certain that the pertinent features would stand out without the benefit of contrasting hues. To see what a difference this could make, check the color reproduction of Theodore Earl Butler's *Sunset, Veules-les-Roses* against the small black-and-white one: the whole sea and sky—so alive with blues, pinks, and oranges—virtually disappears! This little demonstration proves the contention of the Impressionists that color and light are one and the same, and that form depends entirely upon this colored light.

Butler came by his Impressionist style very directly; he was Claude Monet's son-in-law. It was in 1888 that another young American artist studying in France, Theodore Robinson, introduced Butler to Monet, who was at that time living in seclusion in the tiny Norman village of Giverny. Robinson would later paint the wedding day in July of 1892 when Butler married Monet's stepdaughter, Suzanne Hoschedé-Monet, in the village church at Giverny.

Butler took from his famous father-in-law his high-keyed colors, his brillance of light, and the broken strokes of paint with which he weaves the surface of his canvas. There is, perhaps, just a hint of the Neo-Impressionist style (of, e.g., Seurat and Signac) in Butler's somewhat more regular touches of paint, when compared with Monet's softer meldings. But this is, on the whole, about as close to Monet as any other artist consistently came.

Something else Butler took from Monet: the tendency to paint in series, recording a single subject over a variety of light and atmospheric conditions. This was Monet's prime way of painting since 1890, the start of his *Haystack* series. In 1909, Monet exhibited his *Waterlily* series (on which he had worked from 1903 to 1908) at Durand-Ruel's gallery. Butler's *Sunset, Veules-les-Roses* (painted on the coast of Normandy, not far from Giverny) probably belongs to a group of eight paintings of this title, all exhibited in December of 1909 at Bernheim Jeune's gallery in Paris.

—PW

Early Modern Art in Europe and the United States

## EARLY MODERN ART IN EUROPE AND THE UNITED STATES

Fittingly, this section contains both a photograph by Alfred Stieglitz and a watercolor and a painting by Georgia O'Keeffe. They were, of course, husband and wife. And O'Keeffe was one of the many young American artists whose careers were launched by Stieglitz at his famous 291 gallery in New York. For the University of New Mexico Art Museum, featuring Stieglitz and O'Keeffe in this section on early modern art has special meaning. We are, of course, a museum heavily concentrated on photography, and thus to highlight a Stieglitz photograph seems particularly appropriate, he being the greatest early 20th-century champion of photography as a fine art. For us, O'Keeffe also has specific resonance. Despite her great fame in the wider world, O'Keeffe never received a one-person exhibition of her work in her adopted state of New Mexico, until the University of New Mexico Art Museum—just three years after its founding—provided her with one in 1966. She, very generously, rewarded us by allowing the purchase, at well below her then-prevailing prices, of her pivotal early watercolor, *Tent Door at Night* (which she had exhibited at her first-ever, one-person exhibition: in 1917 at 291!).

The reason why this museum mounted that O'Keeffe exhibition was and is abundantly clear: while other museums in the state ran away from Modernism, we embraced it. Founding director Van Deren Coke mounted important early exhibitions devoted to the art of B.J.O. Nordfeldt, Cady Wells, Andrew Dasburg, John Marin, and many other Modernist artists who worked in this state, and who had been largely ignored by other New Mexico museums. But also from the beginning, our mission was emphatic in not viewing New Mexican Modernism in isolation. In 1977, culminating more than a decade of collecting early American abstract art, we mounted the first museum retrospective of the American Abstract Artists, an important group of mainly New York-based artists, established in 1936. We also, within our limited budget, collected work (mainly on paper) by leading European Modernists.

Looking through the artists of this section, one sees the fruits of this internationalism: works by Europeans (Beckmann, Kandinsky, Léger, Lucia Moholy and László Moholy-Nagy, Picabia, Picasso, and Schmidt-Rottluff) provide a context for works by such Americans as Bengelsdorf, Hiler, James, Knee, Marin, Morris, O'Keeffe, Sheeler, Strand, and Zorach. Equally celebrated are Modernist works by that talented wave of immigrants: Genthe, Graham, Kantor, Kelpe, Lozowick, Matulka, Walkowitz, and Weber. Finally, there is the recurring sub-text of how Modernism and the Modernists (especially, Graham, Marin, and Morris) consciously responded to Native American art. Thanks to our heritage of exhibitions and collecting, the University of New Mexico Art Museum is well-positioned to celebrate the messy vitality of Modernism, on both continents and in a wide variety of mediums.

## FERNAND LÉGER

b.1881 Argentan, France
d.1955 Gif-sur-Yvette, France
*Le Vase*, 1922
Lithograph
20 3/4 x 17 1/8 in. (52.7 x 43.5 cm)
Julius L. Rolshoven Memorial Fund
74.406

Léger came of solid, not to say stolid, Norman stock: his father was a cattle breeder, and Léger's face—in photographs made throughout his life—had a bluff engaging honesty. But early on, the young Léger became a devout enthusiast of the new pace and rhythm of the so-called Machine Age. The first automobile, the first motion picture, the first airplane—each appeared during Léger's youth, and he embraced them all.

He had come to Paris as an architectural draughtsman, but in 1903-1905 switched his studies to art, and in the years just prior to World War I, Léger became one of the earlier (and more original) adherents of Cubism. He served in the Corps of Engineers during the war, and was gassed at the front. Yet he came out of these horrific circumstances more than ever wedded to the notion that mankind (and its art) must progress through the new technologies and machines.

In 1924, Léger attended adjacent exhibitions of art and of the newest in aviation, and he wrote of these contrasting experiences:

> I had come from vast dull, gray surfaces, stuck in pretentious frames, and here were beautiful hard, metallic objects, firm and useful, with pure local color—the infinite subtlety of the steel in active juxtaposition with the bright reds and blues; the whole was dominated by the geometric power of the forms.

Local color (especially the broad, uninflected brown of the vase—which was printed as a separate run) and geometric power are, of course, also hallmarks of *Le Vase*. It was Léger's first color lithograph, and impressive in size when compared with the prints by other French artists of the day. The majestic size was absolutely imperative: even today, the better part of a century after their creation, we accept these forms as celebratory of important forces unique to modern times.
—PW

## JOHN D. GRAHAM
### (IVAN GRATIANOVITCH DOMBROWSKI)

b.1881 Kiev, Ukraine
d.1961 London, England
*Red Bottle*, c.1930-1931
Oil on canvas
15 x 23 in. (38.1 x 58.4 cm)
Julius L. Rolshoven Memorial Fund
70.169

Graham once listed as his professions "judge, diplomat, librarian, dishwasher, porter, secretary, teacher of art, college professor, art dealer, artist, writer." Uncharacteristically for this great teller of tales, Graham left out "officer in the Czar's cavalry," in which capacity he had served during World War I.

Son of minor Polish aristocrats, Graham arrived in New York City in 1920, and shortly thereafter took up art (studying at the Art Students League under, among others, John Sloan), changed his name (Ivan to John, Gratian to Graham, and Dombrowski supplied his middle initial), and married for the third (or fourth?) time. Though short of stature, his was a commanding presence: photographs and eyewitness accounts both attest to his dandyish dress code (self-enforced even during periods of acute financial distress) and his hypnotic stare.

By 1930, he had formed a group with Stuart Davis and Arshile Gorky (the latter, another name-changed refugee); the three were dubbed, by the art world, "the Three Musketeers." Graham knew everyone. More importantly, he brought to a generation of American artists the messages that African and North American Indian art were to be taken seriously, that artists should examine closely theories of the subconscious, and—above all—that Picasso demanded their highest respect.

Graham painted our *Red Bottle* at the height of his allegiance to Picasso; it belongs to a small group of similar still lifes, including *White Pipe* (dated 1930, at the Grey Art Gallery, New York University), *Blue Abstraction* (dated 1931, at the Phillips Collection, Washington, D.C.), and *The Yellow Bird* (undated, at the Weatherspoon Art Gallery, University of North Carolina Greensboro). Highly derivative of Picasso's work from the late 1920s, it contains a typical inventory of Cubist forms: the red bottle (seen both from the side and—the opening—from above), one musical instrument (a guitar?) hovering above the table, and another (the white form, possibly a clarinet) flattened almost to pure abstraction atop the table.

Graham's most personal contribution lies in his exploration of textures: the thin, washy lines in the top third of the painting rest against almost bare canvas, and they contrast with the rich impastos of the central forms. Such textural plays would become a staple device of the New York abstract painters (many of whom revered Graham) in the 1940s and 1950s.                                    —PW

**LUCIA MOHOLY**

b.1894 Karolinthal, Czech Republic
d.1989 Zurich, Switzerland
*Dining Room, Moholy-Nagy House, Dessau*, 1927
Gelatin silver print
5 9/16 x 5 15/16 in. (14.1 x 15.1 cm)
The Beaumont Newhall Collection.
Purchased with funds from the John D. and
Catherine T. MacArthur Foundation
91.15.1

In art, as in other fields, there is often one "hot" city, where a critical mass of the best and the brightest have gathered together, and where the best young students come to learn and to bask in the reflected glow. Rome was such an art city in the 1760s, Paris in the 1870s, and New York in the 1950s. For seven magical years, 1925-1932, Dessau was as hot as it gets. A bustling industrial city in east-central Germany, Dessau prior to 1925 enjoyed no particular artistic distinction. But in that year, the Bauhaus relocated to Dessau, and suddenly artists and students from all over Germany— and from Russia, the Netherlands, Hungary, France, and just about every other European country—flocked there to be part of what was arguably the greatest, most influential art institution of the 20th century.

Founded by the architect Walter Gropius (1883-1969) in 1919 in Weimar, Germany, the Bauhaus (the name derives from the *Bauhütten*, which were medieval masons' lodges) featured workshop-based training for artists, architects, and industrial designers. All took the same preliminary courses, focussed on abstract principles of design; part of the utopian mission of the Bauhaus was to erase distinctions between fine and applied art, between art and architecture, between craft and industrial design.

Lucia Moholy and her husband, László Moholy-Nagy, came to the Bauhaus in 1923; he (to that point, primarily a painter and graphic designer) headed the preliminary design course; she assisted him in his new photographic experiments and documented in her own photographs both the people of the Bauhaus and the amazing reinforced concrete, steel, and glass buildings which Gropius designed for their new Dessau quarters. Our photograph is one of several variants, showing Moholy-Nagy's own dining room in the faculty apartment complex. The chairs and table were designed by Marcel Breuer (first student, then faculty member), while the painting on the wall is by Moholy-Nagy. Though now three-quarters of a century old, these coolly geometric spaces and objects still seem contemporary (the Breuer chairs remain in production!). The Bauhaus set—and continues to set—the standard for modernity in art, architecture, and design.                              —PW

**LÁSZLÓ MOHOLY-NAGY**

b.1895 Bacsbarsod, Hungary
d.1946 Chicago, Illinois
*Untitled*, c.1928
Gelatin silver print (photogram)
14 7/8 x 10 7/8 in.
(37.6 x 27.7 cm)
Gift of Beaumont Newhall
74.435

Even if he had never made a single work of art, Alfred Stieglitz would still be at the very top of any list of those responsible for bringing American art into the 20th century, and for bringing photography into equal consideration with the more traditional mediums. It was Stieglitz who, at his 291 gallery (so-named for its address on New York's Park Avenue) in the years 1905 to 1917 first brought to American audiences works by Picasso, Braque, Matisse, Rodin, and the like. Most ambitious young American artists flocked to these path-breaking exhibitions, and many asked Stieglitz to review their own portfolios. He offered advice and encouragement, and the list of artists he invited to exhibit at 291 is an honor role of extraordinary talents: John Marin, Marsden Hartley, Arthur Dove, Georgia O'Keeffe, and Max Weber, among others.

In photography, Stieglitz was both an enabler of other artists (most notably, Paul Strand) and a propagandist for the medium. The two journals which he edited—*Camera Notes* and, even more famously, *Camera Work*—beautifully reproduced the art of leading American and European photographers. Stieglitz was also a formidable talent in his own right, moving over the course of his long photographic career from the softly sentimental to works which embraced the new spirit of Modernism. *The Flat-iron Building*, captured during a blizzard, was one of his key images; of its genesis, he wrote:

> *I stood spellbound as I saw that building in that storm. I had watched the structure in the course of its erection. But on that particular snowy day, I suddenly saw the Flat-iron building as I had never seen it before. It looked, from where I stood, as if it were moving toward me like the bow of a monster ocean steamer, a picture of the new America which was still in the making.*

Francis Picabia, one of the many younger European artists whom Stieglitz befriended, created a wonderful, slightly sad, "portrait" of Stieglitz, as a camera (based on the vest pocket Kodak) reaching for the ideal, but slumping exhausted to one side. Certainly, for five crucial decades, Stieglitz gave his all for the cause of modern art.    —PW

## ALFRED STIEGLITZ

b.1864 Hoboken, New Jersey
d.1946 New York, New York
*The Flat-iron Building*, c.1903
Platinum print
6 5/8 x 3 3/8 in. (16.8 x 8.2 cm)
Gift of Mr. Ferdinand Hinrichs
76.193

## FRANCIS PICABIA

b.1879 Paris, France
d.1953 Paris, France
*Ici, c'est ici Stieglitz*
(*Here, here is Stieglitz*),
1915
Linocut
14 3/4 x 10 3/4 in.
(37.5 x 27.3 cm)
74.150.1A

**GEORGIA O'KEEFFE**

b.1887 Sun Prairie, Wisconsin
d.1986 Santa Fe, New Mexico
*Tent Door at Night*, c.1913-1917
Watercolor
19 x 24 3/4 in. (48.3 x 62.9 cm)
Purchased with funds from the Julius L.
Rolshoven Memorial Fund and the
Friends of Art
72.157

O'Keeffe's *Tent Door at Night* presents an enduring mystery: just exactly when was it made? The reason why we want to answer that question is pretty simple: *Tent Door at Night* is one of the earliest (and one of the most powerfully convincing) American near-abstractions, and we want to know whether it came out of, or predated, O'Keeffe's association with Alfred Stieglitz. The artist, from whom this watercolor was directly purchased, was very emphatic: she said that she painted it in 1913, while on a camping trip in the Great Smokies. What we know for certain is that she showed it from April 3 to May 14, 1917, in the very last exhibition mounted by Alfred Stieglitz at his famous 291 gallery. A photograph, by Stieglitz, shows *Tent Door at Night* hanging on the wall, surrounded by other, easily identifiable watercolors and drawings by O'Keeffe.

Most historians who have looked at a lot of O'Keeffe watercolors think that *Tent Door at Night* was probably done around 1916-1917. This is, first of all, the date of most of the other works in that 1917 exhibition at 291. And, while none of those other works looks exactly like *Tent Door at Night*, many of them share its rich, deep blue. Finally, it was only by 1916 or thereabouts that O'Keeffe had been exposed, through Stieglitz, to the art and ideas of Picasso, Braque, Hartley, and Marin. How could she have made such a boldly abstract work as early as 1913? historians argue.

Maybe, just maybe, through her knowledge of Arthur Wesley Dow's art and theory. O'Keeffe re-started her faltering career as an artist in 1912, when she attended a summer art class at the University of Virginia taught by Alon Bement. A professor of art at Columbia, Bement was a disciple of Dow, and introduced O'Keeffe to Dow's ideas and to two of Dow's very influential books: *Theory and Practice of Teaching Art* (which she purchased) and *Composition* (which she couldn't afford). Dow pushed notions—derived from his study and appreciation of Japanese art—of simplification of forms and bold contrasts of light and dark. Intriguing, indeed, is the close similarity between *Tent Door at Night* and one of the woodblock illustrations in Dow's book, *Composition*. Could it be that Dow, rather than one of the Stieglitz circle of artists, was on O'Keeffe's mind when she painted *Tent Door at Night*? We'll never know. But at very least we ought not to reject her claim of a 1913 date for her watercolor.          —DRG

Detail from plate 27 of Dow's *Composition*.

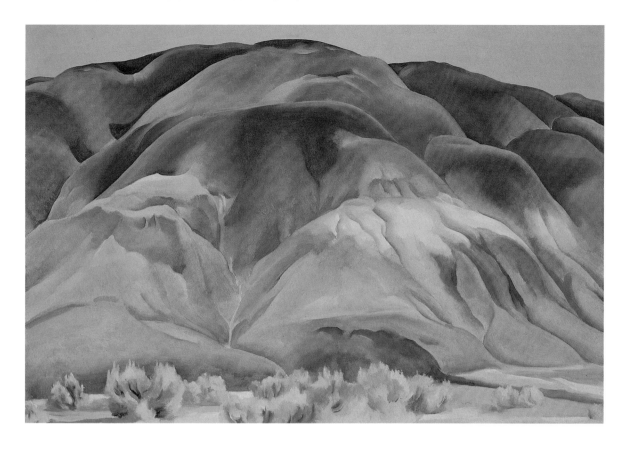

## GEORGIA O'KEEFFE

b.1887 Sun Prairie, Wisconsin
d.1986 Santa Fe, New Mexico
*Grey Hill Forms*, 1936
Oil on canvas
20 x 30 in. (50.8 x 76.2 cm)
Gift of the Estate of Georgia O'Keeffe
P87.1

O'Keeffe first encountered New Mexico (and, it is safe to say, vice versa) in 1917. She was then head of the art department of West Texas State Normal College in Canyon, Texas, and detoured through Santa Fe on her way to Colorado. "I loved it immediately. From then on I was always on my way back." That way back took a dozen years: it was in 1929 that she, accompanied by Rebecca Strand, summered in Taos as one of several guests of Mabel Dodge Luhan. But once O'Keeffe started in on New Mexico in earnest, she quickly made the landscape so much her own that even today it is almost impossible to view our northern regions except through her art.

In 1934, fleeing from the social whirl around Mabel Dodge Luhan in Taos, O'Keeffe discovered Ghost Ranch in the Chama River valley. A sort of dude ranch for the rich and famous (conductor Leopold Stokowski and Johnson & Johnson heir Robert Wood Johnson were among the regulars), Ghost Ranch featured an easy informality, relative anonymity, and access to some drop dead gorgeous scenery. O'Keeffe boarded there from 1934 through 1937, at which point she bought her own house.

*Grey Hill Forms* depicts a sandy range in Navajo country, some 150 miles northwest of Ghost Ranch. Once O'Keeffe discovered this spot, she returned time and again. "Those hills! They go on and on—it was like looking at two miles of grey elephants," she later recalled. As is typical of O'Keeffe's landscapes, she gives us little clue as to scale or perspective. A few foreground junipers, then a jump (how far back?) to the hills, softly washed with a rainbow of colors.

This was one of O'Keeffe's favorite paintings, as she indicated by inscribing the backing board with a big five-pointed star, in which she placed her approving initials "OK." That same backing board also bears the label of An American Place: Alfred Stieglitz's (last) New York City gallery, in which *Grey Hill Forms* was exhibited in February and March of 1937. All in all, a lovely pedigree for this striking example of her mature landscape style. —PW

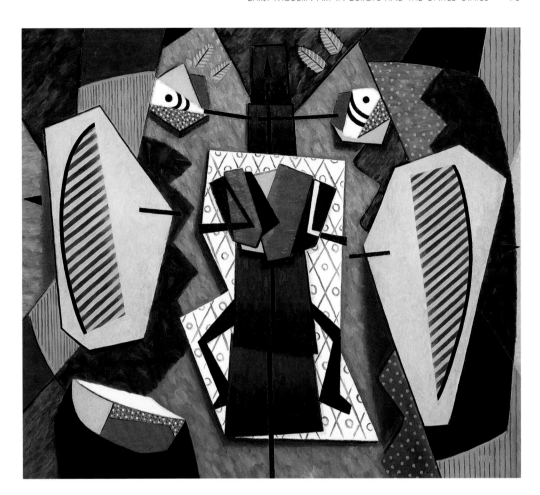

**GEORGE L. K. MORRIS**

b.1905 New York, New York
d.1975 New York, New York
*Indians Hunting #4*, 1935
Oil on canvas
34 5/8 x 39 in. (87.9 x 99.1 cm)
Purchased with funds from
the National Endowment for the
Arts, with matching funds from
the Friends of Art
74.319

In 1973 the University of New Mexico Art Museum received a grant from the National Endowment for the Arts (one of a series of such grants from those years) to fund—with matching local donations—the purchase of works by living American artists. Our commitment to American Modernism being firmly established, director Van Deren Coke located *Indians Hunting #4* by the leading American Modernist George L. K. Morris as a possible purchase, and wrote the artist, asking the circumstances of that painting's creation. Morris replied:

*I spent some time in Santa Fe in the thirties, and explored the Indian pueblos between San Ildefonso and Acoma, all the while filling notebooks with sketches of design fragments which interested me. I also noted the designs of the northwest Indians, and even those in the East. I selected those which seemed to fit into the plastic scheme of the work on which I was engaged. As the painting in question came shortly after my trip to New Mexico, the chances are that the influence was that of the Southwest. But of course I can't be sure, as the work was executed in my New York studio on my return—where all my notebooks were at my disposal.*

Morris, an American blueblood (he was educated at Groton and Yale, and descended from General Lewis Morris, a signer of the Declaration of Independence), was an internationalist in matters of art; he studied with Léger in Paris in 1929-1930, and kept very much in touch with up-to-date currents in European painting. A 1935 visit to the Paris studio of Robert Delaunay prompted Morris's turn to pure abstraction. Subsequently, he was one of the founding members (and, later, long-time president and chief spokesperson) of the American Abstract Artists.

But at this point in his career, he was struggling to create an art that could be at once both modern and specifically American. Like many of his near-contemporaries (John Sloan, Barnett Newman, Jackson Pollock) he turned to the art of Native American peoples to find both an appropriate subject matter and an appropriate style. His "Indo-Cubism"—flattened, geometric forms, with specific references to Native American imagery—resulted from this quest. Though perhaps more at home in a steel-and-glass building by Le Corbusier than in a kiva, it still represents—in colors vivid and forms energetic—this important moment in early American Modernism.    —PW

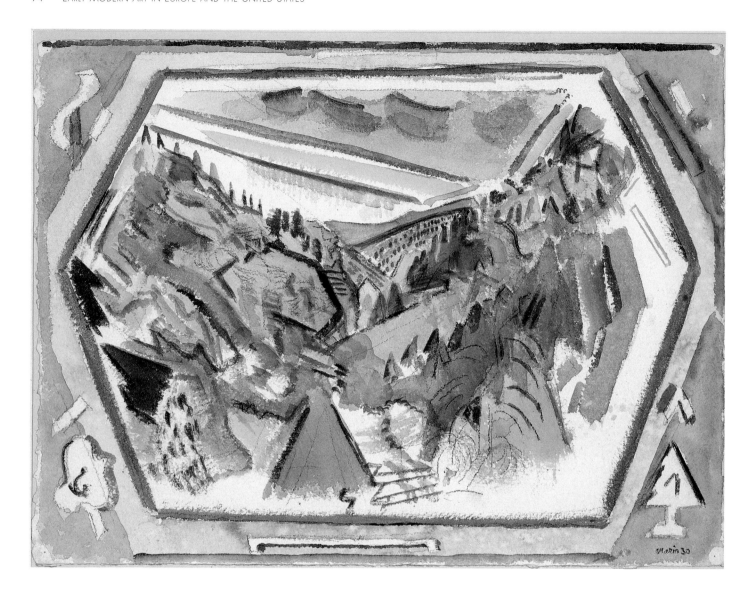

# JOHN MARIN

b.1870 Rutherford, New Jersey
d.1953 Cape Split, Maine
*Little Canyon, New Mexico*, 1930
Watercolor
15 1/2 x 21 in. (39.4 x 53.3 cm)
Julius L. Rolshoven Memorial Fund
66.136

Arguably the best American artist of the first half of the 20th century (and—beyond reasonable argument—the best watercolorist of that bunch), John Marin spent two intensely productive summers in New Mexico. Mabel Dodge Luhan invited him out in 1929, at the instigation of Georgia O'Keeffe (who knew Marin well, not the least because of his long association with her husband, Alfred Stieglitz's 291 gallery). In a 1968 letter to Van Deren Coke, O'Keeffe recalled:

> *Marin was a very casual sort of person. When I was in Taos, Mabel said to me one day, "We must get some other interesting people here—who shall we ask?" I suggested Marin. Her answer was, "Oh, he isn't interesting, is he?" I assured her that I thought he was, so she said, "well, let's wire him to come." When he got the wire he packed up and came.*

Casual or not, Marin produced over one hundred watercolors during this 1929 stay in New Mexico and a return visit in 1930. Many, like our *Little Canyon*, were painted near the streams of northern New Mexico; Marin liked to combine sketching expeditions with trout fishing, in companionship with three Taos painters, Ward Lockwood, Andrew Dasburg, and Loren Mozley, who showed him all the best spots.

Marin was a fully mature artist by this time, and his characteristic style—derived from Cézanne—of loosely brushed, open areas of paint, was already largely in place. Still, under the influence both of the landscape and the local Native American cultures, his style evolved in New Mexico, with profound significance both for the work he would do later back East, and for the New Mexican artists (Gina Knee, being but one among many) who followed his lead. Notice here the hexagonal interior frame—like the central field in Navajo rugs (which Marin admired and collected). Notice also the hieroglyphic devices in the corners of his watercolor: two trees in the lower corners, perhaps a winding road in the upper left. Marin wrote about his admiration for the symbolic expressions of natural forms found on Indian jewelry. Above all, note the sharp, angular facets into which the landscape is sliced. This look, fully consistent with the Pueblo design aesthetic, became for later artists *the* way to represent the New Mexico landscape.

—PW

**PAUL STRAND**

  b.1890 New York, New York
  d.1976 Orgeval, France
  *Marin Working (near Twining, New Mexico)*, 1930
  Gelatin silver print
  4 5/8 x 3 5/8 in. (11.7 x 9.2 cm)
  Inscribed, "Moment stolen by Paul Strand".
  Gift of Andrew Dasburg
  65.22

**GINA KNEE**

  b.1898 Marietta, Ohio
  d.1982 Suffolk, New York
  *Sun, Wind, and Stars*, c.1935
  Watercolor
  19 5/8 x 24 1/2 in. (49.8 x 62.2 cm)
  Gift of the artist
  77.83

**PAUL STRAND**

b.1890 New York, New York
d.1976 Orgeval, France
*The Dark Mountain, New Mexico*, 1931
Platinum print
4 5/8 x 5 15/16 in. (11.8 x 15.1 cm)
Gift of the Paul Strand Foundation, Inc.,
in honor of Beaumont Newhall
80.290

Paul Strand grew up in New York City, and as a high school student studied photography under the legendary photo-documentarian, Lewis Hine. While still in his teens, Strand began to haunt Alfred Stieglitz's 291 gallery, and show his photographs to the great man. In 1916, he had his first one-person exhibition at 291, and his first work published in *Camera Work*. Encouraged by Stieglitz, Strand moved even faster and farther toward the goal of "absolute unqualified objectivity" (Strand's own words, in a 1917 essay).

In 1922, Strand married Rebecca Salsbury—who was English-born, but as a child travelled the American West, courtesy of her showman father, the manager of Buffalo Bill's Wild West show. As "Beck" Strand, she became an intimate of Stieglitz and O'Keeffe, and began to try her hand at becoming an artist. In 1929, when she and Georgia were summering in Taos (as guests, naturally, of Mabel Dodge Luhan), she found her métier: reverse painting on glass. This was a folk medium in Europe and in New England, and both Wassily Kandinsky and Marsden Hartley had dabbled with the technique. But it was Rebecca Strand who learned how to take full advantage of the luminous quality imparted to oil paint when seen through glass.

Paul Strand joined his wife in New Mexico in the summers of 1930, 1931, and 1932. Already enamored of the vernacular architecture of rural Maine and Canada's Gaspé (where he photographed in the '20s), Strand quickly focussed his camera on the weathered adobe-and-wood structures of northern New Mexico. On his glass-plate negatives, he captured—and then printed on paper, often using the richly expressive platinum medium—"a range of almost infinite tonal values which lie beyond the skill of human hands" (Strand's words, again from his 1917 essay).

After the summer of 1932, the Strands went their separate ways, eventually divorced, and each married again. But that time together in New Mexico was spent creating some of the finer expressions of Early Modernism in American art: Rebecca's folk-inspired, monumentally simplified, reverse glass paintings, and Paul's exquisitely precise, yet emotionally charged photographs of the local architecture.                —PW

**REBECCA SALSBURY STRAND JAMES**

b.1891 London, England
d.1968 Taos, New Mexico
*Austerity*, c.1930
Oil on glass
24 1/2 x 17 1/2 in. (62.2 x 44.4 cm)
Gift of the artist   68.1

**CHARLES SHEELER**

b.1893 Philadelphia, Pennsylvania
d.1965 Dobbs Ferry, New York
*Side of White Barn*, c.1915-1917
Gelatin silver print
7 1/2 x 9 3/8 in. (19.1 x 23.8 cm)
Gift of Eleanor and Van Deren Coke
72.379

Later, Sheeler would best be known for his brawny images of American industry: steam locomotives and sprawling factories (as in his *Power House No. 1*, from a 1927 series celebrating the River Rouge plant of the Ford Motor Company, built to manufacture the new Model A). Such images—be they photographed or painted, and he did both, superbly—locate Sheeler firmly within the international style of spare, laconic Modernism, which flourished equally in Europe and the United States.

However, as this very early Sheeler photograph demonstrates, this great American artist came to maturity not in photographs of steel and iron, but rather in a series documenting the vernacular wooden architecture of Bucks County, Pennsylvania. Beginning probably in 1910, Sheeler and his close contemporary and fellow artist Morton Schamberg (1881-1918) rented an 18th-century stone farmhouse in Doylestown, not far from Philadelphia. Built by a Quaker, Jonathan Worthington, its spare aesthetic attracted both young artists. Sheeler began to photograph the staircases and other details in the mid-teens; soon, he moved on to record as well various of the old wooden barns in surrounding Bucks County. Our *Side of White Barn* comes from this series, of which Edward Steichen would later say in admiration, "Sheeler was objective before the rest of us were."

This new objectivity was very different from the soft-focus favored by the then-prevailing Pictorialist photographers. It pointed the way to a whole new generation: to Paul Strand, Edward Weston, Ansel Adams, and beyond. To, also, a whole generation of painters—Sheeler himself, Georgia O'Keeffe, and Charles Demuth among others—whose flatly composed, geometrically arranged images of the 1920s would later become known as Precisionism. One can, without being too farfetched, even see in this photograph the birth of an American 20th-century appreciation of the stripped down and the essential that would much later, in the 1960s and 1970s, find expression in the Minimalism of Don Judd and Agnes Martin.

A final note: in addition to Sheeler's signature, this photograph bears his hand-written inscription, "To Lt. F. V. D. Coke." It was a gift to the future founding director of the University of New Mexico Art Museum, who was during World War II serving in the U.S. Navy.    —PW

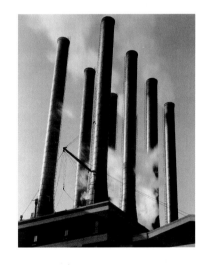

**CHARLES SHEELER**

*Power House No. 1 – Ford Plant,*
1927
Gelatin silver print
7 1/2 x 5 7/8 in. (19 x 14.9 cm)
Gift of Eleanor and Van Deren Coke
72.428

**KARL SCHMIDT-ROTTLUFF**

b.1884 Rottluff, Germany
d.1976 Berlin, Germany
*Frauenkopf (Head of a Woman No. 2)*,
1915-1916
Woodcut
6 3/4 x 9 3/8 in. (17.1 x 23.9 cm)
74.196

**MAX BECKMANN**

b.1884 Leipzig, Germany
d.1950 New York, New York
*Das Karussell,* 1921
Drypoint
11 5/8 x 10 in. (29.5 x 25.4 cm)
Julius L. Rolshoven Fund
70.19

Many art historians see western art, since as far back as the 17th century, as veering between two tendencies: the Apollonian (calm, measured, harmonious) and the Dionysian (frenzied, wild, orgiastic). In the early 20th century, these opposites are often identified as the defining characteristics of, on the one hand, Cubism and, on the other, Expressionism. One waggish critic claimed that all of 20th-century art was but a footnote to Cubism. Looking back at that century, it now seems possible to claim that Expressionism had as great an impact: it flourished in the first decade, revived again (as "Abstract Expressionism") in the middle years, and in the 1980s and 1990s became the style of many of the most vital young artists on both sides of the Atlantic.

Karl Schmidt-Rottluff helped to invent German Expressionism, and—particularly in his woodcuts—became one of its strongest and most characteristic exponents. Born in eastern Germany (in the town of Rottluff), he enrolled in architectural school in nearby Dresden in 1905. That same year, he participated in the founding of *Die Brücke* (The Bridge—the name came from a quotation in Nietzsche's *Also sprach Zarathustra*), which quickly became the most vital art movement in Germany. It was the shared ambition of *Die Brücke* members (some of them: Erich Heckel, Ernst Ludwig Kirchner, and Emil Nolde) to create an art uncompromising in its break from academic traditions. Their paintings in the period 1905-1911 (after which date, they began to go individual ways) shared a certain look: radically simplified forms, sharply angled geometries, broad areas of paint, bold colors, and flattened space.

Schmidt-Rottluff was a key participant in this painting style; he was the leader in defining an equivalent style in prints, and he quickly centered his printmaking on woodcuts. Note that he didn't use this medium for displays of technical virtuosity (as did such earlier German "fine" artists as Dürer and Goltzius). Rather, he harked back to a folk tradition of bold simplification and forceful contrasts of deep blacks against the white page. After World War I, artists such as Max Beckmann continued Expressionism, but bent it toward social commentary. In the early years, the pure power of the image was reason enough to make art.

—PW

**JAN MATULKA**

b.1890 Vlachovo Brezi,
Czech Republic
d.1972 Queens, New York
*Still Life,* c.1933
Ink and graphite
14 3/4 x 20 in. (37.5 x 50.8 cm)
77.94

Matulka had already studied art for two years in Czechoslovakia when he emigrated to the United States in 1907. From 1908 through 1917, he trained at the venerable (and staunchly conservative) National Academy of Design in New York; the ultimate award he won there, the Joseph Pulitzer Prize, funded a year-long journey of artistic self-discovery through Florida, the Bahamas, New Mexico, Arizona, and Mexico. He came back to New York a committed Modernist, apparently more the result of his exposure to Native American art and culture than to any contemporary painters with whom he might have rubbed shoulders.

In the 1920s and 1930s, Matulka journeyed extensively from his base in the United States, to Paris (where he maintained a studio from 1922 until 1934), to Czechoslovakia, and occasionally elsewhere in Europe. As a teacher at New York's Art Students League during the years 1929-1931, he brought his enthusiasm for both the avant-garde in Europe and the traditions of Native American peoples to his students, who included Dorothy Dehner, Burgoyne Diller, George McNeil, I. Rice Pereira, and David Smith—all of them luminaries in American art of the 1930s, 1940s, and 1950s, and all of them forever full of praise for Matulka.

Like Picasso, Matulka ranged widely and rapidly through various styles. An etching from 1923, *Untitled (Four Nudes in a Landscape)*, features heavily muscled women rendered with expressionistic verve. His *Sailors and Lifeboats* of c.1930, shows his fascination with nautical machinery (a fascination which he shared with many European and American artists of the 1920s and 1930s: for example, Le Corbusier and Ralston Crawford) and his mastery of a Cubism-inspired style of shorthand simplification of forms. Finally, this *Still Life* of c.1933, with its unlikely combination of objects quasi-human and mechanical, evidences Matulka's appreciation of Surrealism and, in particular, the Italian *Scuola Metafisica* (Giorgio de Chirico, Carlo Carrá, et al.). Note how one line can serve to describe two realities: the left shoulder of the dressmaker's dummy, for example, becomes one of the wire guards of the space heater. Matulka's old teachers at the National Academy would have been at once horrified and proud!

—PW

**JAN MATULKA**

*Sailors and Lifeboats,* c.1930
Gouache and graphite
19 5/8 x 14 1/2 in. (49.8 x 36.8 cm)
72.531

As much as any visual artist, the dancer Isadora Duncan (1878-1927) epitomized the Modernist spirit of the early 20th century. A child of western America (she was born in San Francisco), Duncan early on determined to break free of the reigning classical traditions. Freedom, fluidity, and creativity were the hallmarks of her highly personal interpretive dances, which took Europe by storm in the decade-and-a-half run-up to World War I.

The American artist Abraham Walkowitz met Duncan in Paris in 1906. More than his meetings with Matisse and Picasso, it was this encounter with Isadora that transformed his art. He drew her obsessively; her fluidity became his, her freedom of movement inspired his pencil, brush, and pen. The 1908 watercolor (below)—one of four Walkowitz studies of Duncan owned by this museum—faithfully records her hefty form (no problem with anorexia for our Isadora!), the poetic grace of her movement, and also the scandalously (for the time) skimpy "Grecian" dress which was her trademark costume.

Arnold Genthe befriended and numerous times photographed Duncan during her visits to America in the years 1915-1918. After her death—strangled by a flowing scarf which caught in the wheels of her newly-purchased Bugatti in which she was riding along the coast of southern France—Genthe published twenty-four studies of Isadora. This (number two in the book) is the most mysteriously disembodied of them all; it was also Duncan's favorite. Of it, and of Genthe, she wrote in her 1927 autobiography:

> Arnold Genthe is not only a genius but a wizard. He had left painting for photography, but this photography was most weird and magical. It is true that he pointed his camera at people and took their photographs, but the pictures were never photographs of his sitters, but his hypnotic imagination of them. He has taken many pictures of me, which are not representations of my physical being, but representations of conditions of my soul, and one of them is my very soul indeed.

—PW

## ARNOLD GENTHE

b.1869 Berlin, Germany
d.1942 New Milford, Connecticut
*Isadora Duncan*, c.1915-1918
Gelatin silver print
8 x 5 1/4 in. (20.3 x 13.3 cm)
Julius L. Rolshoven Fund
92.29

## ABRAHAM WALKOWITZ

b.1878 Tyumen, Russia
d.1965 Brooklyn, New York
*Isadora Duncan*, c.1908
Ink and watercolor
10 x 8 in. (25.4 x 20.3 cm)
Gift of Virginia Zabriskie
99.27.1

## ROSALIND BENGELSDORF

b.1916 New York, New York
d.1979 New York, New York
*Untitled*, 1937-1938
Oil on canvas
23 1/4 x 53 7/8 in. (59.1 x 136.8 cm)
Purchased with funds from the National
Endowment for the Arts, with matching funds
from the Friends of Art
74.321

Rosalind Bengelsdorf in 1936 signed the originating charter of the American Abstract Artists. This hardy group of mainly New York City-based artists championed abstract painting and sculpture at a time (during the Great Depression) when most critics and publics preferred, on grounds political as well as aesthetic, one or another version of realism.

Yet, the abstractionists were not without influence, particularly when it came to snaring mural commissions under the Federal Art Project. This particular painting was one of two which Bengelsdorf worked up as models for a large (65 square foot) mural for the Central Nurses' Home at the Chronic Disease Hospital on Welfare Island (now Roosevelt Island), in New York City's East River. The selection committee chose Bengelsdorf's alternative proposal (which included representational elements, such as a giant piano keyboard); executed in 1938-1939, the mural, alas, disappeared at an unknown date.

At this time Bengelsdorf was in her early twenties, fresh out of art school. She had studied (quite traditionally) at the Art Students League, then in 1935-1936 more experimentally with the famous European-trained abstractionist Hans Hofmann at his first school on 57th Street in New York City. In an interview published in 1976 in the Vassar College Art Gallery catalog, *7 American Women: The Depression Decade*, Bengelsdorf recalled:

*Hofmann taught me how not to make holes in the picture. It had nothing to do with flatness. On the contrary, it was a process of dealing with many depth levels by combining back and front planes to expand, contract and merge with every other shape on the canvas, just as forms interact naturally. Nothing is static or empty in nature.*

There is certainly nothing flat, static, or empty about our painting. At first, it appears a rather simple organization of geometric shapes in a restricted palette. But this is deceptive. The geometries are actually quite complex and difficult to pin down (in the whole painting, there may be only a single rectangle—all the other shapes having at least one slanted side), while the colors are surprisingly varied (at least five different blues, and as many tan-to-brown hues, for example).

When Bengelsdorf married the artist Byron Browne in 1940, she gave up her own painting, though she continued to teach and write about art. Based on the many excellences of this early work, one cannot help but mourn the painting career she might have enjoyed.

—PW

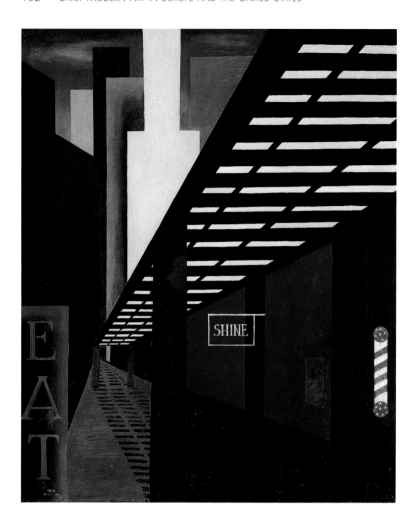

### HILAIRE HILER

b.1898 St. Paul, Minnesota
d.1966 Paris, France
*The El*, 1931
Oil on canvas
28 3/4 x 23 5/8 in. (73 x 60 cm)
Gift of Adele and Jacob Herz and Josephine
and Malvin E. Herz
77.26

In Paris between the two world wars, one of the great hangouts for artists, writers, and jazz aficionados was the Jockey Club, located on the corner of rue Champagne-Première and boulevard Montparnasse. Patrons included Ezra Pound, Jean Cocteau, Isadora Duncan, Mary Pickford, and Constantin Brancusi. "Kiki" (Alice Prin)—who also modelled for Chaim Soutine, Amadeo Modigliani, and Marcel Duchamp, among others—sang at the bar. But the man who made it go was the expatriate-American, artist-writer-pianist, Hilaire Hiler.

Pressed into service as café manager in 1923, Hiler painted murals of cowboys and Indians on the outside of the Jockey Club, perched two monkeys on the piano, and sold drinks at rock bottom prices. The good times lasted for just over a decade; in 1934, with the Great Depression in full sway and the rumblings of war distinctly to be heard, Hiler joined the general exodus of Americans and returned to New York. Somehow, during that tumultuous period, he had managed to produce a body of work—including *The El*—which is at once both highly personal and emblematic of important international currents in early modern art.

Inspired by a brief trip to New York in 1931 (but probably painted in Paris), *The El* celebrates the modern, quintessentially American, ver-

tical city. Indeed, within the "concrete canyons" of this city, so little daylight penetrates that the colors are muted, somber, crepuscular, save only the jaunty barbershop pole in patriotic red, white, and blue. Against the flat geometries of the skyscrapers, the elevated tracks jump out of the picture with startling velocity.

A quintessentially American city, and unmistakably New York. But is it a quintessentially American painting? Certainly, in his love of machine-precise geometries, Hiler can be lumped with such of his contemporary American artists as Charles Sheeler and Louis Lozowick, artists for whom the term "Precisionists" has been coined. Yet, at the same time Hiler's style definitely shares much with that of Fernand Léger and other French artists of the 1920s and 1930s, artists who called themselves the "Purists." In America and in France—and, for that matter, in Italy, Germany, Russia, Czechoslovakia, and other countries, as well—there was a transatlantic, international enthusiasm for the new, the modern, the metallic, and the machine-made, that affected artists, poets, filmmakers, and citizens of all stripes, including—most emphatically—Hilaire Hiler.          —SNB

While a student of art history and architecture in Hanover, Germany, Kelpe first came to know the art of Wassily Kandinsky and of such other pioneering abstractionists as Kurt Schwitters, László Moholy-Nagy, and Naum Gabo. He later recalled, in a letter to University of New Mexico Art Museum Director Van Deren Coke, "When I saw these exhibitions it came to my mind that abstract art could be a substitute for music." Kelpe carried that metaphor farther in a 1936 catalog statement, published on the occasion of an exhibition at the Hartford (Connecticut) Athenaeum:

*I compose my paintings of form and color, like a musician composes music with rhythm and sound. It is not that I try to imitate music or musical effects, but that I want to produce pictures which are an organization of forms not representing objects in nature. Just as the compositions of classical composers are organizations of sounds and not sounds from nature—an organization with an independent meaning of its own.*

Kelpe came to the United States in 1925. He lived for several years in Rocky Hill, New Jersey (just outside Princeton), and he became an influential member of the American Abstract Artists group, upon its founding in New York in 1936. In discussions, artists' forums, and exhibitions during the 1930s, Kelpe represented the Kandinsky wing of abstraction, which held that abstract art should be a language universal and pure.

As amply demonstrated in *Composition #216*, Kelpe masterfully handled transparent watercolors. The small scale of this work reinforces its jewel-like qualities and draws the viewer into its mystical space.                                            —JT

## PAUL KELPE

b.1902 Minden, Germany
d.1985 Austin, Texas
*Composition #216*, 1930
Watercolor and graphite
8 1/2 x 5 7/8 in. (21.6 x 14.9 cm)
78.230

## WASSILY KANDINSKY

d.1866 Moscow, Russia
d.1942 Neuilly-sur-Seine, France
*Kleine Welten I*, 1922
Lithograph
10 1/4 x 9 in. (26 x 22.9 cm)
63.53

**LOUIS LOZOWICK**

b.1892 Ludvinovka, Ukraine
d.1973 South Orange, New Jersey
*Machine Ornament*, c.1926
Ink
15 3/4 x 10 1/2 in. (40 x 26.7 cm)
Purchased with funds from the
National Endowment for the Arts
72.99

Of all the issues facing artists in the 1920s—how to respond to Cubism, whether or not to go abstract, what about Freud and his ideas—none was more momentous than the relationship between art and the machine. Frightful images of tanks and bombers were seared into the very souls of all who witnessed the carnage wrought upon warriors and civilians alike during World War I. But could all that power be harnessed for good? Should artists resist the machine, or should they rather embrace it?

Many American artists choose the latter course, celebrating the machine aesthetic in both word and image. Paul Strand, for example, rejoiced in the fact that his photographs literally emanated from a machine (the camera); writing in 1934 about his great benefactor, Alfred Stieglitz, he could equally have been writing about himself:

> *He fought for the machine and for its opportunity to channel the impulses of human beings, for the respect which was due it. This machine toward which he so freely moved, through which he was impelled to register himself, was a despised, a rejected thing. It became a symbol of all young and new desire, whatever form it might take, facing a world and a social system which tries to thwart and destroy what it does not understand. Photography became then a weapon for him, a means of fighting for fair play, for tolerance for all those who want to do anything honestly and well.*

In the world of "hand" art (painting, drawing, printmaking) Louis Lozowick was perhaps the most consistent and eloquent champion of the machine and its possibilities—both aesthetic and social. His series of *Machine Ornament* ink drawings, begun in 1922, were featured in a one-person exhibition in New York in 1926; the following year, Lozowick wrote for the catalog of the important Machine Age Exposition, held in New York City's Steinway Hall:

> *The whole of mankind is vitally affected by industrial development and if the artist can make his work clear in its intention, convincing in its reality, inevitable in its logic, his potential audience will be practically universal. And this is perhaps as high a goal as any artist might hope to attain.*

—PW

**PAUL STRAND**

b.1890 New York, New York
d.1976 Orgeval, France
*My Ackeley Camera*, New York, 1922
Gelatin silver print
9 3/8 x 7 1/4 in. (23.8 x 18.4 cm)
Gift of the artist in memory of Nancy Newhall
75.10

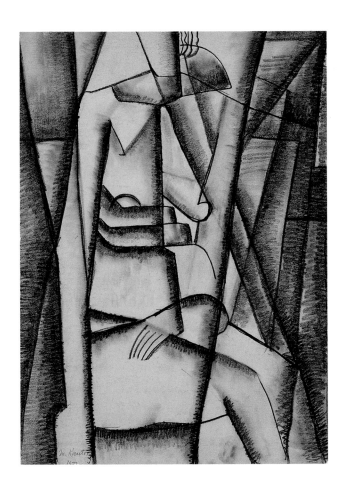

**MORRIS KANTOR**

b.1896 Minsk, Belarus
d.1974 New York, New York
*Cubist Nude*, 1922
Graphite
19 1/2 x 14 1/2 in. (49.5 x 36.8 cm)
Purchased with funds from the National
Endowment for the Arts
72.98

Like so many other immigrants-turned-artists of his generation, Kantor (who arrived in the United States in 1906) as a young man embraced Modernism. Perhaps it was a continuation of the optimism about the still-young century in their adopted country that led these new arrivals to seek out the freshest and the boldest in the visual arts, and make it their own.

For Kantor, that equated with Cubism, which he first encountered when he enrolled in New York's famous Independent School of Art in 1916. Up to this point, his highest ambition had been to become a cartoonist. In a 1940 autobiographical essay (published in *The Magazine of Art*), Kantor recalled:

> *The Independent School of Art was like a new world to me; the language spoken there was as foreign to my ears as English had been when I first arrived in this country. I had never known artists or conceived that there might be more to art than mere reproduction, but here I came into contact with a group of rebels in art. The constant talk was the Armory Show, Cezanne, Van Gogh, Gauguin, Picasso.*

For the next several years, Kantor worked in a style closely derived from Analytical Cubism. But when we compare *Cubist Nude* with Picasso's 1912 *Head of A Man*, some fundamental differences quickly announce themselves: the Kantor is denser, heavier, both in the human figure and in the surrounding space. In another passage from that 1940 autobiographical essay, Kantor nicely describes his method and speaks to this difference:

> *I dealt mostly with nudes in exaggerated forms, carrying the background into a design suggested by the movement of the figure. My main experiments, at this time, centered in trying to make the whole design play in and out all through it, giving to the subject both a molded and a corrugated effect.*

Like an origami figure seated in a space also folded from corrugated cardboard—exactly!                                                          —PW

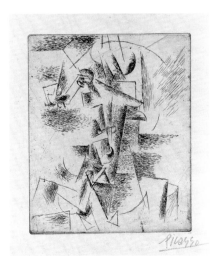

**PABLO PICASSO**

b.1881 Malaga, Spain
d.1973 Mougins, France
*Head of a Man*, 1912
Etching
5 1/8 x 4 3/8 in. (13 x 11.1 cm)
Julius L. Rolshoven Memorial Fund
84.84

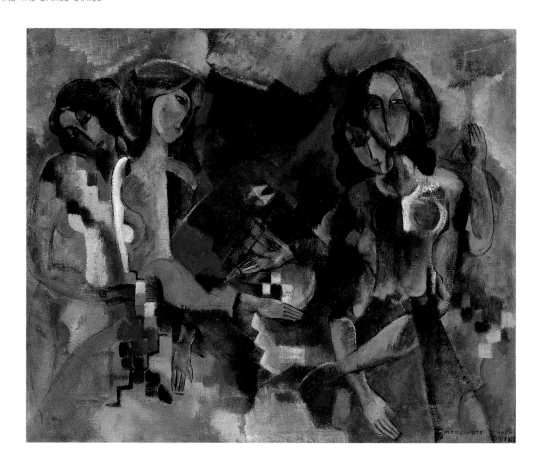

## MARGUERITE ZORACH

b.1887 Santa Rosa, California
d.1968 New York, New York
*Women in Garden*, 1918
Oil on canvas
19 1/2 x 24 in. (49.5 x 60.9 cm)
Purchased with funds from the
Friends of Art
68.156

Among early American modernists, husband-and-wife (or wife-and-husband) teams abounded. O'Keeffe and Stieglitz. Rosalind Bengelsdorf and Byron Browne. Suzy Frelinghuysen and George L. K. Morris. Paul and Rebecca Strand. And (just to restrict the list to artists included in this catalog) Marguerite and William Zorach. She, California born and educated, arrived in Paris in 1908; he, foreign born but raised and first employed as a commercial lithographer in Ohio, followed in 1910. They met as fellow students in a private art school ("La Palette"), and married in 1912 in New York City. As emissaries of up-to-date French Post-Impressionism, they and their art were regarded as wildly modern.

Together, the Zorachs showed at virtually all of the landmark early exhibitions of modern art, including the famous Armory Show of 1913, which gave many Americans their first, first-hand look at Picasso, Duchamp, and other radical European artists. Crowds flocked and gaped at the (to them) nearly abstract works on display. Incomprehension and ridicule were the order of the day, and cartoonists (including Briggy, of the *Evening Sun*, who compared Cubism to a folk quilter) had a field day.

Actually, maybe Briggy had a point. Marguerite Zorach's *Women in Garden*, painted just five years later in 1918, both resembles and celebrates women's needlework. By this time, Zorach had been thoroughly exposed to the fractured, fragmented, sometimes transparent and overlapping forms of Cubism. She had also proved herself adept at embroidery and batik, and indeed spent most of 1918 working on two large and elaborately embroidered bedspreads for an important collector (Mrs. Nathan Miller). Especially in American art of this period, the folk and the highly sophisticated were frequent allies.                    —PW

*The Original Cubist*
Cartoon by Briggy, in the *Evening Sun*
(New York), April 1, 1913

**MAX WEBER**

b.1881 Bialystok, Byelorussia
d.1961 Great Neck, New York
*Greek Pot and Fruit*, 1930
Oil on canvas
18 1/4 x 22 in. (46.4 x 55.9 cm)
Gift of Joy S. Weber
97.10

*Art has a higher purpose than mere imitation of nature. It transcends the earthly and measurable. It has its own scale and destiny. A work may be ever so anatomically incorrect or "distorted" and still be endowed with the miraculous and indescribable elements of beauty that thrill the discerning spectator.*

Max Weber, 1930

Weber, like many European and American Modernists, went through something of a crisis of style in the years following World War I. From age ten, he grew up in New York, and in his late teens studied art under Arthur Wesley Dow at Brooklyn's Pratt Normal School (now called Pratt Institute). His most vital education, however, took place in Paris, where he lived from 1905 to 1909, studying first at the famous Académie Julian and then later, and more importantly, with Henri Matisse. Returning to New York, Weber exhibited at Stieglitz's 291 gallery; later, he co-founded and taught an influential course on modern art at the Clarence White School of Photography, and generally established himself as one of the leaders of the young American Modernists. His style from 1916 through 1919 can best be described as a vigorously brushed, animated version of Cubism, verging at times on the abstract.

'Round about 1920, everything changed. Like so many other artists of his generation—Picasso and Léger in France, O'Keeffe in the United States—Weber tiptoed up to non-objectivity, then retreated from it to an art more grounded in the real world. In his own words, Weber returned to "the works of God themselves," both to the human figure and, dominating his art in the 1920s, especially to still-life.

Clearly, the influence of Cézanne is apparent in our *Greek Pot and Fruit* of 1930. The subject matter—apples, crumpled cloth, and earthenware pitcher—couldn't be more Cézannesque. And Weber flattens space (by tilting the table top, and having the cloth rise abruptly as a backdrop to the fruit) in ways that deliberately recall the Frenchman. If there is imitation, yet there is here also great strength and conviction and beauty. And even great individualism, especially in the richly varied handling of paint, now dry and scumbled (the background wallpaper), now moistly translucent (the wooden table). In his return to the depiction of humble, everyday objects, Weber found the basis for some of his finest creations.

—JSW & PW

Raymond Jonson and the Art of Mid-Century

## RAYMOND JONSON AND THE ART OF MID-CENTURY

*The world is in a terrible mess, but I feel that we have more of a job than we ever had.*

Ansel Adams, July 1940

When Ansel Adams wrote those words (in a letter to his friend Cedric Wright) he summed up the situation of many artists at that fateful time. The Great Depression and the rise of fascism had, by 1940, given way to war in Europe, and though the United States was not yet part of the conflict, most realized that it was likely only a matter of when, not if, we would become involved. How do you make art under such circumstances? Do you persist in some form of Modernism (which, at least implicitly, entails a belief in progress)? Or do you seek refuge in earlier forms of art, perhaps some which evoke a more tranquil past?

A decade later, in 1950, everything had changed. The Allies had triumphed, and the United States was the biggest "winner" of all. Our industrial might and pre-eminence in geopolitics were matched by the emergence of American art as the recognized world leader. But now, what should a thoughtful artist be: cheerleader for an age of affluence, or conscience (guilty or otherwise) of the new consumer society? What styles, and what subjects, were appropriate?

The artists whose works make up this mid-20th century portion of our collections answered such questions in many different ways. But all were marked by their times. Raymond Jonson (1891-1982) and his cohorts in the New Mexico-based Transcendental Painting Group represent a fresh breath of Modernism: still based on European models, but infused with new energies (some derived from Eastern philosophies). Jackson Pollock (1912-1956), Minor White (1908-1976), and David Hare (1917-1992) show how some of the most vital mid-century American painting, photography, and sculpture grew out of Surrealism. Agnes Martin (b.1912), Oli Sihvonen (1921-1991), and Richard Diebenkorn (1922-1993) began their careers right around 1950, and went on to define what it meant to be a major American artist in the 1960s and beyond.

Through many gifts, and through several shrewd purchases, the University of New Mexico Art Museum has built a collection which celebrates this period when American artists moved from being provincial bit players, to assuming center stage in world art. We also, through our geography, do a better job than many others in documenting the contributions of artists from both coasts, as well as from New Mexico itself. Where we must acknowledge a weakness (and it is one shared with most other American museums) is in not including in our collections sufficient work by European (and Asian, and African) artists of this same generation. Finding and adding such works, both to give a context to our current Americas-focused collections, and to show the contributions other countries made to world culture, remains an important initiative.

**RAYMOND JONSON**

b.1891 Chariton, Iowa
d.1982 Albuquerque, New Mexico
*Oil No. 8 (Chromatic Contrasts No. 14)*, 1943
Oil on canvas, 40 x 32 in. (101.6 x 81.3 cm)
Reserved Retrospective Collection of the Jonson Gallery
82.221.0425

*Jonson is probably the factor most responsible for encouraging the intense productivity and high level of professionalism of the young Albuquerque artists by offering them one-man shows at his gallery. In his generosity and ability to stimulate other artists, Jonson is comparable to Hans Hoffman, and would undoubtedly be a nationally known painter if he had been working on the East or West Coast all these years.*

Elaine de Kooning, 1960

Like several European Modernists (Kandinsky, Mondrian), Raymond Jonson entered his period of greatest experimentation (and greatest accomplishment) in mid-life. As a young man in Chicago (from 1910 onward), he experimented in a wide range of early-modern styles, all derived from European models; after moving to Santa Fe in 1924, and perhaps inspired by the fractured landscape and the reductive geometries of the local vernacular architecture, he settled upon a decorative Cubism, in which style he worked for over a decade. His *Grand Canyon Trilogy* of 1927-1928 shows off this manner to great effect, marrying intense colors to the blocky shapes and encasing the vertiginous plunge of the canyon in a then-radical, V-shaped canvas. But this is still provincial art, albeit of a high order.

It was in the 1930s, a time of vast social upheavals caused by the Great Depression, a time when artists on both sides of the Atlantic were retreating to "safe" representation, that Jonson plunged into pure abstraction. Not only did he create some of his finest works in the decade-and-a-half beginning about 1938 (a period here represented by his *Oil No. 8* of 1943), he also: (1) helped found and keep afloat through his personal energies a group of like-minded abstractionists, the Transcendental Painting Group (TPG), (2) began to commute to Albuquerque to teach at the University of New Mexico, where he initiated a series of amazing one-person exhibitions (artists included Mark Rothko and Arshile Gorky) in the Art Department's rudimentary exhibition space, and (3) persuaded the University Regents to create the Jonson Gallery: a combination residence, studio, and gallery space, which opened in January of 1950. Since Mr. Jonson's death in 1982, the Jonson Gallery operates as a branch of the University of New Mexico Art Museum, still dedicated to preserving the histories of Jonson, his TPG colleagues, and other notable artists who exhibited there during Jonson's lifetime, and also to promoting the careers of younger artists.

—PW

**RAYMOND JONSON**

*Grand Canyon Trilogy, Second Movement*, c.1927
Oil on canvas
67 1/2 x 51 3/4 in.
(171.5 x 131.4 cm)
Reserved Retrospective Collection of the Jonson Gallery
82.221.0668

## HORACE TOWNER PIERCE

b.1916 Meeker, Colorado
d.1958 Albuquerque, New Mexico
*Spiral Symphony: Movement I, No. 8*, 1938-1939
Watercolor on paper, 6 3/4 x 9 in. (17.1 x 22.9 cm)
Purchased with funds from a bequest from the
Edith Gregg Estate
Jonson Gallery Collection
85.36

## HORACE TOWNER PIERCE

Sketch for *Spiral Symphony*, c.1938
Graphite on paper
Jonson Gallery Archives

Born on the POT ranch in Meeker, Colorado, Horace Towner Pierce moved to Taos on Labor Day 1936. There, at the art school headed by Emil Bisttram (1895-1976), he met a fellow-student, Florence Miller. They fell in love, became members of the Transcendental Painting Group (which included Bisttram and Raymond Jonson), married, and decided that easel painting was dead—more or less in that order.

In 1937, Horace conceived an animated, abstract film, which he eventually titled *Spiral Symphony*. It was to be approximately eight minutes long, and divided into four movements. The avant-garde composer Dane Rhudyar (1895 -1985)—a close friend of the TPG artists, who went on to a distinguished career in American music—was asked to provide a musical score. The theme: nothing less than the cycle of life. In a typescript in the Jonson Gallery archives, the artist describes the first movement:

> *First Movement: (two minutes) BIRTH or condensation out of void. This movement begins in the absolute quiet of blue-violet. It is pure geometric progression, the basic struc-ture of life. This is represented by two opposing spirals, which symbolize the positive and negative forces in nature, proton and electron, male and female and so on. As the movement progresses the spirals assume a more organized shape and become pregnant with the forms of the Second and Third Movements. The other three movements are "The CRYSTAL," "The FLOWER," and "DEATH or the return to void."*

In April of 1940, Pierce showed his thirty air-brushed watercolors for *Spiral Symphony* at the Museum of Modern Art, in an exhibition *American Design for Abstract Film*, but he never obtained the financing to realize the movie. Today, all thirty watercolors are preserved at the Jonson Gallery, where they remain emblems of the optimism that at least some American artists could summon up in those difficult years.    —PW

**FLORENCE MILLER PIERCE**

b.1918 Washington, D.C.
*First Form #1*, 1944
Oil on canvas
26 x 36 1/2 in. (66 x 92.7 cm)
Purchased with funds from the National
Endowment for the Arts, and matching
funds from the Friends of Art
Jonson Gallery Collection
89.13.3

*Pierce is intrigued by the beauty of number and the perfections of geometry. Like Kandinsky, Malevich, and Mondrian before her, she seeks to express a higher order of being through purely abstract visual means.*

Michaël Amy, *Art in America*, 1998

The youngest member of the Transcendental Painting Group, Florence Miller studied art in her native Washington, D.C. (both at the Phillips Collection's studio school and at the Corcoran School of Art), and in Taos at Emil Bisttram's school (where she met, and then married, Horace Pierce). When Jonson and Bisttram initiated the TPG in 1938, Florence Miller and Horace Pierce were two of the original nine founding members.

Of all the members of the TPG, Florence Miller Pierce in her paintings (and in her exquisite graphite drawings) of the late 1930s and early 1940s best epitomizes what "transcendental" is all about. Her forms may be rooted in biology, and thus in the earthly realm. But by the delicacy of texture and color, and by a weight-defying, all-over glow of light, these forms lift free of gravity and hover in a space and in a reality separate from our own. They quite literally "transcend" the materials (in the case of *First Form #1*, oil on canvas) out of which they are constructed.

And, of all the members of the TPG, Florence Miller Pierce best demonstrated (and continues to demonstrate) how that movement—through constant reinvention—could be a springboard to continual modernity. After a period in the 1960s and early 1970s in which she experimented with a wide variety of mediums (from polyurethane to cement), Pierce in 1972 began working with poured resin. Gradually, she evolved what is now her signature medium: successive layers of resin, variously translucent and opaque (and sometimes given texture by being blotted while still wet), poured onto mirrored Plexiglas. Her works of the last two decades have been widely exhibited, and critics have justifiably hailed them for their innovation and contemporaneity.                    —PW

**FLORENCE MILLER PIERCE**

*Untitled*, 1995
Resin, mirrored Plexiglas, plywood
24 x 24 in. (61 x 61 cm)
Gift of the artist
Jonson Gallery Collection  95.18.5

## WALKER EVANS

b.1903 St. Louis, Missouri
d.1975 New Haven, Connecticut
*Todd's Gun Store*, 1935-1936
Gelatin silver print
8 x 9 15/16 in. (20.3 x 25.4 cm)
Gift of Joan and Van Deren Coke
91.11.91

A college drop-out, whose real education came—as for so many Americans of his generation—while wandering about and reading French literature in Paris in the 1920s, Walker Evans first turned seriously to photography in 1930 and 1931. Under the mentorship of Lincoln Kirstein, he documented the Victorian architecture of Boston and its vicinity. In 1935, he parlayed that experience into an assignment for the Farm Security Administration: a Federal agency, the photographic unit of which (under its legendary boss, Roy Stryker) amassed over 270,000 photographs, by such photographers as Ben Shahn, Dorothea Lange, Marion Post Wolcott, Russell Lee, and Jack Delano.

Of his experience working for the FSA, Evans later said, "I developed my own eye, my own feeling about this country. Oh, gosh, yes, that was great for me!" Indeed, that "eye" which emerged was striking and distinctive: tightly focussed, rigorously exclusive of extraneous material, very straightforward and very modern, and yet attuned to social implications and incongruities. The writer James Agee (who famously collaborated with Evans on *Let Us Now Praise Famous Men* in 1936) remarked on his photographs' possessing "the cruel radiance of what is."

When Evans photographed Todd's Gun Store, he likely knew of its status as the oldest surviving commercial business in Montgomery, Alabama. Founded in 1822 as "The Little Gun Store" by Nicholas Becker, a Prussian gunsmith, it became "Todd's Gun Store" when George H. Todd married Becker's daughter and took over the business in 1848. As an antiquarian, Evans was no doubt fascinated by the store's legendary status as much as by the collage of objects and lettering across the facade.

And what of the Asian establishment on the second floor? Did Evans know that Chinese markets, restaurants, and laundries were established all over Alabama and Louisiana in the early 1870s, as Chinese laborers were brought by the hundreds from California to rebuild the railroads in the aftermath of the Civil War? Whether he knew that specific history or not, Evans was keenly appreciative of social juxtapositions such as this: the offices of the American Woodsmen on the left, the Chinese place upstairs on the right, and in between, the old gun store (advertising, among other things, firecrackers).   —ROW & PW

## JACKSON POLLOCK

b.1912 Cody, Wyoming
d.1956 Southampton, New York
*Untitled*, 1939
Colored pencil and lead pencil on paper
6 x 7 1/8 in. (15.2 x 18 cm)
Gift of Vernon Nikkel of Clovis, New Mexico,
in memory of Frank F. Nikkel, Anna Zielke
Nikkel, Ruth Nikkel, Irene Hutchinson, and
Martha Nikkel Critelli
89.10.5

## PABLO PICASSO

b.1881 Malaga, Spain
d.1973 Mougins, France
*Untitled*, from the portfolio *Sueño y mentira de Franco*
(*Dream and Lie of Franco*), 1937 (detail)
Etching
67.108.2

"Pollock broke the ice." So avowed his fellow, and at least equally influential, Abstract Expressionist, Willem de Kooning. When pressed at Pollock's memorial service in 1956 to explain his oft-quoted remark, de Kooning said that he didn't mean that Pollock had created a style to be followed, but rather that he had made American art a world-respected force, and had thereby opened doors for a whole generation of American artists. After Pollock, Americans no longer had to look to Europe for models of how to make art. And yet, as our 1939 untitled drawing clearly evidences, Pollock stood upon the shoulders of the European Surrealists in general, and upon those of Picasso, in particular.

In early 1939, Pollock—battling chronic alcoholism—entered psychoanalysis with Dr. Joseph Henderson, a disciple of Carl Jung. During a yearlong course of treatment, Pollock gave Henderson sixty-nine drawings, brought from his studio to serve as the basis for their sessions. Ever since their release by Dr. Henderson in the late 1960s, critics and psychiatrists have argued over whether these drawings are best understood as art, or as Pollock's attempts to illustrate Jungian notions of archetypal symbolism located within the collective unconscious.

Our drawing clearly depends upon Pollock's sophisticated grasp of Picasso's nearly-contemporary preparatory studies for, and works related to, his famous *Guernica*. The anguished horse's head (in Pollock, combining two different points of view) may be closely compared with that in one of the panels of Picasso's *Dream and Lie of Franco*. To make this comparison is not to belittle Pollock's accomplishment. Even in this small-scale drawing, one sees the energy, the passion, the dense compression of almost violent forces, that would within very few years find their way into Pollock's mature paintings.

—PW

**EDWARD WESTON**

b.1886 Highland Park, Illinois
d.1958 Carmel, California
*New Mexico, El Sanctuario, Chimayo,* 1941
Gelatin silver print
7 5/8 x 9 5/8 in. (19.3 x 24.5 cm)
The Beaumont Newhall Collection.
Purchased with funds from the John D. and
Catherine T. MacArthur Foundation
87.22.1

"Photography" and "New Mexico" go together like "coal" and "Newcastle." Since the 1860s, distinguished photographers have been drawn to this state, both by the landscape and by the cultures which have flourished within it. Edward Weston and Ansel Adams, separately and together, represent the mid-20th century flowering of the medium, and their images of New Mexico have particular resonance for the University of New Mexico's photography programs and collections.

It's late July of 1940. Beaumont and Nancy Newhall are visiting California for the first time, and are in the company of Ansel Adams (whom they had met—through Alfred Stieglitz—the previous year in New York). After a photography conference in San Francisco, Ansel suggests that they give his friend Edward Weston a ride back to his home in Carmel. They pile into Ansel's car and head south, chatting all the way. It ends with an impromptu dinner at Edward's new cabin on Wildcat Hill in Carmel, and with Ansel, Beaumont and Nancy, and Edward and Charis Weston fast friends for life. Nancy will collaborate with Ansel on several book projects; Beaumont—and several of his photo history graduate students at the University of New Mexico—will write often about Edward (and Beaumont's last house, in Santa Fe, will be designed in reminiscence of the cabin on Wildcat Hill).

The vision shared by both photographers, and embraced by both Newhalls, was one of clarity, precision, and regard for exquisite detail and subtle nuances of light. In 1932, Ansel Adams and Edward Weston were two of the founders of f:64: a group of Californians, who named themselves after the smallest possible aperture opening on a lens, the setting which gives the greatest and sharpest depth of field. From the many works by each in our collection, we here illustrate two "signature" pieces: Edward Weston's photograph of the *Sanctuario* in Chimayo (which Beaumont Newhall personally selected to be purchased in his name) and Ansel Adams's iconic image of Hernandez, in northern New Mexico, lit by both the setting sun and the moon.

—PW

**ANSEL ADAMS**

b.1902 San Francisco, California
d.1984 Carmel, California
*Moonrise, Hernandez, New Mexico,* 1941
Gelatin silver print, printed c.1950
15 5/8 x 19 1/2 in. (39.7 x 49.5 cm)
64.80

**BILL BRANDT**

b.1904 Hamburg, Germany
d.1983 London, England
*Deep Shelter*, 1940
Gelatin silver print
9 1/4 x 7 5/8 in. (23.5 x 19.4 cm)
Gift from the collection of David Delgarno
and Brenda Hochberg
99.30.1

On September 7, 1940, Hitler's Luftwaffe unleashed the Blitz on London. Bombings lasted for seventy-six consecutive nights (interrupted only by one night of bad weather on November 2nd). The world—and, in particular, the United States, which was of course not yet at war—watched with grim fascination to see if the Londoners could somehow withstand this unprecedented barrage.

At the height of the Blitz, Hugh Francis, the Director of the Photographic Division at the Ministry of Information, commissioned the photographer Bill Brandt to record life in London's makeshift underground shelters, including the subway (or "tube") stations at Liverpool Street Station (in the East End) and Elephant and Castle (in South London). Brandt spent a bit over a week, from November 4 through November 12, 1940, making some thirty-nine photographs both in the stations and in other shelters (including a church crypt). His assistant recalled setting up primitive flash units to supplement the meager available light, and then crawling amid the sleeping crowds and holding a flashlight over the heads of the subjects so that Brandt could focus his camera.

*Deep Shelter* was shot inside an unfinished tunnel at Liverpool Street Station; three people turn out to be a young girl, her doll, and—presumably—her mother. Both the doll and the older woman "sleep" with their mouths open (Brandt later recalled the contrast between the cacophony of the bombs above ground and the stillness in the tubes, broken only by the incessant snoring). His work of the 1930s had been pure social documentary. Now, life in the shelters brought a sense of the surreal to his art, and also a sense of romantic wonderment. As life in Great Britain was forever changed by the Second World War, so too was Bill Brandt's photographic vision decisively transformed by his nights in the tubes. —PW

**BILL BRANDT**

*Tattoo Artist at Work*, 1937
Gelatin silver print
6 1/4 x 8 in. (15.9 x 20.3 cm)
94.36.11

## THE PHOTOJOURNALISTS

By the second decade of the 20th century, advances in the technologies of both cameras (faster, more portable) and presses (especially, the rotary offset) brought photographs to both magazines and the daily newspapers. Casasola—with images which he took himself, and with many others fed to him by a small army of "stringers" all across Mexico—recorded the famous personages and types of his country's Revolution, and he represents the first generation of photographers who thought of themselves as photojournalists.

Salomon came later; his career flourished between the two World Wars. Using an unobtrusive 35mm camera, he specialized in recording the intrigues of international politics in the 1920s and 1930s. This image comes from several rolls of film which he shot during an all-night session of European diplomats, addressing the delinquent war reparations owed by Germany to the Allies. Note that Salomon, a Jew, would die at Auschwitz, a direct victim of the rise of Hitler which he had documented.

Photojournalism as both a profession and an art form really came into its own just in time for World War II. Weegee, Smith, Cartier-Bresson, and Frissell belong to the restless, peripatetic generation of photographers who brought great passion and integrity to their images. And those images, which appeared in newspapers and weekly magazines on both sides of the Atlantic, were a principal—maybe the

### AUGUSTÍN VICTOR CASASOLA

b.1874 Mexico City, Mexico
d.1938 Mexico City, Mexico
*Women Soldiers*, c.1915
Gelatin silver print, printed c.1950
The Beaumont Newhall Collection. Purchased with funds from the John D. and Catherine T. MacArthur Foundation
11 1/2 x 13 15/16 in. (28.3 x 35.4 cm)
90.10.3

### ERICH SALOMON

b.1886 Berlin, Germany
d.1944 Auschwitz, Poland
*War Reparations Meeting in Den Haag*, 1930
Gelatin silver print, 4 1/4 x 6 in. (10.8 x 15.2 cm)
The Beaumont Newhall Collection. Purchased with funds from the John D. and Catherine T. MacArthur Foundation
86.163

### WEEGEE (ARTHUR FELLIG)

b.1900 Zloczew, Poland
d.1969 New York, New York
*The Human Cop*, 1943
Gelatin silver print, 13 1/4 x 10 1/2 in. (33.7 x 26.7 cm)
74.233

principal—vehicle by which the generation of 1935-1955 (that is to say, the pre-television generation) knew of the world and its unfolding dramas. Weegee's images appeared in the New York newspapers; he covered everything from murders (by monitoring the police-band radio, he often got to crime scenes ahead of the cops) to high society events. Eugene Smith's work—including some of the most famous images of the war in the Pacific—often appeared in Henry Luce's *Life* magazine as a carefully sequenced group, conceived and printed as a "photo essay," and accompanied by a minimum of text. The Frenchman Cartier-Bresson originated what became an almost universal catch phrase of photojournalists: he wrote about the quest for the "decisive moment"—that instant, to which the photographer must be ever alert, in which an event which might transpire over hours, or even days, is revealed with utmost clarity. Before and after World War II, Frissell was a top fashion photographer. From 1942 through 1945, she worked on assignment for first the Red Cross and then the War Department, recording both morale-boosting images such as this one, and front-line action.

The equation of truth with a sometimes gritty black-and-white image helped, we may imagine, create the atmosphere in which post-war Abstract Expressionism would be born.          —PW

## W. EUGENE SMITH

b.1918 Wichita, Kansas
d.1978 Tucson, Arizona
*Maude Administering Vaccinations to School Children,* 1951
Gelatin silver print, 9 3/4 x 13 7/16 in. (24.8 x 34.3 cm)
Gift of Judith Hochberg and Michael Mattis
94.25.13

## HENRI CARTIER-BRESSON

b.1908 Chanteloup, France
*Gestapo Informer Recognized by a Woman She Denounced,* 1945
Gelatin silver print, 10 1/8 x 15 in. (25.7 x 38.1 cm)
Gift of Joan and Van Deren Coke
91.48.58

## TONI FRISSELL

b.1907 New York, New York
d.1988 St. James, New York
*Light for a Wounded Soldier,*
from the series *Somewhere in England,* 1943
Gelatin silver print, 7 1/2 x 7 9/16 in. (19 x 19.2 cm)
The Beaumont Newhall Collection. Purchased with funds from the John D. and Catherine T. MacArthur Foundation
90.28.3

## OSVALDO LOUIS GUGLIELMI

b.1906 Cairo, Egypt
d.1956 Amagansett, New York
*Soliloquy*, 1945
Graphite
17 x 11 1/2 in. (43.2 x 29.2 cm)
Purchased with funds from the Friends of Art
74.16

airo—where O. Louis Guglielmi was born—was almost a random event; his Italian father was an itinerant orchestral musician, and the Guglielmi family touched down in Milan, Geneva, and several other European cities before settling in New York in 1914. Guglielmi dropped out of high school to enter the rigorously conservative art school run by the National Academy of Design. In a statement published in the catalog of the Museum of Modern Art's 1943 exhibition, "American Realists and Magic Realists," he recalled his five years as a student in the Academy's "barracks-like" building:

> *In the end I was an exacting draftsman and something of a painter, but I realized that I had learned nothing of value, that the teachers were unimaginative, knew little and gave out less.*

Well, maybe. Guglielmi never needed to gain inspiration from others; he had it to burn, within himself. And being an "exacting draftsman" enabled him—as in our pencil drawing—to give his visions hallucinatory power and conviction.

For much of the 1930s, with the United States in the grip of the Great Depression, Guglielmi painted bleak urbanscapes, often peopled by the impoverished working classes. But often, also, with some odd quirk of the imagination (people trapped in a giant bell jar), that led him to be labeled a "social surrealist." Gradually, the surrealism overwhelmed the social message.

Our drawing—executed just after Guglielmi was discharged from the U.S. Army—reprises two (lost) paintings of 1940: *Soliloquy*, which depicts a musician holding a cubist-distorted cello, and *Objects and Image*, which features a hand-shaped vase with a bouquet of mimosa blossoms. Here, Guglielmi replaces the cello with that same vase of flowers, which now sports a wig and rests on an abruptly truncated table. Note also that our gentleman wears a (his?) heart on his sleeve. The meaning is, to say the least, unclear, but poetically rich with possibilities.                    —PW

## CLINTON ADAMS

b.1918 Glendale, California
*Highway 66*, 1946
Egg tempera on panel
16 x 22 in. (40.6 x 55.9 cm)
87.9

*Highway 66* celebrates both a time and a place. The time: 1946, the end of World War II. Adams (and so many other veterans) returning to civilian life, the real beginnings of America's love affair with the automobile, and in art the search (with almost as many different answers as there were artists engaged in it) for a style appropriate to the nation's new sense of confidence. The place: New Mexico and more particularly, Albuquerque. Aside from the unlikely poetry of its name, Albuquerque was a significant way station for Adams, on his way home to California from his last military base on New York's Long Island. It was the home of several UNM faculty members with whom he had established friendships while, earlier, stationed in Colorado Springs. It was also the home of Raymond Jonson, about whom Adams had learned much from his UNM friends, and whom he finally met on this trip through Albuquerque.

As the artist freely avows, *Highway 66* is heavily infused with the forms and spirit of Stuart Davis. Adams had, just prior to his departure from New York, seen the major Davis retrospective at the Museum of Modern Art. The bold, flat patches of color, the alternation of abstract shapes and recognizable forms, the love of signs and the world of commerce—all these are taken from Davis.

Yet *Highway 66* has a jauntiness and an inventiveness of shape and color which elevate it beyond "school of Davis" and make it a minor masterpiece of observation and wit and artistic intelligence. See how the Texaco star floats against the terracotta sky, how the blue of the highway makes the road as open and endless and blissful as a Judy Garland song, how perfectly clear—if effortlessly rendered—are the jack and its handle (overly familiar instruments to Adams, who suffered four flats as he travelled West on war-years-bald tires). It's a wonderful picture, large beyond its size, and full of the spirited optimism with which Americans flexed their post-war muscles.

Fifteen years after he painted *Highway 66* in his California studio, Adams used the road again, to move from Los Angeles (where he was founding Associate Director of the Tamarind Lithography Workshop) to Albuquerque, to become Dean of the College of Fine Arts at UNM. From that post, he oversaw the founding of the University of New Mexico Art Museum.
                                                                —PW

## MINOR WHITE

b.1908 Minneapolis, Minnesota
d.1976 Boston, Massachusetts
*Untitled (Decaying Boiler with Sumac)*, 1954
Gelatin silver print
7 3/8 x 9 3/8 in. (18.7 x 23.8 cm)
Purchased with funds from the Friends of Art
78.125

*"Mysticism" in photographs is a delightful idea, full of danger of overreaching the visible elements, but perhaps intensely rewarding. I know its danger, and pursue it anyway. I believe that, like* Alice Through the Looking Glass, *with the camera one comes so close to reality that one goes beyond it and into the reality of the dream.*

Minor White, 1953

Minor White came to his career in photography mainly through Ansel Adams and Edward Weston. But, while he appreciated their clear-headed and sharp-eyed realism, he was from the beginning aware that his own temperament dictated a very different path: mystical, more overtly emotional, more about depths of realities than about the aesthetics of things. Like Adams, he loved nature (his undergraduate degree from the University of Minnesota was a B.S. in botany). But he also went through a Catholic youth, then a period of intense immersion in Zen Buddhism, then to a study of the mystical Russian philosopher Gurdjieff. After an evening with Adams, Weston, and others in Carmel, California, in 1951, White wrote in his journal:

*Ansel: creative talent at the service of men. Edward: sharing beauty with others. Thus I get my own direction: causing in others the mystical experience of a communion with the world.*

This image, of a decaying metal boiler surrounded by sumac, exemplifies the magic of Minor White's photographs. It is, first of all, beautiful in both its composition and its printing, which exploits the full range of subtle tonalities available in a gelatin silver print (Adams and Weston would have applauded!). It's also morbid, even creepy. While, in the 1950s, most Americans were celebrating shiny new automobiles and other trappings of post-war success, Minor White instead turned his camera (and asked his contemporaries to turn their attention) to death, decay, degradation.

Yet, there is also a sense of triumph: of nature (represented by the ever-so-common, and ever-so-resilient sumac) moving swiftly to erase the discarded emblem of human industry.

—PW

**ROBERT FRANK**

b.1924 Zurich, Switzerland
*Bar—Gallup, New Mexico*, 1955
Gelatin silver print, printed 1977
13 1/4 x 8 3/4 in. (33.7 x 22.2 cm)
78.176

If you stand too close to an impressionist painting, it's impossible to see it fully. Similarly, most native-born Americans cannot see the greater context that surrounds their own social, economic, and political milieu. Robert Frank, a Swiss-born photographer, was one of the first to show us unsparingly to ourselves through the medium of photography.

In 1955, Frank became the first foreign-born photographer to receive a Guggenheim fellowship. Using his grant, he spent the better part of a year criss-crossing the United States in a 1950 Ford business coupe, creating thousands of negatives; he selected and carefully arranged eighty-three of these images (including *Bar—Gallup New Mexico*) into a book, *The Americans*, first published in Paris in 1958. The United States, having emerged victorious from World War II, was the world's unchallenged military and economic power, with the ambition to become the leading cultural power as well. However, underneath the pride and prosperity, there were serious social problems that we chose not to recognize. Frank revealed these to us with bracing candor and eloquence in *The Americans*.

*Bar—Gallup, New Mexico* was shot in December 1955, as Frank travelled west on old Route 66. The image is lopsided, indistinct, grainy, smoky, eerily lit by a single fluorescent fixture. In terms of accepted photographic beauty and technique of the period, everything is wrong. The picture's tilt to the left creates a feeling of disorientation. We feel the loss of the control that one gets from the surety and comfort of horizontal and vertical, of things and people in their "right" places; here, things are askew.

Further, the psychological space is just as nervous and edgy as the dimensional space. Frank creates a sense of unease, of being out of place, or in the wrong place, or in the midst of a bad dream. There is an acute awareness that this photograph was taken surreptitiously, probably because of the discomfort that Frank, as an outsider, must have felt in this menacing, masculine space. Unlike all of the other photographs in the book, in this one Frank is too intimidated to take it boldly and directly from eye level. The tension between the photographer and the central standing man (so confrontational in his pose) is highlighted by the way Frank has cropped the edges so that the other figures are not fully seen.

It is possible to describe and explain the content of any picture and to attribute to it some significance. What can never be clarified adequately is why an image is wondrous in its power to evoke the imagination. All great images are mysteries, and therein rests their power. *Bar—Gallup, New Mexico* is one of those mysteries.　　　　—JM

## RICHARD STANKIEWICZ

b.1922 Philadelphia, Pennsylvania
d.1983 Huntington, Massachusetts
*1960-33*, 1960
Welded steel and iron
20 1/8 x 11 7/8 x 9 7/8 in. (51 x 30 x 25 cm)
Julius L. Rolshoven Memorial Fund  74.10

*His sculpture, using junk, is a creation of life out of death, the new life being of a quite different nature than the old one which was decaying on the junk pile, on the sidewalk, in the used-car lot.*

Fairfield Porter, 1959

Richard Stankiewicz grew up in the industrial outskirts of Detroit during the Great Depression, with a junkyard next door supplying the raw materials for homemade toys. He studied mechanical drafting, engineering, and geometry at Cass Technical High School in Detroit, served in the U.S. Navy during World War II, then was one of the famously talented group of students studying at the Hans Hofmann School of Fine Arts in New York in the late 1940s. During the 1950s, Stankiewicz returned to junk metal, now as a medium for fine art, and in so doing he helped define the new American sculpture in the postwar era.

*1960-33* (the "33" identifies it as the thirty-third sculpture he completed that year) disdains traditional carving and modeling techniques, and avoids the niceties of polished surfaces so proudly displayed by older statuary. Instead, we find crusted, rusted, corroded bits and pieces of discarded machines. Chance and improvisation play important roles here. But so, too, does what Stankiewicz called "the discipline of organization."

The central cylinder is cut away, opened up—the welder's torch serving as a surgeon's knife. Inside, the tubes and pipes evoke intestines and other unnameable organs. Sometimes, these Stankiewicz "creatures" are whimsical and cute; Fairfield Porter (and other critics of the time) saw something life-affirming in the artist's ability to recycle the detritus of the mechanical age; but *1960-33* tends to the morbid, functioning like a horribly wounded animal. It certainly exudes an emotional power all out of proportion to its modest scale. As with Minor White's boiler, the discarded metal becomes a metaphor for the human condition. The expressionism of both artists is anything but abstract.                                                              —PW

In January of 1987, the American artist David Hare visited UNM's Tamarind Institute (for the third time, after an interval of a dozen years) to create a group of lithographs. *Flying Head*, reproduced below, is one of the nine prints which he made at that time. While he was in residence at Tamarind, and seeing that Hare's much earlier *Thirsty Man* bronze was featured in our lower gallery display of the permanent collection, the University of New Mexico Art Museum invited him over for an informal reception in his honor. When asked to comment on his then forty-year-old work, Hare declined, saying in effect that he no longer felt any particular relationship to the piece, that it was, in his words, "as if it had been created by another person."

Which goes to show how, sometimes, artists can be pretty darn obtuse when it comes to their own work. Hare, according to all of his biographers, remained to the end of his long and distinguished career the American artist most consistently attuned to the ideas of the Surrealists. Just look at the strikingly similar vocabulary of forms shared by *Thirsty Man* and *Flying Head*: the bone shapes, the snarly little snout-mouths, the strange reversals of solids and voids. This was, of course, the international vocabulary of Surrealism, a sort of visual Esperanto spoken by Picasso, Matta, Ernst and—in America—by O'Keeffe, Pollock, and Hare.

Hare came to Surrealism as almost his birthright: his cousin, the artist Kay Sage, married the French Surrealist painter Yves Tanguy. During the World War II years, Hare not only associated closely with such Surrealists-in-exile as André Breton, Marcel Duchamp, and Max Ernst, from 1942 through 1944 he edited the Surrealist periodical *VVV*, with those three men as his informal editorial board. The mythic, the subconscious, the power of the irrational: these values remained central to Hare's beliefs, and to his art, for the rest of his life.

—PW

### DAVID HARE

b.1917 New York, New York
d.1992 Jackson Hole, Wyoming
*Thirsty Man*, 1946
Bronze, 31 x 12 x 7 in. (78.7 x 30.5 x 17.8 cm)
Purchased with funds from the National Endowment for the Arts, with matching funds from the UNM Foundation, Inc., and the Friends of Art
72.113

### DAVID HARE

*Flying Head*, 1987
Lithograph
30 1/2 x 23 1/8 in. (77.5 x 58.7 cm)
Collaborating printer, Beth Lovendusky
The Tamarind Archive Collection  87.25.22

## SAUL BAIZERMAN

b.1889 Vitebsk, Russia
d.1957 New York, New York
*Exuberance* (*First Sculptural Symphony*),
c.1940-1949
Copper
63 x 79 x 8 in. (160 x 200.7 x 20.3 cm)
Julius L. Rolshoven Memorial Fund
70.311

*How do I know when a piece is finished? When it has taken away from me everything I have to give. When it has become stronger than myself. I become the empty one, and it becomes the full one. When I am weak and it is strong, the work is finished.*

Saul Baizerman, quoted in *Art News*, March 1952

One would not have wanted to be a Greenwich Village neighbor of Saul Baizerman. Famously, the rings of his hammer could be heard even out on the street as he painstakingly crafted sculptures out of copper sheets. The artist went half-deaf. But the results were spectacular: his was one of the great careers in mid-century American sculpture. Which demonstrates, among other things, that an artist—even one who worked in an age which revered the notion of the permanent avant-garde—need not be a total revolutionary in order to create significant art.

Baizerman was a pioneer of sorts: nobody before (or since) made sculpture exactly the way he did. As the artist noted, his vast hammered sheets give the lie to the notion that sculpture must be either additive (built up out of stuff) or subtractive (carved away from a larger body of material). Also, unlike most relief sculpture in which the objects either stand out from or sink back into a definite plane, there's a delicious ambiguity to Baizerman's work: these bodies seem to swim in and out of a space that is both ours and theirs.

For all his innovations, Baizerman was essentially a conservative: in an age in which most of his most significant peers moved to abstraction, he persevered in the grand tradition of figural art. and he specifically acknowledged Michelangelo, Rodin, and Meunier as important precedents for his art. Closer to home (and in time), we may also note the influence of the Franco-American sculptor Gaston Lachaise. But whereas Lachaise celebrated full-blown sexuality, Baizerman's nudes are curiously androgynous—which, also curiously, makes them right at home in our time, perhaps even more so than in his.                —PW

## GASTON LACHAISE

b.1882 Paris, France
d.1935 New York, New York
*Torso,* 1927
Bronze
48 x 23 x 12 1/4 in.
(121.9 x 58.4 x 31 cm)  66.133

## FAIRFIELD PORTER

b.1907 Winnetka, Illinois
d.1975 Southampton, New York
*The Big Studio*, 1951
Oil on canvas
78 1/4 x 60 1/2 in. (198.8 x 153.7 cm)
Gift of Gloria Vanderbilt through the American
Federation of Arts Museum Purchase Award
63.159

*There is something very hard-headed and unsentimental about Porter's work, an honest appraisal of what the eye sees. Nature is analyzed and offered as patches of paint which fit together. There are no tricks, no obvious patterns, no composing by the line, yet everything holds together. The stove in* The Big Studio *is not displeased at being cast in the role of prima-donna.*

Lawrence Campbell, *Art News*, 1952

We see here the interior of Fairfield Porter's studio in Southampton, New York. The Porters had moved from Manhattan out to the eastern end of Long Island in October 1949. Now, the Hamptons are the high-pressure haunt of the rich and famous. In the 1960s and 1970s, they were a pre-eminent artists' colony. But in 1949, Southampton and its neighbors were largely rural, and dominated by vast acres of potato farms: it was the country. Porter installed his studio in a small barn at the back of his property. His main additions: a large studio window, plus a coal stove to heat (however inadequately) the uninsulated space. And this is what he records in *The Big Studio*.

Already in his mid-forties, Porter was in 1951 just coming into his own both as a remarkable artist, who successfully swam against the considerable current of the Abstract Expressionism then dominating New York painting, and as an equally remarkable and clear-headed critic, whose collected writings remain to this day among the best commentaries on the art of his time. Porter studied fine arts (mainly, art history, with a smattering of theory and design courses) as an undergraduate at Harvard, then spent two years in New York at the Art Students League (taking mostly life drawing classes). His most important instruction came from several tours of Europe, where he immersed himself in the works of both Old Master and modern painters (especially, Vuillard and Bonnard). He spent the war years as a draftsman for an industrial designer, working on naval ordnance. His paintings from the 1940s were mainly cityscapes, either views from the window of his fourth-floor studio, or street scenes.

Stacked up against the wall in *The Big Studio* are several canvasses: one primed in Porter's typical warm ground, another back to us, and the third (and right-most) recognizable as his *Wines and Liquors No. 2*, from c.1945 (and today in the collection of the Parrish Art Museum, Southampton). Is this city scene being symbolically discarded, as Porter adjusts to his new, rustic environment?                          —PW

**AGNES MARTIN**

b.1912 Macklin,
Saskatchewan, Canada
*Untitled*, c.1954
Oil on board
36 1/8 x 47 3/4 in.
(91.8 x 121.3 cm)
Anonymous gift in honor of
Vernon Nikkel
93.43

There's a wonderful story about Agnes Martin and the University of New Mexico Art Department. Martin, armed with a newly-minted B.S. from Columbia University Teaching College, arrived in New Mexico in 1946, and started taking art classes both in Albuquerque and at the University's summer school in Taos (one of her early student watercolors—a mountain landscape in a vaguely John Marin-esque style—is in the Jonson Gallery collection). At one point, she applied for admission to the graduate program (her main motivation, she would later freely admit, was to keep the use of her studio). Professor Raymond Jonson emerged from the caucus at which her application was considered, to tell her, "Agnes, we've decided instead to put you on the faculty." Thus she became a Teaching Associate, and taught on and off for the next couple of years.

It would be after her return to New York City in 1957 that Martin would find her mature style: symmetrical compositions, often based on grid patterns, and usually colored in thinly painted washes. Her apparently simple, yet deceptively complex vocabulary (Martin insists that she is not a Minimalist, but rather an Abstract Expressionist) remains intact to this day. The artist describes the 1957-1967 decade of living and working in lower Manhattan's Coenties Slip area (where her neighbors included Ellsworth Kelly, Jack Youngerman, and Robert Indiana) as the time "when I got on the right track."

And yet the work Martin did in the 1950s, after she had left Albuquerque to live in Taos, holds enormous fascination. She worked very rapidly at this time; in 1955 alone, after a Wurlitzer Foundation grant allowed her the luxury of bulk purchases of art supplies, she reportedly produced over 100 paintings (most of which she later destroyed). Our painting, though almost totally abstract, seems to contain a bird-like apparition (and a none-too-friendly one, at that) in its upper reaches. Most notable is the quick, nervously quavering line which scratches across the surface as if searching for, but not finding, a rhythm into which it could comfortably settle. Here, certainly, the expressive and Expressionist impulses are very palpable.    —PW

**AGNES MARTIN**

*On a Clear Day,* 1972-1973
Serigraph
9 x 9 in. (22.8 x 22.8 cm)
Gift of the artist
75.83

**RICHARD DIEBENKORN**

*Blue*, 1984
Woodblock print
40 1/8 x 24 5/8 in.
(101.8 x 62.6 cm)
Gift of Fay and Jonathan Abrams
91.72

**RICHARD DIEBENKORN**

b.1922 Portland, Oregon
d.1993 Berkeley, California
*Untitled*, 1951
Oil on canvas
54 3/4 x 37 3/4 in. (139.1 x 95.9 cm)
Gift of the artist  51.11

The 1950 census counted 95,815 Albuquerque residents. What it couldn't measure was the enormous excitement in the University of New Mexico's Art Department, which was then one of the "hot" places for an aspiring artist to be. Mitchell Wilder in *Atlantic Monthly*, Elaine de Kooning in *Art in America*, Joan Evans in *Art Digest*, and Lawrence Campbell in *Art News* all wrote in the 1950s about Albuquerque's emergence as a major center of modern art.

The dominant medium was painting. The dominant mode was abstraction. And the hottest of the young painters was Richard Diebenkorn. Like many others, he came to Albuquerque under the GI Bill to study in (and, in his case, to earn an M.A. degree from) UNM's Department of Art. Before entering the Marine Corps (in

1943), Diebenkorn had studied two years at Stanford, and following the war, he took his undergraduate degree at the California School of Fine Arts, where his main teacher was David Parks. In 1948, Diebenkorn had a one-person exhibition at the California Palace of the Legion of Honor. It was thus a very sophisticated, already accomplished, artist who enrolled at the University of New Mexico in January of 1950.

Still, by the artist's own later accounts, his two years in New Mexico were crucial to the development of his mature style. He talked about the influence of the spare desert landscape, seen both from the ground and in a memorable commercial airplane journey from Albuquerque to San Francisco. He also took energy from the lively cadre of painters at UNM: both faculty (Raymond Jonson, Enrique Montenegro) and fellow students (Robert Walters, Rita Deanin, Paul Harris). Whatever the sources and resources, his art took flight. And in such paintings as this one from his 1951 M.A. thesis exhibition, his handling of paint became much more assured, and caught up with the quirky draughtsmanship which he brought with him from San Francisco. The result: you can't really tell where painting and drawing separate from each other. The space opens and closes, the light both falls upon and emanates from his surfaces. It's a grand achievement, and one that fully predicts the celebrated career which followed.                    —PW

## MILTON RESNICK

b.1917 Bratslav, Ukraine
*No. 8*, 1955
Oil on board, 30 x 31 in. (76.2 x 78.7 cm)
Julius L. Rolshoven Memorial Fund  86.204

*Paint is like the storm, and I'm a straw lost in this strong wind. Paint is the master.*

Milton Resnick

For years, critics and art historians didn't know quite what to do with Milton Resnick. Born in 1917, he is a close contemporary of Pollock, de Kooning, Kline, et al. But unlike most of the "First Generation" of New York School artists, Resnick served in the U.S. Army during World War II, so his career was late in getting started. He didn't have his first one-person shows until 1955, which misplaced him in the public mind as a "Second Generation" figure—supposedly to be judged against such other artists as Helen Frankenthaler and Larry Rivers.

Finally, enough time has passed that the critical wars of the 1950s (abstraction vs. representation, who poured paint directly on a raw canvas first) seem faintly ridiculous. Resnick in particular has benefitted. Now, critics don't worry so much about how to label him. Instead, they have begun to notice that his paintings—all the way from the 1940s to now—constitute one of the strongest, sustained careers in post-World War II art.

This strength was revealed in a full-scale retrospective devoted to Resnick by the Houston Contemporary Arts Museum in 1985. It is also evidenced in a single painting: his *No. 8* of 1955, painted the very year Resnick first came to public attention with one-person shows at the de Young Museum in San Francisco (he taught at Berkeley that year) and at the Poindexter Gallery in New York. It is a typically "tough" New York painting. Thomas Hess, reviewing the Poindexter show in *Art News*, wrote about the "musculature" and "raw personality" of Resnick's work.

At the same time, there's a good deal of elegant lyricism here, and the curved shapes often suggest human torsos. Hess—typically astute when it came to looking at his contemporaries' art—found Resnick's pictures to be "classical works, expressions of organic stability and optimism." A half-century later, it still looks fresh, and convincingly demonstrates why New York painting of the 1950s conquered the world of art.

—PW

**OLI SIHVONEN**

>   b.1921 Brooklyn, New York
>   d.1991 New York, New York
>   *Dialogue Spring*, c.1966
>   Oil on canvas, 72 x 52 in. (182.9 x 132.1 cm)
>   72.612

Critics talk about two possible models for 20th-century art: literature or music. Oli Sihvonen's *Dialogue Spring* —almost heartachingly beautiful—seems a nearly perfect example of art-as-music. Two ellipses (one a pure pumpkin orange/yellow, the other a mottled violet) hover, not quite touching, against a yellow/green field. The axis of the bottom ellipse turns slightly away from the horizon line of the top one. It's all as pure and as apparently effortless as a Mozart (or Erroll Garner) piano composition. It stuns you into silence, as does all great art.

But of course, there are references to the "real" world. There is a story, there is literature. Even in describing the painting, inevitably words that connote nature ("pumpkin," "violet," "field") creep into play. Sihvonen named his painting *Dialogue Spring* in full awareness of the springtime palette: the green of newly sprouted leaves, the yellow and violet of the earlier flowers. Still, despite precedents in nature, the artist makes us see these combinations of shapes and colors as if nothing like them had ever existed before.

Sihvonen studied at Black Mountain College, located near Asheville, North Carolina, in that famous institution's heyday: the late 1940s. His mentors included Ilya Bolotowsky, Buckminster Fuller, and—above all others—Josef Albers, the great color theorist and refugee from the Hitler-disbanded Bauhaus. A small Sihvonen woodblock at the Jonson Gallery (where he showed, twice, in the 1950s) strongly evidences the influence of Albers. By 1956, Sihvonen was living in Taos. Many still recall the joy of visiting his house/studio, with his gloriously colored canvasses ranged outside in the sunlight. In 1965, he was included in the famous Museum of Modern Art exhibition, "The Responsive Eye," and, in 1967, Sihvonen moved to New York City where for the rest of his life he lived and painted in a walk-up, Chinatown studio. Though sustained public success eluded him, Sihvonen created some of the most truly beautiful paintings of the 20th—or, for that matter, any other—century.                                    —PW

**OLI SIHVONEN**

>   *Block Print IV*, 1949
>   Woodblock print
>   8 3/8 x 13 in. (21.3 x 33 cm)
>   Bequest of Raymond Jonson,
>   Jonson Gallery Collection
>   82.221.1239

# Later Twentieth-Century Art

# LATER TWENTIETH-CENTURY ART

It's almost a truism that every age has the greatest difficulty coming to grips with the art closest to its own time. This has perhaps especially been the case over the last few decades. For a while in the 1960s, in the aftermath of Abstract Expressionism, critics at least tried to sort out what was going on with a veritable blizzard of "isms" and other movement names. Pop Art, Minimalism, Op Art, Photo Realism, Conceptual Art, Earth Art, Performance Art, Lyrical Abstraction—within the decade 1960-1970, each of these found critical voices to champion it as the newest great thing.

Then ... almost nothing. Maybe both critics and artists were exhausted by the frenetic effort of "trend spotting." True, "Post Modernism" was tried out (first in architecture, then in other art mediums) as a catch-all term to describe the art of the 1970s and early 1980s, when some artists stopped attempting to innovate and instead contented themselves with recycling past ideas and styles. But nobody was very satisfied, either with the term or with the art that resulted.

So what was an artist, or a critic, or a collecting-exhibiting institution such as a university art museum (such as the University of New Mexico Art Museum) to do? For us, and for others, the answer was pretty simple: forget about finding typical examples of this or that trend, and concentrate on those qualities of eloquence and integrity which mark the best art of all periods and cultures.

As contemporary art has become more and more expensive (in part, because contemporary art galleries have become more and more expensive to rent and to run), the temptation has been to concentrate instead on the art of earlier times. Certainly, as the previous sections of this handbook abundantly evidence, over the past few decades we've been able, within the limits of our extremely modest purse, to purchase some truly wonderful examples of Renaissance and Baroque and 19th- and earlier 20th-century art. But, as a teaching institution, we have a real obligation to try to keep current. You can't teach chemistry from a forty-year-old textbook; neither can you teach art (or world culture) exclusively from decades-old paintings.

So we've looked to friends, and to our Friends of Art, and to our continuing close association with UNM's Tamarind Institute (the lithographs of which we archive) to keep us credibly current. Fortunately, there are still tons of wonderful artists out there whose works are not extravagantly priced, who yet still fully represent values both very contemporary and very timeless. How good a job have we done in fulfilling this most important and, arguably, most difficult part of our mission? Judge for yourself from these catalogue entries. Or, better yet, from the works, themselves, when you visit our galleries. Or, best of all, wait for a vantage point some twenty or thirty years into the 21st century. We look forward to hearing from you.

## JOAN BROWN

b.1938 San Francisco, California
d.1990 Putttaparthi, India
*The Moon Cast a Shadow on a Midsummer Night*, 1962
Oil on canvas
71 3/4 x 142 in. (182.2 x 360.7 cm)
Gift of Dr. Samuel West
76.250

*I really dug painting, and I loved the application as well as the look of the paint, right out of the gallon can. I loved what happened when I was using the trowel, the physical exuberance of just whipping through it with a big, giant brush.*

Joan Brown, 1975

In 1960, at age twenty-two, the brash Californian (1) received her M.F.A. from the California School of Fine Arts, (2) had her first one-person exhibition at the Staempfli Gallery in New York City, and (3) was the youngest artist in the Whitney Museum's "Young Americans" exhibition. Not a bad trifecta!

Our painting (from the collection of Dr. Samuel West, the fabled dentist/collector, who traded his professional services for work by many of the best young Bay Area artists of the 1960s) comes from two years later, from 1962. She had just finished a group of paintings after Rembrandt, to whom she was attracted both by his expressive and emotional subjects and by his rough, complicated oil-painted surfaces. Brown, typically, raised the ante. She painted so thickly—literally trowelling on the paint, building it up to depths of two, three, or even more inches—that sometimes whole areas would self-destruct and slide off her canvasses. The critic Philip Leider, writing in a 1963 review, wrote in both horror and admiration of Brown's "tough, moody, coarse, and even ugly paint."

As for her subject matter, it became very autobiographical. She was a swimmer, a competitive distance swimmer who swam many a meet in San Francisco Bay. *The Moon Cast a Shadow on a Midsummer Night* may be part fantasy, part fact. On a rich-black night, two nude women (or is it a single figure, seen twice?) stand in the waves. Their great blocky bodies turn the aesthetics of, say, Botticelli's *Birth of Venus*, on its head. Instead of winsome grace, they literally embody the eternal strength of Easter Island sculpture. The surf bounces off from them, and they just stand there, impassive and monumental.

In later Brown paintings, the paint thinned and the mood (especially, when she included one of her cats) turned at times downright whimsical. But the figure style and the reliance upon autobiography remained intact, right up until her untimely death by accident in India.

—PW

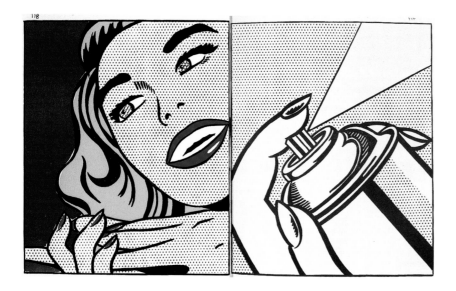

**ROY LICHTENSTEIN**

b.1923 New York, New York
d.1997 New York, New York
*Girl* and *Spray Can,* 1963, from the portfolio
*1-cent Life*, printed 1964
Lithographs
each 12 5/8 x 10 5/8 in.
(32.1 x 27.1 cm)
Purchased with funds from the Friends of Art
94.7

In both London and New York, "Pop goes the easel!" was the defining phrase for 1962, the year of a BBC television film of that title, and of breakthrough one-person exhibitions by Andy Warhol, Claes Oldenburg, Jim Dine, and Roy Lichtenstein. By 1963, all four of those artists—plus twenty-four of their contemporaries, from both Europe and the United States—were busily engaged in the greatest of all Pop Art printmaking projects: a portfolio of lithographs, printed in Paris and published in Bern in 1964, called *1-cent Life*.

It all came from the fertile brain and febrile energies of a Chinese poet-painter, Walasse Ting. In 1961, he sat in a small black room in Paris and quickly wrote sixty-one poems: funny, frequently scatological, many about an America that he at that time barely knew. Ting showed his poems to the American expatriate painter Sam Francis, who in turn connected up with the publisher E. W. Kornfeld. In Ting's recollections (published in *Art News* in May 1966):

*Sam Francis take his money from Swiss bank to buy 17 tons white paper like white snow. All lithographs as hundred kind of flowers in spring melt on pages.*

*Four printing companies work one year, everything must be perfect, changes and reprinting, money running away like April rain in Paris.*

*Some artists come to Paris to make lithographs. In New York I carry zinc plates to their studios, we drink and laugh.*

The resulting publication weighed in at nine pounds. Each of the edition of 2000 contained sixty-one lithographs (one illustration to each Ting poem). For many of the twenty-eight artists, *1-cent Life* caught them at a critical moments in their careers.

In Roy Lichtenstein's case, for instance, these are among his very earliest Pop Art prints, and show him working toward a style which mimics commercial techniques. From about 1961, Lichtenstein's paintings featured several characteristic elements: (1) restricted colors (usually the red, yellow, blue, and black of commercial printing), (2) bold, outline drawing, and (3) the use of a crude dot pattern to signify a half tone. This last device came from the Benday dot pattern, used also in commercial printing (but usually invisible to the casual glance). Lichtenstein blew up the scale of the dots to make them insistent. Here, he hand drew them (later, they are much more mechanically ordered). Ting recalled:

*Lichtenstein: Spent two weeks, each hour one dot, looks like gentleman prefer the blond.*

—PW

**GERALD LAING**

b.1936 Newcastle-on-Tyne, England
*Skydiver VIII*, 1964
Oil and graphite on canvas
116 x 96 in. (294.6 x 243.8 cm)
Gift of Mr. and Mrs. Michael Findlay
77.215

Many graduates of Sandhurst, the Royal Military Academy of Great Britain, have gone on to distinguished careers in other disciplines. But Gerald Laing must be among the very few who carved out a considerable name in the annals of later 20th-century art. After Sandhurst, after service as an infantry Lieutenant in the Royal Northumberland Fusiliers, Laing attended St. Martin's School of Art in London in the early 1960s, just in time to catch (and become a leading participant in) the first wave of Anglo-American Pop Art.

Indeed, Laing epitomized the transatlantic nature of Pop. In the summer of 1963, he caught a cheap flight from London to New York, with introductions in his pocket to Andy Warhol, Roy Lichtenstein, James Rosenquist, and Robert Indiana. He worked for a while as an assistant to Indiana, in a section of whose studio he completed eight paintings which he left behind when he returned to England. Much to his surprise and delight, some months later the art dealer Richard Feigen telegraphed an offer to buy those paintings and give Laing shows at his galleries in New York, Chicago, and Los Angeles.

Laing painted his *Skydiver* series in New York in 1964. Typically, as here, each painting combined two images: the skydiver and a collapsing parachute, both derived from color photographs which appeared as magazine illustrations. The series explored multiple permutations, sometimes on a single canvas, but more often—as here—in a diptych format, with one or another of the two sections oddly shaped. Our skydiver seems like unto the angels which hover in separate panels above Early Renaissance altarpieces; irrationally, he appears to be supported by the parachute beneath.

The magazine illustrations which served as Laing's sources were actually printed in quite good detail, with continuous gray tones. But Laing both simplifies them, and renders the shading in and around the skydiver in what amounts to a parody of the cheapest kind of comic book illustration technique: the Benday dot pattern (a kind of poor-man's screen, with abrupt transitions for light, middle, and dark shadings). This intrusion of a blatantly commercial art technique into the world of fine art was something that the American Pop artists (especially, Lichtenstein and Warhol) were also doing at this same time in the early and mid-1960s; the shaped canvas was more usually associated with 1960s abstractionists (Frank Stella, pre-eminently). Together, these devices stamp *Skydiver VIII* as a product of its time.    —PW

**LARRY POONS**

b.1937 Ogibuko, Japan
*Stew Ball*, 1966
Graphite on graph paper
15 1/4 x 17 in. (38.7 x 43.2 cm)
Gift of Vernon Nikkel, Clovis, New Mexico,
in memory of Frank F. Nikkel, Anna Zielke
Nikkel, Ruth Nikkel, Irene Hutchinson,
and Martha Nikkel Critelli
89.10.1

Like Oli Sihvonen (whose painting, *Dialogue Spring*, appears in the previous section), Poons was included in the landmark Museum of Modern Art 1965 exhibition, "The Responsive Eye." Like Sihvonen's, his art of this time is often categorized as being part of the Op Art (so-named, for being optically "charged") movement. Like Sihvonen's in its purified abstraction, Poons's art also often approaches the status of music. (It's perhaps worth noting that Poons first attended the New England Conservatory of Music for two years, studying composition, before switching over to the Boston Museum of Fine Arts school, where he stayed for an even shorter six months).

But, compared to Sihvonen, Poons belongs to a younger, post-World War II, generation. There's a marvelous made-for-public-television tape of Poons in 1967, in which he smokes incessantly, wears a Shelby Racing T-shirt, looks like a slightly chunkier James Dean, and generally plays the role of the angry young painter. All that while, from about 1963 to 1968, he was making some of the most ravishingly beautiful, some of the most perfect, paintings you would ever hope to see.

Our *Stew Ball* is not exactly a study for one of these paintings (Poons always maintained that his drawings had no particular relationship to the paintings, although he did allow that they helped him work out what he called the "scaffolding" he would employ in the paintings). Indeed, compared with our drawing, the paintings of this period were significantly less full of incident: over a field of a single pure color, Poons dispersed ellipses (and, sometimes, circles) of other colors. The paintings might be six to twelve feet on a side; the ellipses were only three or so inches across; this scale sense comes across pretty well in *Stew Ball*, as does the sense of an underlying grid supporting the ellipses. What the paintings don't have is anything like the cross-hatched trapezoids in this drawing. One can only guess that they represented, for Poons, an approximation of the weight and the thrusts of energy that accrued to the sometimes brilliantly colored painted ellipses of his canvases, which positively vibrated with optical excitement.

Around 1970, Poons—still at the height of popularity with both critics and collectors—bravely shifted gears, to lushly poured paint which he built up in more and more lavishly encrusted textures. He's still very much around, but has never—to most eyes—recaptured the magic of his early career.

—PW

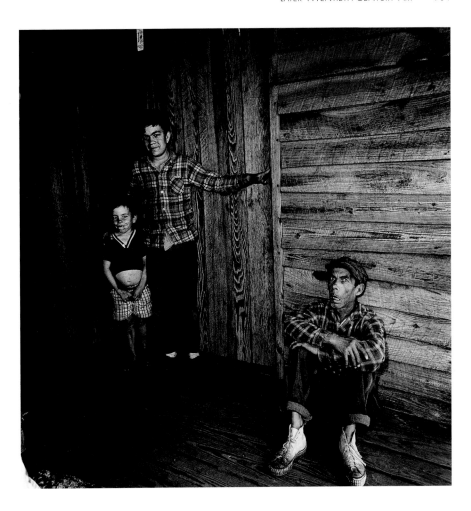

## DIANE ARBUS

b.1923 New York, New York
d.1971 New York, New York
*Untitled*, from the photo essay
"Let Us Now Praise Dr. Gatch," 1968
Gelatin silver print
10 1/2 x 10 1/8 in. (26.7 x 25.7 cm)
94.29.1

Standard biographies of Diane Arbus start with her early education at New York City's Ethical Culture School, move on to her marriage and partnership in fashion photography with Allan Arbus, her study of "art" photography with Lisette Model in the mid-1950s, and her two Guggenheim fellowships (1963 and 1966), then highlight her breakthrough inclusion in the Museum of Modern Art's "New Documents" exhibition in 1967, and conclude with the troublesome notoriety of her last years. The images that biographers and critics concentrate upon are her powerful portraits of nudists, transvestites, the mentally handicapped, and other disturbed or disturbing outcasts.

Rarely mentioned is the fact that Arbus, during her lifetime, found by far her greatest audience (and financially sustained her career) through assignment work for such mainstream magazines as *Esquire, Harper's Bazaar, The New York Times Magazine, Glamour, Show,* and *The Sunday Times Magazine* (London). (A notable exception to this silence: the exemplary exhibition and catalogue devoted to Arbus's magazine work, put together by Thomas Southall in 1984; Southall, who took his graduate degree in the history of photography at the University of New Mexico, was then curator of photography at the University of Kansas's Spencer Museum of Art.) Our photograph— so very beautiful and so very challenging, even horrifying, at the same time—came out of one such assignment: to provide photographs to illustrate a June 1968, *Esquire* muckraking article written by Bynum Shaw, and entitled "Let Us Now Praise Dr. Gatch."

That article title clearly recalls the 1941 book *Let Us Now Praise Famous Men*, written by James Agee and with extensive photographs by Walker Evans, resulting from a 1936 journey the two took together to sharecropper country in Alabama. Roughly thirty years later, Shaw and Arbus followed Dr. Donald E. Gatch around his rural practice in and near Bluffton, South Carolina. The good Dr. Gatch battled malnutrition, parasites, and other severe health problems among dirt-poor outcasts (most of them, African-American) from the Great Society. Arbus probably took our photograph (which didn't make it into print) in the Tiger Ridge region, just across the state line in Georgia. Shaw describes the poor white inhabitants as inbred, withdrawn, and suspicious, all of which descriptors certainly apply to Arbus's photographic record. Evans, in Alabama, took photographs of either the people (in close-ups) or the vernacular architecture. Arbus shows this family in context, and one can't help but admire the soft beauty of the lumber out of which their dwelling is constructed, while at the same time deploring the palpable effects of the abject poverty in which they live.

—PW

## DONALD JUDD

b.1928 Excelsior Springs, Missouri
d.1994 New York, New York
*Table Piece*, 1969 (no. 70, from an edition of 200)
Stainless steel
2 1/2 x 24 x 20 1/4 in. (6.4 x 61 x 51.4 cm)
Gift of Robert W. Peters  91.75.4

## DONALD JUDD

*Untitled*, 1970
Ink on paper
16 3/4 x 21 5/8 in. (42.5 x 55.1 cm)
Gift of Vernon Nikkel, Clovis, New Mexico,
in memory of Frank F. Nikkel, Anna Zielke
Nikkel, Ruth Nikkel, Irene Hutchinson, and
Martha Nikkel Critelli  89.10.2

Formed from a single sheet of stainless steel, this piece comprises four upside down channels. Each is 2 feet long, and the open ends of the channels are exactly twice as wide (5 inches) as they are high (2 1/2 inches). The top surface is broken by three grooves resulting from the folds of the metal. Though uniform and unadorned in finish, each plane reflects light (and collects surrounding colors) differently, resulting in a subtly varied, visually rich experience.

Judd would have described this piece so much better, and probably in half as many words. Like Fairfield Porter, he was at an early stage of his career a master reviewer/critic. And his criticism, like his art, was laconic, precise, lapidary. Here's Judd reviewing (in *Arts Magazine*, April 1963) an exhibition of paintings by Josef Albers (one of the older painters whom he wholeheartedly admired):

*The paintings are all concentric, dropped squares. There are no mitered corners or other lesser schemes.* High Spring *has a central cerulean green square, a concentric band of a somewhat cool medium gray, and a wider, final band of apple green. The center is acute, intense, and ambiguous.*

Judd's language, like his art, was spare, lean, purposeful. Both fit right in with the terseness of American vernacular speech and habit. "Square" deal, "straight" shooter, "plain" speaking—these are all perceived American virtues, and the adjectives describe a style of art as well as a way of life. That art style, of which Judd was the generally acknowledged leader, emerged in the 1960s. Abstract, geometric, and reductive, it came to be known as Minimalism (a term which Judd disliked; he called himself "an empiricist"). Though born in the United States, Minimalism became the most international and long-lived of later 20th-century art movements. Judd, himself, created exquisitely minimalist art right to the end of his life, working in drawings, prints, architecture, and furniture, as well as sculpture in a variety of materials. He was a master of scale, surface, and detail, and his works shine with moral purpose.          —PW

## JOHN MCLAUGHLIN

b.1898 Sharon, Massachusetts
d.1976 Dana Point, California
*#1*, 1967
Oil on canvas
47 7/8 x 59 3/4 in. (121.6 x 151.8 cm)
Gift of the artist
70.168

At least superficially, McLaughlin's painting looks much like Judd's sculpture: spare, geometric, abstract. And McLaughlin, like Judd, has often been labeled a minimalist. But here, the label is perhaps even more likely to obscure rather than to clarify or inform the true nature of this work of art, and of this artist's oeuvre.

First of all: what are we looking at? A painted black (vertical) rectangle sits within a larger (horizontal) white one. It (the black rectangle) looks to be more or less lined up at the center of the canvas, and to be more or less of the same proportions as that larger containing rectangle. Look longer, and finally pull out a tape to confirm it, and you come to realize that these relationships are truly less rather than more. That is, the black rectangle has been "slid" to the right, about 1 5/8 inches across the center line. Also, its proportions (46 1/2 inches high by 28 1/8 inches wide) are considerably narrower than those of the full canvas. And why are the borders top

and bottom just 5/8 inches wide, while that to the left is a full 3 1/2 inches? Minimalist art, typically, celebrates the cerebral, the rational, the geometrically precise. McLaughlin's painting turns out to be, by contrast, very intuitive, its relationships deriving more from aesthetic "rightness" than from mathematical formulae. Looking into McLaughlin's life for clues, we discover that he only turned to painting in 1938 (at the age of forty). Prior to that, he had immersed himself in Japanese culture, living for a time in Japan, and dealing in a small way in Japanese prints and ceramics. He loved Asian paintings because "they made me wonder who I was. By contrast, Western painters tried to tell me who they were." He particularly admired the works of the 15th-century artist Sesshu and his follower Sesson:

*Certain Japanese painters of centuries ago found the means to overcome the demands imposed by the object by the use of large amounts of empty space. This space was described by Sesshu as the "Marvelous Void." Thus the viewer was induced to "enter" the painting unconscious of the dominance of the object.*

This strain of Eastern, transcendental aestheticism can be traced back through Arthur Wesley Dow in the early 20th century, through even James Abbot McNeill Whistler and 19th-century "Japonism." McLaughlin—a Zen monk in minimalist garb—represents but one of several late 20th-century American artists for whom Asian art and thought were vital resources
—PW

## FOUR CALIFORNIA SCULPTORS

In the 1960s, sculpture came in for special attention, with many of the leading ideas of the time seemingly demanding to be realized in three dimensions. At that same time, too, West Coast art emerged as a significant counterweight to the dominance of the New York School. These four sculptors—Conner, Hudson, di Suvero, and Mattox—all came to the San Francisco Bay Area in the 1950s, and all helped to lead the vital school of California sculpture which emerged out of that region around 1960.

Bruce Conner remains equally well known as an experimental film maker and as a sculptor; both facets of his career became established right around 1960, when he released his first films and had his first one-person exhibition at San Francisco's Batman Gallery. *The Clock* shows Conner's early mastery of assemblage: the art of accretion, of gathering together disparate (often, discarded) elements, and making out of them an evocative, concrete whole. Fur, floral ornaments, rhinestones, glass, beads, feathers, and torn lavender hosiery are just some of the materials caught under the black spray of paint. There is almost something of the horror film aesthetic here. Listen for the screech of a fingernail across a blackboard, or the slow ominous drip of water. Then, footsteps creak on the stairs, and ...

Robert Hudson helped to define the Funk Art movement in the Bay Area in the 1960s. The term, "funk," comes out of the world of jazz, where it signified loose improvisation, with an element of dirtiness thrown in. Hudson's complex painted-metal sculpture certainly fits the loose part of the definition, however it's more whimsical than dirty. There are a few right angles thrown in. But mostly it seems like an eager puppy dog, ready to fly off in several directions all at once.

It may stretch things a bit to call Mark di Suvero a California sculptor. He left for New York in 1957, and now has the most international presence of any of these four sculptors. That presence is mainly predicated upon his mammoth public art pieces, many featuring steel I-beams, polychromed and balanced in visually precarious tension. But they (and even more so, his smaller pieces, such as *Gust*) still evidence his roots in the devil-may-care, California-inclusive attitude toward sculpture he imbibed during his school years at Berkeley in the 1950s.

It's hard to define a "characteristic" Charles Mattox piece: his life in art spanned eight decades, from youthful realistic landscapes to lasers. By the 1940s, he was experimenting with electromagnets to make sculptures of random movement. But it was in the Bay Area, in the 1950s and early 1960s, that Mattox became fully attached to kinetic sculpture: especially, of the almost comic motorized sort, such as this untitled piece from his *Linkage Series*. From 1968, Mattox lived and worked in Albuquerque, where he was Professor and then Professor Emeritus of sculpture, and a much revered figure in the community.

Four California sculptors. Their works, of many moods and in multiple materials, reflect the experimental nature of that state, and that state of mind of the 1960s.                    —PW

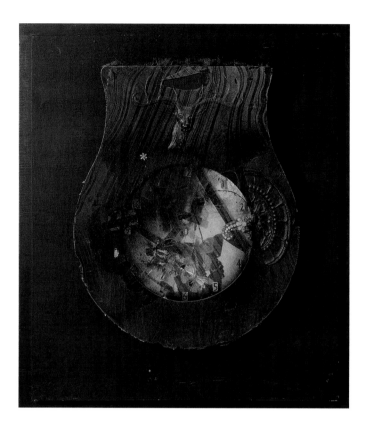

**BRUCE CONNER**

b.1933 McPherson, Kansas
*The Clock*, 1960
Mixed media
17 1/2 x 15 1/4 x 1 1/2 in. (44.5 x 38.7 x 3.8 cm)
Gift of Dr. Samuel West
76.266

**ROBERT HUDSON** (above left)

> b.1938 Salt Lake City, Utah
> *Untitled*, 1962
> Painted metal
> 40 3/4 x 24 1/2 x 13 1/4 in. (103.5 x 62.2 x 8.3 cm)
> Gift of Dr. Samuel West  76.262

**MARK DI SUVERO** (above right)

> b.1933 Shanghai, China
> *Gust*, c.1974-1983
> Welded steel
> 42 1/2 x 37 x 11 3/4 in. (108 x 94 x 29.8 cm)
> Gift of Enrico Martignoni  91.76

**CHARLES MATTOX** (below left)

> b.1910 Bronson, Kansas
> d.1996 Albuquerque, New Mexico
> *Untitled*, from *Linkage Series*, c.1975
> Wood, metal, plastic, with motor
> 18 1/2 x 16 1/2 x 11 in. (47 x 41.9 x 27.9 cm)
> Gift of the Estate of the Artist  97.5.28

## MICHAEL HEIZER

b.1944 Berkeley, California
*Splice of Negations*, 1968
Ballpoint pen, 18 1/2 x 24 3/4 in. (47 x 62.9 cm)
Gift of Vernon Nikkel, Clovis, New Mexico, in memory of
Frank F. Nikkel, Anna Zielke Nikkel, Ruth Nikkel,
Irene Hutchinson, and Martha Nikkel Critelli
69.28

Up until 1967, Michael Heizer pursued what was at that time a fairly traditional art career: study at the San Francisco Art Institute, a move to New York, affiliation with the famous Park Place Gallery— where he showed his Minimalist shaped canvasses, with his signature cut-out centers. Then, suddenly, he renounced painting, renounced all traditional art mediums, and began creating enormous things out in the desert lands of California and Nevada.

Some of Heizer's new works looked a bit like paintings: he dragged huge bags of pigments out onto dry lake beds, and spread them around in patterns briefly photographed, but soon dispersed by the shifting winds. Others might, with some stretch of the imagination, fall loosely within the notion of sculpture: he scratched designs (at times, based on randomly dropped match sticks) into these same lake beds, at first using nothing more than the toe of his boot. Quickly, these designs became larger and larger. In 1968, Robert Scull, the famous Pop Art patron, underwrote *Nine Nevada Depressions:* a 520-mile line of loops, troughs, and other disturbances dug into leased sites. The following year, Heizer bought sixty acres on Mormon Mesa in Nevada and began his most ambitious project, *Double Negative*. On facing sides of a deep arroyo, Heizer excavated two huge notches, removing an estimated 250,000 tons of desert rock. Now, thirty-plus years later, these cuts are already eroding, filling in with debris from their collapsing sides. The ephemeral and the monumental meet in space and time. Entropy conquers art.

*Splice of Negations* belongs to this sequence of art making. Though never carried out, the drawing suggests a vast scheme, hundreds of feet, maybe hundreds of yards long. As has often been noted, this body of work resembles nothing so much in the history of art as the vast, ancient Peruvian diagrams which can only be seen from the skies (and which have given rise to wild speculation about space visitors). Also often noted is the fact that the artist made childhood visits to these sites with his father, the anthropologist Robert Heizer.

Michael Heizer was, of course, not alone in such pursuits. Robert Smithson, Walter De Maria, Charles Ross, Sushaku Arakawa were other artists of this time who also chose to leave the world of gallery spaces and traditional object making, in favor of vast projects out in nature. Earth (or Land) Art is the rubric coined to describe their efforts. These projects, which continue today, never transformed the world of art. But individually and collectively, these artists presaged the modern commitment to environmental studies.                                    —PW

## DANIEL BUREN

b.1938 Boulogne-Billancort, Seine-et-Oise, France
*Untitled*, from the series *Discordance/Coherence*, 1970
Striped fabric with hand painting
62 x 54 5/8 in. (159 x 140 cm)
Gift of Vernon Nikkel, Clovis, New Mexico, in memory
of Frank F. Nikkel, Anna Zielke Nikkel, Ruth Nikkel,
Irene Hutchinson, and Martha Nikkel Critelli
2000.5.3

*Painting at degree zero, the ultimate limit of experience and maximal critique of painting, overflowed its own framework, to pass from its status as finished critical object, to that of interrogating visual tool.*

Daniel Buren, 1987

In April of 1968 Parisiennes awoke to find over 200 billboards in and around their city covered with white and green vertically striped paper. Soon, lots of people (some in the arts, some not) were receiving in their mail envelopes, with no return address, containing a similar striped paper. Then two "sandwichmen" made their appearance in various districts of Paris, carrying front and back boards covered with the same paper. The color might vary (usually green, sometimes red, occasionally some other color). But always the stripes alternated white and a color, always the stripes were vertical, and always—when Buren produced them—they were exactly 8.7 centimeters wide (in this commercial fabric, they are a smidgen wider; the next-to-furthest-out white stripes have also been overpainted in white).

The plague of striped paper (or, sometimes, cloth) spread. To New York (where abandoned storefronts got their windows covered, and sides of parked trucks suddenly became moveable art works). To Switzerland (where the police were not amused, and the perpetrator—Daniel Buren, of course—was briefly arrested). "Interrogating visual tool," indeed. Buren (with other artists of his generation) was questioning what art could/should be, and where it should/could be experienced. In the aftermath of Abstract Expressionism, and perhaps as an antidote to it, Buren declared both in his art and in accompanying statements a not-so-quiet revolution. All those properties hitherto associated with "fine" art—uniqueness, composition, refined and subtle handling of materials, the expression of individual personality in a way designed to elicit complicated emotions (ranging from "oohs" and "ahs" of delight to outright terror)—all those properties were wiped away, in favor of a depersonalized art that cropped up in unexpected places (through the mail slot, on the side of a truck).

At least that was the program of "painting at degree zero" (the phrase comes, by the way, from Roland Barthe's earlier essay on "the degree zero of writing"). But, ironically, we can now look at Buren's thirty-year-old painting and, legitimately, see it as touchingly beautiful. The revolutionary has attained Old Master status (well, almost).—PW

## VIJA CELMINS

b.1939 Riga, Latvia
*Untitled*, 1970
Lithograph
20 1/4 x 29 1/4 in. (51.4 x 74.3 cm)
Collaborating printer, Tracy White
The Tamarind Archive Collection
74.447.2017

Vija Celmins and her family, one of hundreds of thousands of such families displaced during World War II, arrived in Indianapolis, Indiana, in 1949. Placed in a 4th-grade class, but not knowing any English, the young refugee sat at her desk and drew. And drew, and drew. Two decades later, working over a stone at Tamarind Lithography Workshop in Los Angeles, Vija Celmins still drew incessantly, almost obsessively. Working with #4 and #5 Korn's lithographic pencils, and starting in one corner and moving diagonally across the surface, she painstakingly created (recreated?) the surface of the ocean, wave after wave after wave. When printed in dark grey ink (50% Hanco Opaque White, 40% Sinclair & Valentine Stone Neutral Black, 10% Sinclair & Valentine Blue) on paper already tinted light grey (90% Hanco Opaque White, 4% Sinclair & Valentine Stone Neutral Black, 3% Sinclair & Valentine Royal Blue, 3% Sinclair & Valentine Purple), the

resulting image is one of the great tours de force of 20th-century lithography. Indeed, for sheer elegance and demonstrated mastery of the complete range of tonalities available within the medium, it rivals anything done by the great 19th-century practitioners of the medium.

Still today, viewers' jaws almost inevitably drop out of admiration of the technical virtuosity. But this print—and this remarkable artist—have a lot more going for them than simply technique. From 1963 to 1976, Celmins lived in Venice, California, then a pretty down-and-out neighborhood, but close to the sea, and she would of an evening walk over to Venice Pier and stare out at the Pacific. She began to take very informal photographs of the ocean, and in the late 1960s began to draw from these photographs, using graphite pencils of varying hardness and working on a specially prepared surface: a light ground of acrylic paint over paper. There are several tensions inherent in these drawings (and in this closely-related lithograph): the tension between the two-dimensional surface of the paper and the spatial depth of the surface of the sea, the tension where the limitless expanse of the ocean hits the edge of the paper, the tension between the fluidity and restless motion of the waves and the stillness of the drawing, the tension between the greyness of the depicted water and our knowledge/memory of the range of colors in the original. Add to all this our collective memory of the ocean as a miraculous, even religious place of life's origins, and you get a wonderfully heady brew. Which, in the hands of Vija Celmins, became the starting point for some of the most evocative images of our time.                                    —PW

## JOSEPH RAFFAEL

b.1933 Brooklyn, New York
*New Guinea Warrior*, 1971
Oil on canvas, 84 x 74 in. (213.3 x 188 cm)
Purchased with funds from the National Endowment for the Arts,
with matching funds from the UNM Foundation, Inc.
72.115

*New Guinea Highlander Dressed for a Festival*
(photograph by Don McCullin)
*New York Times Sunday Magazine*
cover illustration, March 15, 1970.

*Photorealism [Hyper Realism, Super Realism]. Style of painting, printmaking and sculpture that originated in the USA in the mid-1960s, involving the precise reproduction of a photograph in paint or the mimicking of real objects in sculpture.*

The Dictionary of Art, 1996

In 1969, the distinguished British photojournalist Don McCullin travelled to New Guinea where he shot, among other events, a three-day festival of highland tribespeople. The *New York Times Sunday Magazine* of March 15, 1970, ran one of McCullin's color photographs on its cover (and several more inside, all related to an article by the very distinguished anthropologist, Margaret Mead). In 1971, the American realist (Photorealist?) painter Joseph Raffael propped up that *Times Sunday Magazine* cover next to a roughly seven-foot by six-foot canvas, and began—freehand—to paint a picture.

And what a picture it is. Whenever exhibited, it stops people dead in their tracks. Because of the sheer scale of this man's face, for one thing. Plus how Raffael cropped away all extraneous surrounding space, filling his surface with the face (pressed right up to the surface of the painting), the beaded hat, the badge of tribal council office, the (cassowary?) feathers. Then there's the color: vibrant, intense, glowing. It's as if the painting is internally lit: it seems brighter, more light-and-color filled than anything else in the room. Even from a distance, it's also apparent that this is not stodgily painted. Instead, the surface is fluid, alive, expressive. Flicks and swirls of thinly washed oil glazes contain (like gasoline floating on water) myriad, shifting, entire spectrums of color.

Raffael loves paint and color (at Yale, where he took his B.F.A., he studied with both the greatest color theorist of the 20th century, Josef Albers, and with one of the most exuberant paint handlers of all the Abstract Expressionists, James Brooks). Most of the Photorealists (Richard Estes, Robert Bechtle, et al.) limited themselves to recording exactly what their photographic source looked like. For Joseph Raffael, the photograph was just a starting place, a jumping-off point. Raffael loves paint, and loves showing off what it can be and do.                    —PW

## JOSEPH BEUYS

b.1912 Krefeld, Germany
d.1986 Düsseldorf, Germany
*Score*, 1971
Ink and rubber stamp on paper
8 5/8 x 8 3/8 in. (22 x 21.3 cm)
Gift of Vernon Nikkel, Clovis, New Mexico, in
memory of Frank F. Nikkel, Anna Zielke Nikkel,
Ruth Nikkel, Irene Hutchinson, and Martha
Nikkel Critelli
89.10.7

So many of the great 20th-century teachers of art were Germans: from Paul Klee (okay, so he was Swiss—but Swiss-German!) at the Bauhaus in the 1920s, to Hans Hofmann at his private school in New York in the 1940s, to Josef Albers at Black Mountain and then at Yale in the post-World War II decades, to Joseph Beuys, who from his home base in Düsseldorf, lectured world wide in the 1960s, 1970s, and early 1980s. So famous were Beuys's lectures that the blackboards upon which he wrote came to be preserved (and sold, for huge sums).

Beuys—like Klee, Hofmann, and Albers—was also an important artist. Important, and hard to classify. Drafted into the Luftwaffe as a radio operator in World War II, Beuys crashed over the Crimea in the winter of 1943. He was (according to his possibly apocryphal autobiography) rescued by nomadic Tartars, who wrapped him in layers of animal fat and felt to bring him back to life. When, after the war, he resumed his life as an artist, shamanistic powers of healing became an important recurring theme for Beuys, as did the use of both fat and felt as characteristic materials in his sculptures. Actually, "sculpture" hardly begins to describe his work, which eschewed the rigid and the permanent in favor of the flowing and the transitory (for example, an elaborate installation of transparent pipes, with honey pumped through them).

*Score* documents Beuys's life as lecturer/teacher/performance artist/political agitator. One stamp documents a public lecture given at the Düsseldorf art school where he taught (and from the faculty of which he was once dismissed as a radical troublemaker). Another ("FLUXUS ZONE WEST"), the avant-garde international group of composers (La Monte Young, John Cage) and artists (Robert Rauschenberg, Nam June Paik) with whom Beuys was closely associated in the 1960s and early 1970s. In 1970, Beuys founded the *Organisation für direkte Demokratie* to promote government by referendum (rather than by representation), part of his core belief that everyone should be empowered both as a creative person and as a social agent (for Beuys, the two were inseparable).

Always recycling humble objects, Beuys made this work on the back of a page torn from the catalogue to a 1971 exhibition featuring the work of Lorenzo Tornabuoni, a young Italian artist. Did Beuys know and delight in the fact that Tornabuoni shared his name with a 15th-century cousin of Lorenzo the Magnificent, and that the original Tornabuoni was a great patron of Renaissance art? Whether he knew it or not, this kind of historical coincidence was just the kind of thing to tickle Beuys's fancy.          —PW

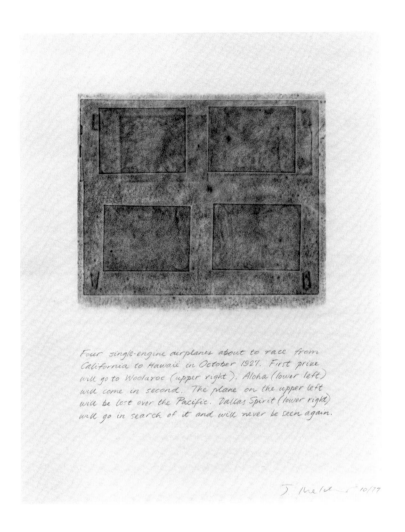

*Four single-engine airplanes about to race from California to Hawaii in October 1927. First prize will go to Woolaroc (upper right). Aloha (lower left) will come in second. The plane on the upper left will be lost over the Pacific. Dallas Spirit (lower right) will go in search of it and will never be seen again.*

## JAMES MELCHERT

b.1930 New Bremen, Ohio
*Four single-engine airplanes about to race...*, 1977
Graphite on paper
23 1/2 x 18 3/4 in. (60.5 x 48.1 cm)
Purchased with funds from the Friends of Art
83.133

In 1927, following Charles Lindbergh's solo flight across the Atlantic, the world went mad for aviators. James D. Dole of Hawaii put up $35,000 in prize money for an Oakland-to-Hawaii race. Melchert's full inscription starkly tells the disaster which resulted:

*Four single-engine airplanes about to race from California to Hawaii in October 1927. First prize will go to Woolaroc (upper right). Aloha (lower left) will come in second. The plane on the upper left will be lost over the Pacific. Dallas Spirit (lower right) will go in search of it and will never be seen again.*

For five straight days, the *New York Times* devoted most of its front page to the race, the search for the two missing planes (*Golden Eagle* and *Miss Doran*), and the subsequent search for Capt. William P. Erwin who had set out in *Dallas Spirit* to trace the route of the lost aviators, and had himself crashed at sea; the (unsuccessful) last-minute appeals of Sacco and Vanzetti were relegated to secondary columns. [n.b.: The winning plane, *Woolaroc*, is a principal exhibit at Frank Phillips's ranch-museum of the same name, in Bartlesville, Oklahoma.]

Melchert's drawing seems to be a rubbing of a photo album page: the four distinct rectangles record photographs on the front of the page, and fainter, overlapping rectangles would seem to be additional photographs mounted on the verso. But a rubbing of a photograph leaves, of course, no trace of the image except its boundaries. Peer as we will into the soft gray, we find nothing to verify Melchert's claim of the subject matter. The planes, their brave pilots and navigators, are as lost to us as they were to the searchers at sea in 1927.

Melchert's entry in *Who's Who in American Art* lists him as "sculptor, educator"; he studied ceramics with Peter Voulkos at the University of California, Berkeley, later taught there, and was at different times Director of Visual Arts Programs at the National Endowment for the Arts, and Director of the American Academy in Rome. In our drawing, he may perhaps best be described as having acted as a whimsical anti-photographer. Still today, this work is as baffling (and strangely beautiful) as on the day of its creation.
                                                                —PW

## JOHN WESLEY

b.1928 Los Angeles, California
*Newark,* 1987-1988
Acrylic on canvas
63 3/4 x 84 in. (162.5 x 213.3 cm)
Purchased with funds from Elizabeth Wills  94.8

*The question that immediately arises with this picture—or any other Wesley picture—is not What does it mean?, but Why did the artist want to paint it?*

Peter Plagens, *Artforum,* 1998

Well, yes. But, at least in the case of *Newark*, what *does* it mean? What's going on here? We're looking out of a picture window. Evidently from a domestic interior (the curtains). But across what looks like the skyline of a 19th-century industrial district. The pale blue sky may be either dawn or dusk. Only a couple of windows glow with pink light, and the sky is filled with three great airliners, flaps down, descending for a landing (presumably, at Newark Airport). It doesn't take much imagination to reverse the illusion, however, and see them as taking off, right to left. And, possibly, to see them as inside the room (the backlighting, reducing both the planes and the mullions of the windows to equal, flat blacks, encourages this ambiguity).

Airliners (727s?), or bombers? Hard, finally, to know. At any rate, there's some terror built into this depiction.

During all of his long and distinguished career, critics have been forced to grapple with the elusive nature of John Wesley's oeuvre. Is he a Pop artist? Or a Minimalist? Or a Surrealist? Or, as most of his many admirers conclude, some unlikely combination of all three? His late wife, the author Hannah Green, compared him tellingly with ancient Greek vase painters (the laconic, outline style, and the elegance of his contours). A biographical note: his first employment, after high school in Los Angeles, was with Northrup Aviation, where he rose from riveter to illustrator. Perhaps in reaction, his first paintings (when he was in his twenties) were very Abstract Expressionist: "flinging paint," as he later described it. By the early 1960s, he settled in to his mature style of repeated, flat shapes and a restricted palette of, mainly, chalky pastels. His subject matter has ranged widely: sometimes loosely drawn from Dagwood and Popeye comics, sometimes (as here) entirely of his own imagination. The critic Thomas McGonigle (writing in *Arts Magazine* in 1979) put it thusly:

*When I look at Wesley's paintings I feel like a child whose parents have just died. I have no practice for this event. I do not know where to hold my hands, when to smile, when to nod my head. The moment is unique and therefore the words are difficult.*

—PW

(detail)

## FÉLIX GONZÁLEZ TORRES

b.1957 Guáimaro, Cuba
d.1996 Miami, Florida
One sheet from *Untitled (Death by Gun)*, 1990 and continuing
Offset lithograph
45 x 33 in. (114.3 x 83.8 cm)
Gift of an anonymous donor
94.45

Ethical museums (and the University of New Mexico Art Museum prides itself on being one) don't usually include in their collections items which they know to have been taken from other museums. But we proudly possess this printed sheet by the late Félix González Torres, even though we know it was taken from an exhibition at the Museum of Modern Art. We do so because that's what both the artist and MOMA wanted! And we do so even though we, being an ethical museum, can never exhibit this sheet (because it is a product of, but not really a substitute for, the intended work of art); but we do—frequently—show it to students and other visitors in our Print Seminar Room.

*Untitled (Death by Gun)* is one of roughly twenty "stack" pieces executed by Félix González Torres, beginning in 1988. Most of the stacks looked the same (and looked, when seen in a gallery at the beginning of the day, rather like abstract, Minimalist sculpture): thick slabs of paper, lying on the floor. At the beginning of the day, the exhibiting institution was to make sure that the stack was nine inches deep. Viewers were encouraged to take away sheets, which the museum from time to time reprinted to meet the demand.

So what's this all about? In a sense, it is a return to the 15th-century origins of printmaking: a way to make an indefinite number of nearly identical images, a way to communicate with the masses. It certainly stands on its head the notion of a limited edition of expensive, hand-pulled prints; the number of sheets of this work that will ultimately be produced is open-ended, and depends upon decisions by both exhibiting institutions ("How often do we want to show it?") and their audiences ("Do I want to take one home with me?").

The content of the stacks varied widely, from beautiful, photo-graphically-derived landscapes, to this chilling piece (adapted from a twenty-five-page spread in *Time* magazine) which documents one week's total of death by guns in the United States. Each gun victim is represented by photograph (if available) and by a brief description of the circumstances. Unlike yesterday's newspaper (or newsmagazine), this grim reminder gets continually renewed currency through Félix González Torres's re-visioning of the potentials for printed images.

—PW

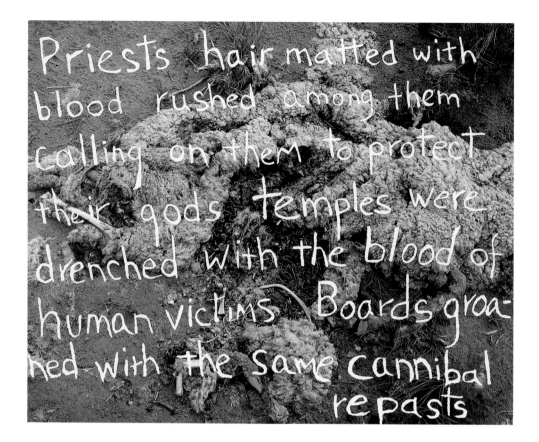

**VICTOR MASAYESVA, JR.**

b.1951 Hotevilla, Arizona
*Prescott on Dining Etiquette*, 1991
Gelatin silver print and paint
15 1/4 x 19 1/4 in. (38.7 x 48.9 cm)
91.50

*Priests hair matted with blood rushed among them*

Think about Cortés and Montezuma and the Spanish conquest of the Aztec Empire. Almost inevitably, and whether you know it or not, the images that come flooding into your head (cavalry charges, big feathered headdresses, lots of gold objects) can almost all be traced back to the purple prose of William Hickling Prescott (1796-1859). A Harvard man (and nearly blinded in a food fight during his undergraduate days), Prescott became the foremost Anglo-United States scholar of the Spanish world. His greatest work, *The History of the Conquest of Mexico* (3 volumes, 1843) remains a heck of a good read, just so long as you're not looking for sensitive social or economic history.

*calling on them to protect their gods*

For Prescott, who relied mainly on Spanish sources, the conquest was a rip-snorting tale of Cecil B. De Mille-esque proportions. In a sober footnote, he admitted that the incidence of ritual slaughter or cannibalism among the Aztecs was variously estimated as between fifty and 20,000 victims per year. But in the pages of his book, horrifying tales of human sacrifice and cannibalism (such as the passage inscribed by Masayesva on his photograph) abound. For the Spanish, and for Prescott, the demonization of the indigenous populations helped assuage any guilt that might have been felt over the treatment of the Aztecs by the conquistadors.

*temples were drenched with the blood of human victims*

Hopi photographer, film maker, video artist Victor Masayesva, Jr., quotes this particularly bloodthirsty passage from Prescott in full awareness that this book in particular helped to create attitudes toward native peoples which served the purposes of United States expansion into the Southwest. Indeed, most of Masayesva's art explores the consequences of photographers and anthropologists, collectors and curators, upon the people and events which they study. Masayesva, himself, studied both literature and photography at Princeton, before returning to live and work on Third Mesa at Hopi. In whatever medium he creates, he frequently overlays images, or images and words, to explore the friction between different points of view. Here, the image beneath the hand-painted Prescott text shows a desiccated carcass (perhaps of a sheep? perhaps of a victim of a coyote, or of the Coyote—the trickster, the disrupter?).

*Boards groaned with the same cannibal repasts*

—PW

**LESLEY DILL**

b.1950 Bronxville, New York
*Beauty crowds me till I die*, 1995
Lithograph with thread
30 1/2 x 16 1/2 in. (77.5 x 42 cm)
Collaborating printer, Nebojsa Lazic
The Tamarind Archive Collection
95.33.10

Before switching to art and obtaining her M.F.A. in painting from the Maryland Institute of Art, Lesley Dill took her B.A. in English (from Trinity College, in Hartford, Connecticut). So, certainly, she was already well-acquainted with the poems of Emily Dickinson when, in 1990, a friend gave her a volume of Dickinson's verse. But that gift sparked a still-continuing series of works, in which Dill investigates—in a variety of mediums, and in a wide range of scales (up to and including monumental billboard projects)—both the meanings of Dickinson's writings and the possible relationships between words and images, between words and our sense of self-being.

*Beauty crowds me till I die*, a lithograph (!) created at UNM's Tamarind Institute in 1995, takes its title from the opening of a four-line poem by Emily Dickinson:

> *Beauty crowds me till I die*
> *Beauty mercy have on me*
> *But if I expire today*
> *Let it be in sight of thee —*

Like the poem, Dill's work celebrates, even exults in, a sense of wondrous, transcendent, quasi-religious beauty. The words are both within the body and spilling out of, or emanating from, it. Poetic affirmation of life and beauty is not separate from, but rather an integral part of who we are.

The figure—clearly female—is made from Mulberry paper, printed on in six colors, cut, crumbled and partially flattened, and then sewn onto a backing heavier paper, with the threads dangling free. The multitude of references evoked by this extra-ordinary work are mostly of the pre-industrial age, of handicrafts in general and (often) "women's work" in specific. We can think about dressmaking patterns, about hand-dyed fabrics, about hand-set and hand-embellished typography. As in all these references, Dill's print hovers somewhere between the unique object (no two of these can possibly be exactly alike) and the typical multiple image (this is, after all, a lithograph printed in an edition of twenty-two signed and numbered impressions).

Dill stretches our sense of what is possible within the medium of lithography. She has also created an object which seems both of our time and of the 19th century, as if the poet and the visual artist collaborated in its production. Which, in a way, they did.

—PW

**JAUNE QUICK-TO-SEE SMITH**

b.1940 Flathead Reservation, Montana
*Ceremony Series: Tule Pollen*, 1997
Monoprint
17 3/8 x 12 in. (44.1 x 30.5 cm)
Collaborating printer, Catherine Chauvin
The Tamarind Archive Collection
98.7.54

In the fall of 1997 Jaune Quick-to-See Smith came to Tamarind Institute, at their invitation, to make a series of prints. Still fresh in her mind was her participation the previous summer in an Okant (Sundance) with her Flathead and Blackfeet relatives at Badger Creek, Montana. Four almost magically fresh monoprints—each impression hand-painted by the artist on linoleum, then run through a press, then over-printed with a black-inked aluminum lithographic plate—resulted. (In addition to *Tule Pollen*, the other three prints of the *Ceremony Series* are *First Salmon*, *Face Painting*, and *Crossing Over*.)

In viewing *Tule Pollen*, would it help to know the specifics of this ceremony? Of course. Does it add to the experience if we have read the artist's paeans to the migratory and oral traditions in which she grew up? Undeniably. But even an outsider, even someone viewing this image without knowing that the artist is Native American, can appreciate both its beauty and its message. The great hand in the sky scatters tule (bulrush or cattail) pollen; beneath, a small figure falls backwards in ... what: joy? awe? gratitude? Some combination of these three?

The symbolism is universal. In Christian iconography, one thinks of God appearing as a blinding flash of light to Saul on the road to Damascus; European artists traditionally show Saul (who, at that moment, became Saint Paul) literally knocked off from his horse by the power of the transforming light. In this monoprint, the wondrous central patch of gold and yellow plays a role both aesthetic (it's simply ravishing to look at) and transcendent: it is, in purely abstract terms, related both to the gift of pollen, and to the idea of an active, vital godhead in nature.

Since taking her M.A. in painting at the University of New Mexico in 1980, Jaune Quick-to-See Smith has achieved international prominence in many roles. She has curated and co-curated important travelling exhibitions of Native American and First Nation art; she has lectured widely both on her own art and of that of fellow artists; she has been an important mentor to many in the next generations of Native American artists. Her own art, exhibited and praised internationally, can sometimes be wittily, sometimes caustically, political. Or, as here, it can be quite wonderfully celebratory. The constant is Smith's ability to tell stories in a visual language both true to her own heritage, and accessible to all humankind.

—CB & PW

**ANNE NOGGLE**

b.1922 Evanston, Illinois
*Face Lift No. 3*, from the series *Face Lift*, 1975
Gelatin silver print
10 3/4 x 15 3/4 in. (27.3 x 40.0 cm)
Purchased with funds from the Friends of Art
83.125

**CINDY SHERMAN**

b.1954 Glenn Ridge, New Jersey
*Untitled*, 1990
Color coupler print
14 x 11 in. (35.5 x 28 cm)
2000.4.2

All art, all art-making, is essentially autobiographical: we can get to know Rembrandt or Van Gogh almost as well through their landscapes as via their self portraits. But in photography of the last quarter century, self portraiture has taken particular pride of place in the oeuvres of some of our most prominent artists, and perhaps particularly so in the cases of several women.

Albuquerque-based Anne Noggle (after a rich and varied series of careers in aviation, including serving as a Woman Air Force Service Pilot in World War II) took her M.A. in photography at the University of New Mexico in 1969. She has, over the past three decades, turned her camera on human subjects as varied as Soviet airwomen and aging couples. But time and again she has returned to herself as subject, in circumstances ranging from the exuberant (*Myself as a Guggenheim Fellow*, 1982) to grief stricken (*The Late Great Me*, at her mother's funeral in 1983) to primly proper (*Almost a Lady*, 1996). *Face Lift No. 3*, made in the aftermath of plastic surgery in 1975, remains one of the most compelling of this continuing series of self-explorations. We (through her lens) stare in fascination at her bruised face; she looks somewhere through and beyond us, while contemplatively chewing on the plant stem; the whirligig garden-ornament plane testifies to her earlier life in the skies, where she was young and above the pull of gravity on flesh.

Cindy Sherman—on almost everyone's list of the most influential artists of our times—began her career in the late 1970s with black-and-white "film stills," in which she assumed prototypical Hollywood heroine roles. In the 1980s, she turned to luscious color, and her costumes and props became ever more elaborate and—often—grotesque, or otherwise disturbing. In our work (untitled, as is true of all of Sherman's self portraits), she appears as everyone's slightly demented great aunt, all dressed up as Mrs. Santa Claus, and surrounded by the most depressingly awful kitsch. The palpably false wig, the absurdly chipmunk-like bulging cheeks, deliberately give away the deception.

Noggle, the great realist, and Sherman, the parodist, separately and together help us to explore the possibilities of living (and aging) in our times.   —PW

## CATALOGUE AUTHORS

| | |
|---|---|
| BKV | Bonnie K. Verado |
| CA | Clinton Adams |
| CB | Cynthia Barber |
| DRG | Douglas R. George |
| FMC | Floramae McCarron Cates |
| HL | Helen Lucero |
| JM | John Mulvaney |
| JSW | Joy S. Weber |
| JT | Joseph Traugott |
| KSH | Kathleen Stewart Howe |
| LPT | Linda P. Tyler |
| PW | Peter Walch |
| ROW | Robert O. Ware |
| SNB | Susan Nunemaker Braun |